W9-CDI-359

Masterworks of Asian Art

Masterworks

of Asian Art

Michael R. Cunningham Stanislaw J. Czuma

Anne E. Wardwell J. Keith Wilson

THE CLEVELAND MUSEUM OF ART

in association with

THAMES AND HUDSON

Board of Trustees

MICHAEL J. HORVITZ, PRESIDENT

DONNA S. REID, VICE PRESIDENT

RICHARD T. WATSON, VICE PRESIDENT

ROBERT P. BERGMAN, CEO AND SECRETARY

MRS. QUENTIN ALEXANDER

JAMES T. BARTLETT

LEIGH CARTER

RUTH SWETLAND EPPIG

ROBERT W. GILLESPIE

GEORGE GUND III

GEORGE M. HUMPHREY II

ANNE HOLLIS IRELAND

ADRIENNE L. JONES

MRS. EDWARD A. KILROY JR.

PETER B. LEWIS

JON A. LINDSETH

WILLIAM P. MADAR

ELLEN STIRN MAVEC

S. STERLING MCMILLAN III

REV. DR. OTIS MOSS JR.

ALFRED M. RANKIN JR.

WILLIAM R. ROBERTSON

EDWIN M. ROTH

MICHAEL SHERWIN

EX OFFICIO

MRS. ALBERT J. DEGULIS

JOHN C. MORLEY

DAVID L. SELMAN

HONORARY TRUSTEES

QUENTIN ALEXANDER

JAMES H. DEMPSEY JR.

JACK W. LAMPL JR.

MORTON L. MANDEL

GEORGE OLIVA JR.

MRS. ALFRED M. RANKIN

FRANCES P. TAFT

DR. PAUL J. VIGNOS JR.

ALTON W. WHITEHOUSE

DR. NORMAN W. ZAWORSKI

This publication was supported, in part, by a grant from the National Endowment for the Arts, a federal agency.

Copyright © 1998
The Cleveland Museum of Art

All rights reserved. No portion of this publication may be reproduced in any form whatsoever without the prior written permission of the Cleveland Museum of Art.

Cover: *Nataraja, Shiva as the King of Dance* (detail). Purchase from the J. H. Wade Fund 1930.331

Editing by Barbara J. Bradley and Troy Moss

Design by Laurence Channing

Production by Charles Szabla, assisted by Carolyn K. Lewis

Photography by Howard Agriesti and Gary Kirchenbauer

Composed in Monotype Walbaum, adapted for this publication by Thomas H. Barnard III, with Adobe PC Pagemaker 6.0

Printed in Great Britain by Balding + Mansell Ltd

Note to the Reader

This book was created for a general readership, and English is used wherever possible. Words in foreign languages requiring transcription into the Roman alphabet have been simplified and diacritical marks eliminated, for example, "Shakyamuni," "Rashtrakuta," "Jomon," "Koryo." Terms that appear in italic type, however, retain their diacritical marks.

Dimensions are given in centimeters, height by length by width.

Library of Congress
Cataloging-in-Publication Data
Cleveland Museum of Art.
 Masterworks of Asian art / Michael R. Cunningham ... [et al.].
 p. cm.
 Collection housed in the Cleveland Museum of Art.
 Includes bibliographical references.
 ISBN 0–940717–42–5 (cloth : alk. paper).
 —ISBN 0–940717–43–3 (pbk. : alk. paper)
1. Art, Asian—Catalogs. 2. Art—Ohio—Cleveland—Catalogs. 3. Cleveland Museum of Art—Catalogs. I. Cunningham, Michael R. II. Title.
N7262.C59 1998
709'.5'07477132—dc21 97–45033
 CIP

Contents

Foreword 7

A History of the Department of Asian Art 9

China and Central Asia 19

India and Southeast Asia 103

Japan and Korea 175

Select Bibliography 251

Foreword

The publication of this volume has been an ambition of a number of us at the museum for quite some time. Finally, we can provide museum visitors, scholars, and individuals worldwide with an introduction in one volume to the range and quality of the remarkable Asian collections of the Cleveland Museum of Art. The more than one hundred objects included in this book have been selected with an eye toward representing the comprehensive nature and special character of these collections, while at the same time reflecting the refinement and aesthetic power of the individual objects that make up the museum's holdings. China, Japan, Korea, India, Central Asia, Thailand, Cambodia, Vietnam, Nepal, Kashmir, and Tibet are all represented in this volume. The objects illustrated have been selected from a collection numbering more than 4,300 works in a variety of media.

In these waning years of the twentieth century the cultures of Asia, whose history and art remain relative terra incognita to the average citizen of Europe or North America, are emerging—for reasons more economic than aesthetic—as of central interest to the Western world. With predictions of the next century being the "Asian Century" because of the dynamism of the area's economies, more and more citizens of the West are turning their attention toward understanding the different cultures of Asia. The art of these societies, encapsulating centuries of ritual, belief, legend, cultural archetype, and self-definition, is a key to developing such understanding. Moreover, the aesthetic and spiritual rewards of viewing, contemplating, and studying the often staggeringly subtle expressions of Asian art cannot be overestimated. Those of us, like myself, who are specialists in the history of Western art are consistently humbled in the face of the sophisticated and nuanced qualities of the arts of Asia. Is it any accident that for more than a century European and American artists have themselves been inspired by Asian art?

Many centuries before today, Asian textiles and other luxury arts were considered by Westerners to be the most desirable such works in the world, emanating from its most ancient and advanced cultures. Paris and Rome were relative backwaters around the year 1000; Constantinople, Cordoba, and Cairo were among the dynamic centers of the Mediterranean world; Samarkand, Angkor, K'ai-feng, and

Kyoto were in many ways the center of the universe. The famous Silk Road carried the ideas and objects of the Far East to the West during the European Middle Ages, and in the thirteenth century the famous Venetian merchant-adventurer Marco Polo lived in Peking in the court of Kublai Kahn and brought the lore of the East back with him to his Mediterranean homeland. As we enter the next century it is interesting to note that the impact of Western "traders" is once again encouraging the pace of our cultural encounter with Asia.

In the following pages, curator Michael R. Cunningham narrates the history of the formation and stewardship of the Asian collections of the Cleveland Museum of Art, with special attention to the relatively forgotten early years. The story is a fascinating one on a number of counts. That an interest in the arts of Asia—not just China and Japan, but Korea, India, and Southeast Asia—was incorporated into the museum's earliest statements of purpose is in itself notable, since it indicates a breadth of vision unusual for the time. Occasional hiatuses notwithstanding, the museum's course of acquiring art from a variety of Asian cultures has remained a cornerstone of its collection activities to the present and, one dares to hope, will remain so well into the future. Indeed, the remarkable balance of East and West is one of the hallmarks of the museum's permanent holdings. This history of the department of Asian art also points up the museum's good fortune in having benefitted from the work of enlightened founders, generations of talented curatorial professionals, generous collaborative collectors, and, in the case of Sherman Lee, a scholar/director renowned in the Asian field.

For their efforts to bring this work to fruition I thank authors Michael Cunningham, Stan Czuma, Anne Wardwell, and Keith Wilson. The book's elegant design was executed by Laurence Channing and its meticulous editing implemented by Barbara J. Bradley and Troy Moss. I also wish to acknowledge the National Endowment for the Arts for supporting this publication.

May this volume bring pleasure and enlightenment to its readers and encourage deeper understanding of the arts and culture of Asia.

Robert P. Bergman, Director

A History of the Department of Asian Art

A
t its incorporation in 1913, the founders of the Cleveland Museum of Art had neither a collection of art nor a building for its display. It would take a few more years for the classic style building to be realized, and a much longer period of time for the museum's art collections to develop. However, early museum records indicate that from its inception this new museum in America's industrial heartland would take an active interest in displaying the arts of the Orient.

This enlightened approach to the formation of a fine arts collection reflecting the achievements of Western as well as non-Western cultures was not an anomaly. While relatively late in the founding of an art museum for the people of the city, when compared to comparable East Coast institutions or to the museums in Chicago (1893), Toledo (1901), and Buffalo (1905), Cleveland already enjoyed a cosmopolitan history of active community affairs dating back to the 1880s. Its status as America's sixth-largest city and an important industrial center fostered the impulses of its civic leaders in their efforts to enhance the city's cultural life. In the main they were businessmen well aware of the cultural attractions of the major East Coast metropolitan areas, as well as such international events as the Worlds Columbian Exposition of 1893 in Chicago, which featured pavilions displaying Japanese and Chinese art and commercial products.

When Frederic Allen Whiting arrived in 1913 to assume his duties as the inaugural director of the new museum, it was but a few scant weeks since the official incorporation (3 June 1912) of the institution known today as the Cleveland Museum of Art. Besides the immediate—and demanding—task of supervising the actual construction and interior design of the building, Whiting set about forming the future collections of art to be housed within the promised structure.

An early indication of Whiting's interest in Asian art can be identified in his January 1914 report to the trustees in which he proposed that the new museum specialize in the arts of India, as it comprised a branch of art "not adequately represented in any American museum." Whiting believed that first-rate objects could be obtained most reasonably, even relatively quickly, and indeed the garden court of the new museum could be transformed into an Indian garden with sculptural and archi-

tectural elements assembled to form a kind of tableau for visitors. Such focus and in-
dividuality in the collections would spotlight the museum, and surely draw crowds to
its galleries. As it turned out, a shortage of building funds and monies donated to en-
able purchasing artwork for the garden court mitigated against Whiting's concept,
which would have placed an Asian culture at the forefront of the young museum's
public identity.

Subsequently Whiting produced a detailed memorandum setting out priori-
ties for the future development of an oriental collection in Cleveland. (No compa-
rable proposal exists pertaining to Western art at the museum.) In doing so he was
presumably guided by experience and precedent: coming from the East Coast he was
aware of the strong Japanese and Chinese collections at the Boston Museum of Fine
Arts, the Metropolitan Museum's activities in collecting later Indian art, and the few
but prominent private collectors in the field such as Charles Lang Freer, the Detroit
industrialist. Whiting realized the importance of private individuals forming sub-
stantial collections of Eastern art at the time, and—significantly—their historical
role in supporting the museums with which they enjoyed enduring relationships. By
the summer of 1914 when he named the museum's advisory board, Whiting had also
identified no less than "twenty future donors of Oriental Art to the museum."

Most prominent among them was, no doubt, Worcester Reed Warner. Origi-
nally from a small town in western Massachusetts, Warner moved to Cleveland from
Chicago in 1881 to establish, with his business partner Ambrose Swasey, the precision
tool and die firm bearing their names. By the turn of the century the success of their
business was assured, and Warner began to turn his attention increasingly toward
civic projects, in keeping with the contemporary atmosphere in Cleveland of com-
munity activism. His wife, Cornelia Blakemore Warner, joined him enthusiastically
in his various projects, especially those involving the arts. In June 1915 the Warners
first hinted at what Worcester Warner would come to call "my scheme."

Frederic Whiting had already been in contact with Worcester Warner as one
of Cleveland's business leaders whom he wished to serve on the museum's fledgling
advisory board. Warner declined, citing his considerable business responsibilities. He
also declined to contribute funds then being solicited from trustees, advisory board
members, and other prominent civic leaders for staging the June 1916 inaugural cel-
ebrations of the new museum.

Instead, in a letter dated 24 June 1915, Worcester Warner launched "his
scheme" for Whiting and the museum trustees to consider. He proposed establishing
an endowment fund by January 1917 in the then-imposing amount of $100,000 "pri-
marily for the purchase of Oriental Art." Furthermore he wished to give the mu-
seum $50,000 outright toward the "securing of a collection of art objects, preferably
Oriental Art." This magnanimous gesture was the earliest and most substantial gift
directed specifically toward the purchase of art that the museum had received (or
would receive for many decades).

Whiting and the trustees were naturally delighted with the prospect of the
Warner bequest, and with the presence in their community of a citizen also intent
upon forming a significant private art collection. Indeed the Warners began to plan
an extended autumn trip to the Orient to visit the temples and cultural monuments
and institutions of West and Southeast Asia and India. They also wished to make
contact with the numerous private collectors and art dealers in Japan whom they had
started to learn about from others. Based upon his previous travel to Japan, Whiting
assisted the Warners by providing information about the most important private col-

lectors he had met there, and by putting them directly in touch with Langdon Warner (no relation), the Harvard University professor and specialist in oriental art at the Fogg Art Museum.

Acknowledged in America and abroad as this country's most experienced specialist in this field, Langdon Warner was engaged by Whiting in 1915 to serve as a consultant to the museum. During his subsequent trips to Europe or even New York, Langdon Warner sought out potential acquisitions for the emerging Worcester Warner and John Huntington collections in Cleveland. The museum also provided funds in 1916 for Warner's field expedition to inner Asia (Turkestan), which never materialized because of political instability in the area. Instead he used the opportunity while in the Far East to locate suitable objects for the museum and Worcester Warner, and to work on the manuscript for a book on early Japanese Buddhist sculpture whose publication (in 1923) was underwritten by the Cleveland Museum of Art, through a solicitation to several of its trustees.

Thus, although there existed as yet no museum facility, Director Whiting, the trustees, and Worcester Warner had, by the summer of 1915, set about building an actual collection of art objects to represent the various cultural achievements of the Orient. Funds from the John Huntington Art Trust, named after one of the museum's three founders, were focused on Indian and Southeast Asian objects within the Eastern world, while Worcester Warner's funds were directed toward Chinese, Korean, and Japanese art.

The Warners' extensive travels over a six-month period in late 1915 and early 1916 took them to India, Burma, and Java. Warner's expertise in astronomical telescope and lens design (Warner and Swasey held important contracts with the United States government for such precision equipment) naturally led him to the classical observatories in Peking (fourteenth century) and Jaipur (eighteenth century). Guided by introductions from Whiting, Langdon Warner, and Charles Freer (an advisory board member), the Warners visited Japan and Seoul, Korea, as well. In fact, Worcester Warner was quite keen on Korean (then spelled "Corean") ceramics and art, and he lamented vociferously in 1915 of missing the opportunity to purchase an important collection of ceramics purported to be second only to that owned by the royal Yi family.

Worcester Warner was entirely sympathetic to Whiting's stated belief that a first-rate collection of Korean ceramics at the museum would help establish its reputation throughout the world. This was the director's third proposed option for highlighting the new museum's collections (assembling Indian art for the garden court and retrieving artifacts from an expedition into Chinese Turkestan had each been unsuccessful), as set out in the 1914 memorandum. While the first Korean ceramic, a Koryo period (918–1392) celadon entered the museum's collection in that year, Worcester Warner's disappointment in securing an entire collection only confirmed his resolve to obtain fine Korean works of art whenever possible. They were to become an important focus of his collecting activities through the ensuing years.

He was greatly aided in these endeavors by J. Arthur MacClean, the museum's first (and at the time only) curator. Appointed by Whiting in October 1914 to oversee the "growing collections of the museum" and "act as general assistant to the Director," MacClean brought impressive credentials with him. Since 1903 he had served in the Asiatic department at the Boston Museum of Fine Arts, certainly the finest single assemblage of Asian art in the Western world. Educated at Harvard and mentored by some of Boston's well-known collectors of Chinese and Japanese

art, MacClean's experience and background disposed him toward the relevance of objects from the East in a public museum's collection. Indeed Whiting announced at his appointment that he hoped that MacClean's "enthusiasm and his knowledge of Eastern art will so stimulate interest in the art of the Near and Far East in Cleveland that his whole attention may, before long, be required for the care of a department of Oriental Art in the Museum."

Certainly there was much to do in preparing the galleries for the June 1916 inauguration. Given the scale of the gallery spaces, MacClean worked actively with local collectors, dealers, and Langdon Warner to identify prospective purchases or loans for the museum. Besides the purchases made through the Worcester Warner endowment (and sometimes by the donor himself) and John Huntington Art Trust funds, important gifts of Japanese and Chinese objects arrived through members of the board of trustees and advisory board: Mr. and Mrs. Ralph King, D. Z. Norton, and John L. Severance. Thus began in earnest a planned, professionally supervised pattern of collecting single objects at the Cleveland Museum of Art, aided by generous funds from the community and modest, singular gifts.

The most active of these collectors during the period 1915–23 was no doubt Worcester R. Warner. In 1917 alone Langdon Warner shipped no fewer than eight cases of Korean objects (including eighty-four ceramics, forty-four bronzes, and nine Chinese and Korean paintings) from Seoul and six cases of Chinese "curios" from Tientsin to the museum for acquisition through Worcester Warner's funds. Two years earlier, in Europe and on the East Coast, he expended more than $30,000 in search of oriental pieces for the museum. Offers of whole collections as well as single objects were also coming to MacClean regularly during these years as a result of his activities at the museum, supported by Worcester Warner. He regularly changed the gallery displays too, focusing on materials (jade, metalwork, or ceramics) or art historical periods. He also arranged for extensive loans from Worcester Warner's private collection or more modest requests from other local patrons, such as D. Z. Norton (Japanese inro, netsuke, and lacquers). New York or Chicago dealers provided material from time to time also.

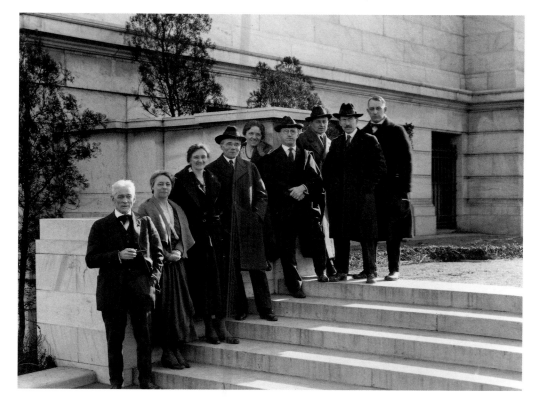

J. Arthur MacClean (second from right), the museum's first curator, stands with other staff members on the side steps of the new museum.

By 1917 MacClean was helping Worcester Warner both prepare a volume highlighting his collection (it was published in 1921) and, more important, define his collection. Worcester Warner wished to "confine" his activities to the Far East, and then later was intent on refining his collecting activities. He inevitably made a point of visiting collectors, museums, galleries, and scholars in the course of his frequent travels to Detroit, Washington, New York, and Boston. MacClean prepared introductions for him to the museum curators and distinguished private collections in these cities. And since the Warner's principal residence was an estate in Tarrytown, New York (next to John D. Rockefeller's), he moved easily in that area's social circles, where his wife was known for giving elaborate parties with oriental settings. Indeed Cornelia Warner's contribution to initiating and shaping the Worcester R. Warner Collection appears positively (but sparingly), as in the spring of that year when she expressed the desire to collect henceforth only Korean and Chinese art. Whiting and MacClean, who was named curator of oriental art in January 1919, were supportive of this shift in focus by their most important patron, even helping to seek a prospective collector in the Japanese art field who would exchange objects with Worcester Warner. Transfers were also enacted with the Huntington collection and its funds.

During the period from the founding of the Cleveland Museum of Art through 1922, Worcester Warner maintained a rigorous business schedule. He also made it a point to travel with his wife to the Orient. Their extended journeys appear in her diary notes as enthusiastic calls for renewed efforts to collect well. And the 1921 publication of the volume documenting portions of their collection seems to have capped their interests and efforts in this arena of their lives. Its production proved to be an intensive project, with letters flying back and forth to MacClean, as well as visits by him and Whiting to Tarrytown to consult on the elaborate volume.

Also about this time MacClean left the museum to join the staff of the Art Institute of Chicago. This change naturally concerned Frederic Whiting, since although other collectors and trustees such as John L. Severance, J. H. Wade, Ralph King, and D. Z. Norton had made a small number of important gifts to the collection of oriental art, Worcester Warner's promised endowment fund as well as his personal collection and active interest in Chinese and Korean art far outshadowed the activity and the potential of any other art donor in Cleveland at that time.

Whiting responded to the challenges of this situation in 1923 by placing the responsibilities of the oriental department within the purview of the curator of prints, Theodore Sizer. Sizer responded gamely to the new administrative challenges, while acknowledging his lack of expertise in matters of oriental art connoisseurship. At the same time Whiting continued to rely on the expertise and goodwill of Langdon Warner at the Fogg Art Museum at Harvard. His research and increased teaching duties there however prevented him from responding as enthusiastically as he had in the past. Thus the affairs of the oriental department subsided dramatically from 1922 until 1929, as other areas of the institution flourished. After Theodore Sizer left the museum in 1927, the newly appointed print curator, Henry Sayles Francis, was put in charge of the department. No significant additions to the oriental collection occurred within this time frame.

By the early months of 1929, however, Whiting was earnestly seeking a suitable successor to MacClean among Langdon Warner's students. He finally succeeded in persuading a graduate student in Chinese languages, Howard Coonley Hollis to join the staff at the museum. Hollis had spent more than three years in China and was teaching at Harvard as well as serving as secretary for the Harvard-Yenching

Institute. His move to Cleveland as curator of Far and Near Eastern art, with the encouragement of his mentor, Langdon Warner, proved auspicious for the museum.

In the same year, 1929, Worcester Warner died without making good on the substantial endowment fund for oriental art that he had promised, and upon which Whiting had clearly relied. The museum's disappointment was somewhat mitigated by the "revival" of the oriental department and by the new curator's ambitious plans for a large Chinese art exhibition later in the year. Following that project, Hollis initiated a pattern of extensive travels to dealers both on the East Coast and in Europe. The acquisition of major works of oriental art through curatorial expertise rather than by donation—a fundamental characteristic of the collecting history of the Cleveland Museum of Art—began with the curatorship of Howard Hollis. Small in number, they proved to be astute decisions at a time when considerable amounts of Chinese, Korean, and Japanese material of widely varying quality and importance were available.

Frederic Whiting's acumen in founding and supporting the oriental department and its various activities ended in the spring of 1930 with his resignation as museum director. During his tenure the department had succeeded in receiving support from collectors Charles L. Freer, Ralph King, D. Z. Norton, John L. Severance, J. H. Wade, and Worcester Warner. Langdon Warner, America's preeminent scholar of Asian art, served as advisor, "non-resident" curator, and agent in the Far East. Special exhibitions and the annual series of rotations in the galleries firmly established the importance of non-Western cultures for the public audience in Cleveland.

Howard Hollis's arrival assured continuity in the activities of the department that were carried on through the appointment of William Mathewson Milliken as the new museum director, in the summer of 1930. That year and the next saw significant donations of Japanese prints from James Whittemore, the acquisition of important Chinese, Indian, and Southeast Asian sculpture, a large exhibition of Persian art, and the promise from Cornelia Warner of her husband's collection.

Howard Hollis's stewardship of the oriental and Near Eastern departments in the 1930s resulted in greater collection depth and breadth, as well as greater prominence for the museum and its activities abroad and within the United States.

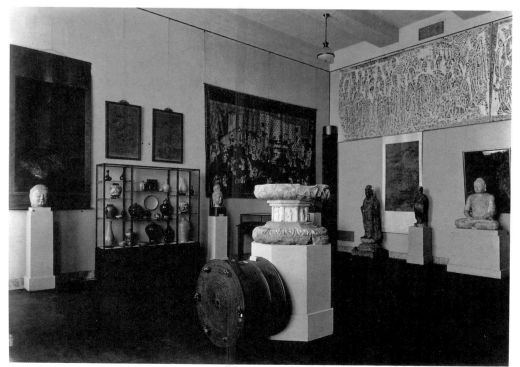

The gallery of Chinese art (1916) included the types of objects then most admired in the West: classical Buddhist sculptures, ceramics, and mural compositions.

Hollis traveled regularly to Europe and made extended trips to the Far East for research and to seek out potential acquisitions. He established relationships with scholars, museum officials, and dealers that were to assist him in his varied exhibition projects, publications, and purchases for the museum. Then, in early 1946 he was asked to go to Japan to work at General Douglas McArthur's general headquarters as chief of its Arts and Monuments Division.

With the approval of the board of trustees and Milliken's support, Hollis set off to Tokyo from where he monitored the preservation of Japan's rich, but fragile, cultural heritage. He enjoyed access to private and public art collections throughout the country, and in Korea as well. He also proved instrumental in establishing the area around that country's most important Shinto shrine, the Ise Grand Shrine, as a national park, thereby assuring its safety and preservation in the modern era.

Hollis returned to Cleveland in the latter part of 1947, but not before he had secured as his Arts and Monuments replacement a former Case Western Reserve University graduate student in American art who had also volunteered in the oriental department at the museum, and who had accepted a position upon graduation at the Detroit Institute of Arts as curator of its oriental collections: Sherman E. Lee. While Lee took over Hollis's duties in Tokyo, in Cleveland Hollis oversaw the newly named department of Far and Near Eastern art briefly before being granted a leave to return to Japan. Perhaps frustrated by his inability to bring significant new acquisitions of Far Eastern art into the collections, Hollis left the employ of the museum at the beginning of 1949, after nineteen years of service. The museum would once again be without a curator in the field of Asian art for several years.

Yet Hollis and Milliken maintained a cordial relationship, which augured well for the museum since Hollis had decided to establish a business in Cleveland as an independent dealer of Far Eastern art. Indeed, from the later 1940s and throughout the 1950s he was the most important source of classical Chinese and Japanese objects in America. Because of this special relationship as well as Hollis's experience and expertise in Japan, the museum was offered rare and unusual works of art from the Far East before other American or European institutions, or private collectors. Milliken availed himself of this advantage and brought into the Japanese collection

Howard Coonley Hollis, the museum's first curator of Far and Near Eastern art.

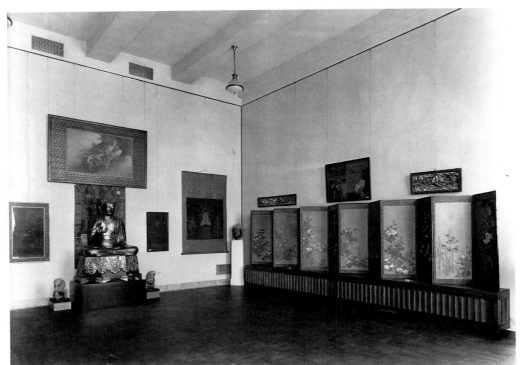

The Japanese art room displayed traditional Buddhist sculpture and paintings, eighteenth-century architectural wood carvings and decorative screens, and a dragon painting from the late nineteenth century.

superb objects and paintings that within a decade were virtually impossible to locate in Japan, much less obtain a government license for their export. The museum was fortunate to realize the opportunities at hand and be able to act upon them. Hollis's loyalty, if not service to the museum, was to endure for more than a decade beyond his retirement.

It was also about this time that Milliken and the museum trustees realized that the collections of Far and Near Eastern art required the professional attention of a specially trained curator. Thus in 1952 they persuaded Sherman Lee, then a curator at the Seattle Art Museum, to return to Cleveland to serve as curator.

Sherman Lee worked actively to build the collection with the assistance of Hollis and also used his own resources in Japan, Europe, and the United States. He also embarked on an ambitious exhibition program, promoted the development of private collections in the community that would augment the museum's holdings, and regularly published research based upon objects entering the collection. Building upon the foundation established by Hollis, Lee began to seriously augment the oriental collections while refining their particular character. He envisioned a truly Pan Asian assemblage of works of art of the highest quality, comparable to those in the Western art collections of several distinguished American and European museums.

When Lee became associate director (1956) and then director (1958) of the museum, his efforts in building the Far Eastern collections and promoting the greater understanding of their cultures through a series of important innovative exhibitions and public educational programming were reinforced. Wai-kam Ho joined the oriental department in 1959 at Lee's invitation, and the two scholars proceeded to form the most distinguished collection of Asian art assembled since the second decade of the twentieth century. Their special exhibition projects over the next twenty years were also extraordinary in American museum history and in the study of oriental art. Bolstered by Leonard C. Hanna Jr.'s magnificent 1959 bequest, the museum soon found itself in an enviable position in the world art market, and with regard to its professional leadership and staffing. In the oriental department new members with expertise in Indian and Southeast Asian (Stanislaw J. Czuma, 1972), and then Japanese (Michael R. Cunningham, 1977) art joined the museum and immediately

Sherman Lee discusses the Kamakura period Wind God *during an interview in the Japanese galleries.*

became involved in the continuing series of special exhibitions, including *Art under the Mongols* (1968), *Eight Dynasties of Chinese Painting* (1981), and *Reflections of Reality in Japanese Art* (1983). The development of the collections in these areas also expanded as dramatically as did the pace of scholarly articles appearing in the museum's monthly *Bulletin*.

At the same time, Wai-kam Ho and Lee fostered private collecting in the community. Lee guided the families of two trustees, helping form the Helen Wade Perry collection of Chinese and Japanese paintings and the Severance and Greta Millikin collection of the ceramics of China, Japan, and Southeast Asia. Each complements the museum's holdings, and both are widely recognized among collectors and scholars worldwide. The Kelvin Smith collection centers primarily on Japanese prints and paintings and, through the generosity of Smith's wife and family, came to the museum to augment its holdings of later Japanese art. Under Lee's watchful eye, and supported by Wai-kam Ho, all three collections took decades to build. The collectors participated in the selection process and were aware of the museum's holdings with respect to their collecting activities. The museum was honored by the gifts of these three collections.

The extraordinary record of published scholarship, art acquisitions, educational programming, and special exhibitions in the field of oriental art during the three decades of Sherman Lee's chief curatorship of the department and directorial leadership propelled the museum into the forefront of the American cultural landscape. By his retirement in 1983 and the arrival of Evan Turner the same year as the museum's fourth director, the museum had come to be recognized throughout the world as an institution whose collections provided visitors with very special, balanced insights into both Western and Eastern artistic traditions.

Aware of his predecessor's achievements, Evan Turner maintained the museum's position as a leader in the Asian art market as he explored new avenues in collecting, exhibiting, and conserving these art objects. Under his direction the department (its name changed to the department of Asian art in 1987) embarked upon an ambitious annual program of having a number of fragile Chinese, Japanese, and Korean paintings restored in Japan by specially trained conservators. A new thrust in collecting activities centered on Tibetan, Central Asian, and early Chinese art, as well as Korean art. And a modest-sized exhibition focusing on a specific theme in Asian art was presented annually as a means of informing the public about the inherent characteristics of this material and the museum's strong holdings in this field. Then, after more than twenty-four years of distinguished service Wai-kam Ho left the museum to assume America's first endowed curatorship in Chinese art at the Nelson-Atkins Museum of Art in Kansas City. In 1985 the department organized and presented another important international exhibition, *Kushan Sculpture: Images from Early India*, under the leadership of Stan Czuma. In the late 1980s Elinor Pearlstein, assistant curator of Chinese art, left to assume new duties in Chicago at the Art Institute, and Stephen Little and then J. Keith Wilson, specialists in Chinese art, joined the staff. Both subsequently went on to assume important positions at the Honolulu Academy of Arts and the Los Angeles County Museum of Art, respectively.

Meanwhile the museum began to prepare for its 75th anniversary in 1991–92 by organizing three complex international exhibitions. One was set aside for an Asian art project that eventually materialized as the first of the three shows: an exhibition of fifteenth- and sixteenth-century Japanese art, *The Triumph of Japanese Style*, organized in cooperation with the Agency for Cultural Affairs in Tokyo under

the guidance of Michael R. Cunningham, then the department's chief curator. The anniversary year's celebration also resulted in a significant number of fine gifts of works of Asian art being given to the museum by longtime friends of the department from throughout the world.

By the time of Evan Turner's retirement in 1993 and Robert P. Bergman's arrival as the institution's new director, significant gains had been made in the conservation and acquisition of Central Asian, Korean, and Southeast Asian art, and early Chinese textiles. The department's admirable record of innovative special exhibitions and scholarship continues to be maintained, enhanced with fresh initiatives and new staff. In 1995 the Nara National Museum invited the museum to join it in an exhibition exchange project, to be realized in 1998, sponsored by the Agency for Cultural Affairs. Honored to be one of the three Western museums selected and eager to share its legacy of collecting Asian art with the Japanese public, the museum has embraced this ambitious project. With the National Research Institute in Tokyo, the museum embarked on a restoration project of some of Cleveland's most important Japanese paintings and lacquer. Enduring relationships with the Korean national museums and the Korea Foundation have resulted in educational programing support and enhanced collection development in this area. In 1998 Ju-hsi Chou, specialist in the field of Chinese painting, assumed his post as the museum's new curator of Chinese art. The millennium is beginning to fade, but the museum's time-honored commitment to collecting, exhibiting, and studying the arts of Asia continues to prosper and grow. M.R.C.

China and Central Asia

Very few Chinese objects or sculptures were made simply for visual stimulation or enjoyment. In a practical culture, things were meant to be used. Most of the greatest ancient works of Chinese art, in fact, had specific functions. Stone Age jades were not just pieces of jewelry but also indicators of role or rank. Likewise, elaborately decorated archaic bronzes served as food and wine containers at symbolic banquets offered to deceased ancestors. The less grand requirements of everyday ancient household life were met by fired clay vessels. By late Bronze Age times, however, in response to changing rules surrounding funerals and burials, ceramic vessels (as well as sculpture) acquired new ritual importance and greater prominence in tombs. Chiefly decorated with molded or painted designs, these mortuary pots frequently exhibit vibrant patterns borrowed from the medium of lacquer, an early southern specialty that gained new importance in the united empires of Qin and Han China.

Early indigenous Chinese traditions related to social hierarchies, ancestor worship, and mortuary rites were profoundly transformed by extensive foreign contact throughout the past 2,000 years. Indian and Central Asian missionaries, crossing mountains and deserts or reaching China by sea, introduced a new spiritual religion that evolved from worshiping the enlightened Buddha. The foreign faith required new forms for education and religious practice. Aside from narrative images illustrating the history and previous lives of the founder, Siddhartha Gautama, Chinese believers created iconic sculptures depicting the Buddha and other Buddhist divinities. Early examples. suggesting the initial importance of foreign styles, were eventually succeeded by sinicized ones created by Chinese painters, sculptors, and craftsmen.

Parallel foreign influences also appear in the Chinese luxury arts of metalwork and ceramics brought about by East-West trade over the fabled Silk Road. Imported Sassanian Persian silver objects inspired new forms and ornamental patterns in China that were especially popular during the Tang dynasty. The imported decorative floral vocabulary lived on in China, echoed, for example, in the beautiful blossoms and sprays—painted in blue—that appear on much later Yuan and Ming porcelain. Lying between the so-called "blue and white" and the earlier, indigenous tradition of green-glazed wares are centuries of increasingly refined glazes and more advanced kiln designs. The monochromes, or single-colored stonewares, of the Song are perhaps the most sophisticated glazed ceramics the world has ever known. With the advent of high-fired porcelain, however, interest turned to increasingly complex methods of painted surface decoration. Underglaze cobalt blue or copper red patterns were eventually joined by overglaze painting in a range of colored low-fired glazes— usually referred to as enamels—that were fixed by a second firing after their application to a finished porcelain.

In addition to ceramics and jade, China is perhaps best known for the arts of the brush: calligraphy and painting. Many examples on the following pages reflect the enduring relevance of earlier styles and subjects, illustrating the Chinese predeliction for rooting new ideas in old. The museum's collection of Chinese paintings is justly world famous, for it includes all major premodern trends and holds works by most of the recognized masters from the fourteenth to the early nineteenth century. These paintings, like many of the other works of art in this catalogue, attest to the acumen of Sherman E. Lee. K.V.

Majiabang culture	about 5000–4000 BC	
Qingliangang culture	about 4500–3000	
Songze culture	about 4000–3000	
Hongshan culture	about 4000–2000	
Liangzhu culture	about 3000–2000	
Longshan culture	about 2300—1800	
Erlitou culture	about 2000–1600	
Shang dynasty	about 1600–1023	
	Erligang phase	about 1600–1400
	Anyang phase	about 1300–1023
Zhou dynasty	about 1023–256	
	Western Zhou dynasty	about 1023–771
	Eastern Zhou dynasty	771–256
	Spring and Autumn period	771–481
	Warring States period	481–221
Qin dynasty	221–206	
Han dynasty	206 BC–AD 220	
	Western Han dynasty	206 BC–AD 25
	Eastern Han dynasty	AD 25–220
Six Dynasties period	317–581	
	Northern Wei dynasty	386–534
	Eastern Wei dynasty	534–549
	Northern Qi dynasty	550–577
Sui dynasty	581–618	
Tang dynasty	618–906	
Five Dynasties period	906–960	
Liao dynasty	907–1125	
Song dynasty	960–1279	
	Northern Song dynasty	960–1127
	Southern Song dynasty	1127–1279
Yuan dynasty	1279–1368	
Ming dynasty	1368–1644	
Qing dynasty	1644–1911	

Pendant

CHINA, NEOLITHIC PERIOD, HONGSHAN CULTURE, ABOUT 3000–2000 BC

JADE (NEPHRITE); H. 13.2 CM

GIFT OF SEVERANCE A. MILLIKIN 1953.628

Jade—a material almost synonymous with China—designates a number of different types of beautifully colored stones that are patterned by natural veins. All examples are extremely hard and must be worked not by cutting but through a grinding process in which quartz or garnet sand is used to abrade away unwanted portions of the stone. In light of the rarity of the material and the technical difficulty of shaping it, it is not surprising that jade was reserved for the greatest artistic achievements of antiquity, including precious jewelry and ceremonial objects such as emblematic axes. Startling ongoing excavations in eastern China are, in fact, showing that the affection for the stone is much older than previously thought, predating the Bronze Age to stretch back to prehistoric times.

One recently discovered Stone Age culture named Hongshan, located in northeastern China, has yielded jades that provide new insight into an amazing object long owned by the museum. The subject of the work is a seated figure with a massive, snouted head supporting four rounded horns. It sits, European style, with pendant legs joined at the bottom by a smooth projecting crescent and its arms in its lap. Once thought to be a tuning peg for a Bronze Age musical instrument, this unusual jade instead resembles sculptural pendants found at Hongshan sites. These newly uncovered jades help prove the purpose of the channel drilled through the shoulders of Cleveland's jade—presumably intended to accommodate a cord—and the function of the object as a pendant. Like other Hongshan jades, this pendant is a simply but naturalistically modeled symmetrical form with smooth swelling surfaces and few linear details. Although few in number, such pendants are important since they represent the earliest surviving examples of representational sculpture in China.

Large complex pendants such as this one must have played an important role in Hongshan society. The subject, probably a human figure transformed by a frightful mask rather than an imaginary creature composed of human and animal elements, suggests that the pendant may have functioned as a shamanistic object used in special rites linking the mortal and spiritual world. Chinese archaeologists have also suggested that larger representational sculpture may have played a role in ritual ceremonies, too, because they have uncovered fragments of monumental terracotta images in the ruins of Stone Age buildings at Hongshan sites. K.W.

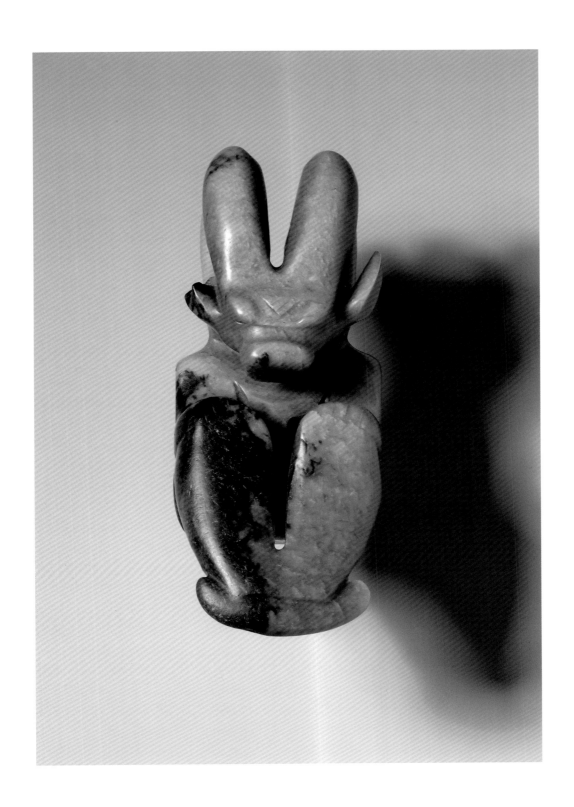

Square Wine Bucket (Fangyou)

CHINA, SAID TO BE FROM ANYANG, HENAN PROVINCE, SHANG DYNASTY, LATE
ANYANG PERIOD, ABOUT 1100–1050 BC
BRONZE; H. 26.7 CM
JOHN L. SEVERANCE FUND 1963.103

This compact, neatly structured vessel is a wine container used in the ritual banquets offered to deceased ancestors in early Bronze Age times. Composed of bronze—an important and valuable man-made alloy of copper and tin, frequently with added lead in China—such objects underscore the significance of Chinese ancestor worship. To conduct the rituals properly, aristocrats and other members of the elite needed a range of vessels representing a number of different functions, so containers like this one would have been used with others, including wine warmers and cups, grain steamers, and meat cookers. In fact, the cast dedication on this *fangyou*—naming a certain deceased "Lady Qi"—links it to bronzes in other museums, all presumably made at the same time for the same person.

Although not specifically made for burial, ritual bronzes were frequently entombed with their owners. The museum's fangyou was probably buried in the same grave as pairs of "Lady Qi" *jue* (wine warmers) and *gu* (beakers), also unearthed earlier this century. Once shiny, these metal objects now have the greenish surface, or patina, characteristic of bronze that has been exposed to oxygen, water, and other substances. Patination actually sealed the lid onto the Cleveland vessel, creating a vacuum that impeded the corrosion process. The fangyou was recently reopened, and its inner walls proved as fresh and coppery as a new penny.

This bronze is said to have been excavated at the late Shang dynasty capital of Anyang, suggesting that it was made in a metropolitan foundry in the greatest city of the time. Such foundries must have been large, judging from the number, size, and weight of Anyang bronzes that have survived to modern times. Chinese production methods that involve the use of ceramic section molds rather than lost wax differ from Near Eastern practices. As employed in ancient China, the section-mold system created objects, their surface decoration, and inscriptions in one casting operation, which accounts for the close structural relationship between vessels and their ornament. On the striking Cleveland fangyou, paired bands containing tense, crested birds occupy the convex and concave surfaces of each side of the square container. The symmetrical designs are divided and framed by discontinuous projecting ribs that reflect the decorative registration in the vessel silhouette. These ribs also reinforce the fundamental architectural character of the shape, an effect further enhanced by the design of the tall peaked lid. The various birds with their bent tails as well as the rigid geometry of the vessel are unusual for a period when rounded vessels influenced by ceramic shapes were particularly popular. K.W.

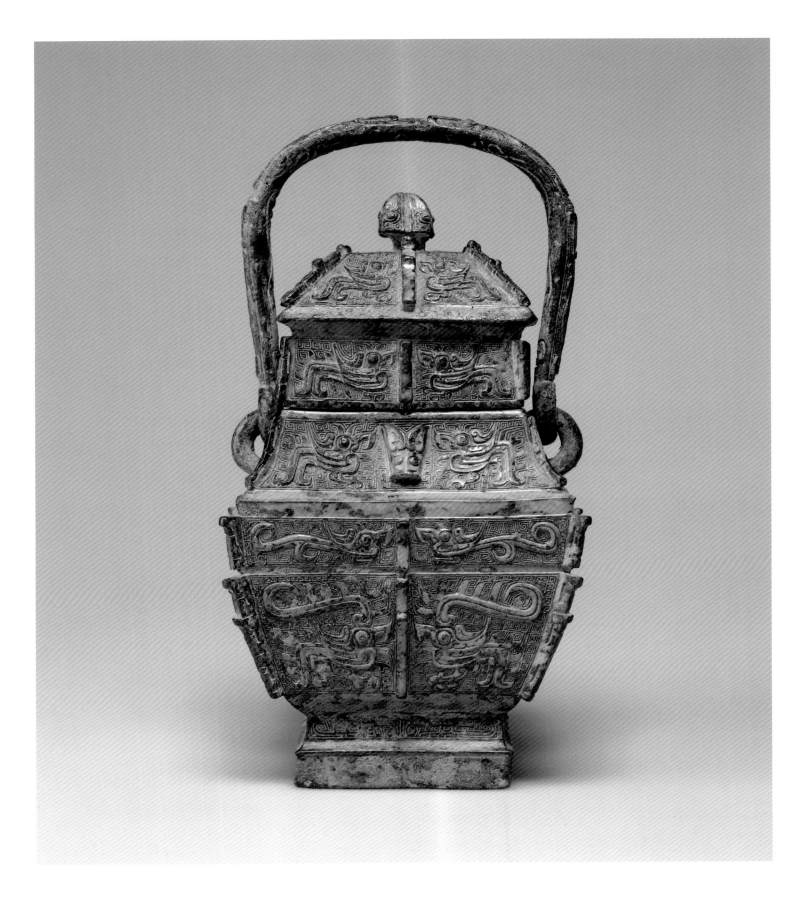

Mr. Lai's Bell (Lai *Zhong*)

CHINA, SHAANXI PROVINCE, LATE WESTERN ZHOU DYNASTY, ABOUT 900–800 BC

BRONZE; H. 70.3 CM

LEONARD C. HANNA JR. FUND 1989.3

By the ninth century BC, bells had become highly sought-after aristocratic possessions in the urban centers of northern China. Frequently created in graduated sets of eight members, they were designed to be hung on wooden racks from loops near the base of their shank. Because they lacked clappers, they must have been played by musicians who struck them on the outside with mallets. Their tones were not random but corresponded to notes in the ancient Chinese musical scale, allowing them to join in large orchestral ensembles. The technical sophistication of these instruments is compounded by the fact that the unusual lens-shaped cavity of the bells allowed each to yield two different notes, sometimes designed to be a third apart. The popularity of these objects, possibly accompanied by the advent of a new kind of formal music, was part of a shift in the function and significance of bronzes in ancient China. No longer made solely for serving the dead, Western Zhou bronzes acquired growing importance in the world of the living.

Cleveland's bell, the finest in the West, beautifully reflects these musical, art-historical, and cultural advancements. The importance of the piece is augmented by the lengthy 118-character cast inscription that covers much of the undecorated surface on one side of the bell. Extraordinary in its own right, this inscription celebrates a man's appointment to royal service in a ceremony conducted by the Zhou emperor himself. Comprising portions of a statement presumably read by the recipient at the time of the event, it states:

> Lai proclaimed: "Great and illustrious was my august late father who made his heart clean following the disciplined virtue of his forefathers and dutifully served the past king. I, Lai, now succeed him in service and dare not fail. Respectfully, from dawn to dusk I will earnestly—even unto death—serve the Son of Heaven, taking as a model the obligation of my forefathers."
>
> I, Lai, was presented with many things.
>
> Then came the [king's] gracious command: "Manage the fisheries and forests of the realm."
>
> "I, Lai, dare to respond to the great, illustrious, sagely, and gracious favor of the Son of Heaven, extolling him and using this as cause to make for my august late father Gongshu a set of harmonized bells. Ding, dong, bing, bong, ding, dong, bing, bong. May they be used in acts of piety, reverently gladdening past luminaries. May the past luminaries who dwell on high help perpetuate this command, sending down upon me good fortune, tranquility, and purity. May I, Lai, live long in service to the Son of Heaven."
>
> May sons' sons and grandsons' grandsons forever treasure these [bells].

As one would expect, this bell is part of an eight-bell set identified by shared decorative motifs and a common inscription text. One smaller member of the set is in a private collection in New York. Another smaller bell is reported to be in a Hong Kong collection. A very large bell and four smaller ones, excavated in 1989 at Mei xian, Shaanxi Province, are other members. Measuring 80 centimeters in height, a fairly standard size for the largest bell in such sets, the large member in China must be the first bell, followed by the one in Cleveland. K.W.

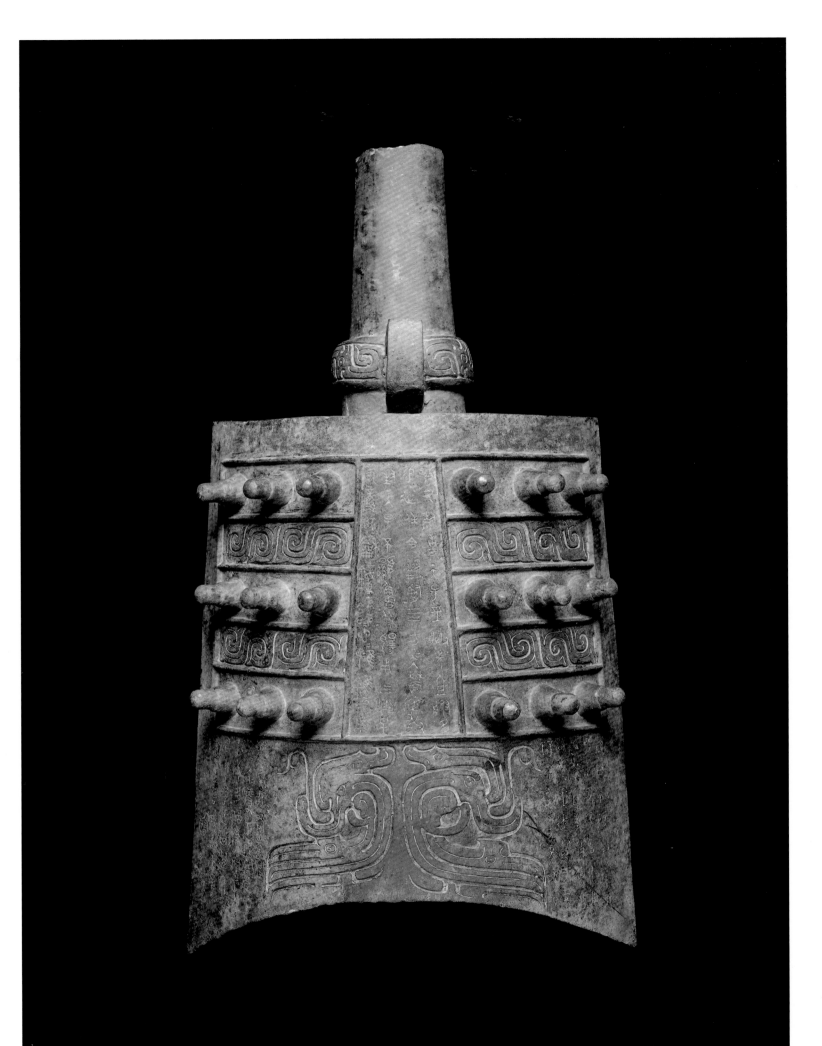

Pair of Plaques

CHINA, HENAN PROVINCE, EASTERN ZHOU DYNASTY, MIDDLE WARRING STATES
PERIOD, STATE OF HAN (?), ABOUT 400–300 BC
JADE (NEPHRITE); L. 22.5 (TOP) AND 20.8 (BOTTOM) CM
PURCHASE FROM THE J. H. WADE FUND AND THE JOHN L. SEVERANCE FUND
1991.78, 1991.79

When Quanrong tribesmen swept into the Chinese capital in 771 BC, they not only forced the Zhou royal family and its nobles to flee eastward to reestablish themselves near the modern city of Luoyang, but also precipitated a slow, steady decline in central authority throughout northern China. Soon, the rulers of a number of vassal states rose to challenge one another—and eventually the royal house itself—for superiority. Competition was not restricted to the battlefield, however, as various courts vied with one another for the visible trappings of power, orthodoxy, and wealth. The energy and interests of the new patrons are readily apparent in the arts. Jade craftsmanship in particular, after languishing for centuries, enjoyed new attention, yielding an attractive variety of exquisite, richly ornamented forms.

The museum's beautiful pair of late Eastern Zhou openwork jade plaques illustrate a level of creativity and technical achievement that was unequaled before or since. Taking the shape of a pair of fantastic creatures, they are at once tiger-like, rhino-like, and dragon-like. Their strong silhouettes are marked with shallow relief bands, and their subtly swelling embellished surfaces are finished to the same degree on both sides.

Only two other pairs of jades approach the drama and quality of this pair recently acquired by the museum. Both were unearthed earlier in this century and are said to have come from an ancient cemetery believed to contain the tombs of the rulers of the wealthy vassal state of Han near the Eastern Zhou capital at Luoyang. The three pairs are sufficiently similar in style and quality to suggest that all were made at roughly the same time and place, presumably workshops sponsored by the Han feudal court during the fourth century BC.

The function of these beautiful objects was recently clarified with the excavation of the tomb of Zhao Mo, a ruler of the southern kingdom of Nanyue (203–111 BC), who died around the year 122 BC. The king, buried in a shroud constructed from small pieces of jade, wore a complex pectoral on his chest. Composed of some thirty-two separate items of jade, gold, amber, and glass, the burial necklace included a jade plaque quite like the Cleveland pair. While substantially smaller and less elaborate, this object suggests that the museum's jades may also have been part of the sumptuous trappings of rank. K.W.

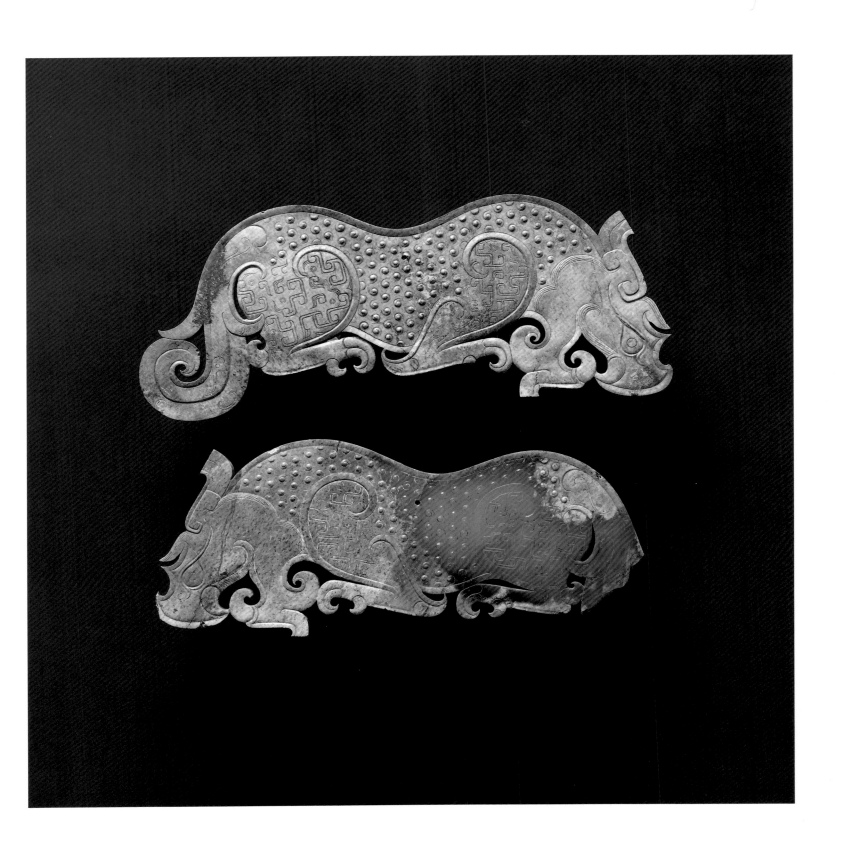

Drum Stand

CHINA, SAID TO BE FROM CHANGSHA, HUNAN PROVINCE, EASTERN ZHOU DYNASTY,
LATE WARRING STATES PERIOD, STATE OF CHU, ABOUT 300–221 BC
LACQUERED WOOD; H. 152.1 CM
PURCHASE FROM THE J. H. WADE FUND 1938.9

This astonishing object, designed to support a light drum, was once part of one of the large orchestras that were the fashion in southern China during the late Bronze Age. Judging from the musical instruments that have been unearthed from the tombs of southern Chu nobility, such sculptural supports were especially popular for percussion instruments. Sets of bells and stone chimes, in addition to drums, were frequently supported by stands featuring a range of naturalistic forms including humans and animals in addition to birds and serpents. In the case of the museum's stand, the missing drum—probably made from a sheet of leather stretched on a lacquered wood frame—would have been suspended between the tall necks of the standing cranes.

Function helps explain the form and structure of the creatures that compose the stand. The tall birds with extraordinarily long necks allowed the drum to be suspended at an appropriate height, and the densely intertwined snakes provided a weighty base to stabilize the object during performances. Such considerations must also have guided the construction, for the base, unlike the separately assembled birds, was carved from a single massive block of wood. After it was carved, the stand was embellished with several coats of brilliantly colored lacquer that also sealed and protected the wood beneath. The intricate patterns—painted in vermilion on a black ground—are in some places naturalistic, and in others, geometric. Feathers appear on the wings and tail of each bird, for example, and scales are drawn on one of the serpents. The geometric designs on the other serpent and on the birds, however, resemble the lively decorative painting found on lacquer vessels used in banquets in aristocratic households at the time.

Birds and snakes were popular subjects in the burgeoning naturalistic art of the late Bronze Age, especially in southern China. Featured together, frequently engaged in combat, graphic representations occur on inlaid bronze vessels, lacquerware, and jade objects. Despite the prevalence of the theme, it is difficult to access its significance. Compounding the mystery, related drum stands excavated more recently from aristocratic tombs in southern China have bases composed of tigers instead of snakes. Thus, despite these discoveries, Cleveland's "Cranes and Serpents" is still unusual and the most impressive example of its type. K.W.

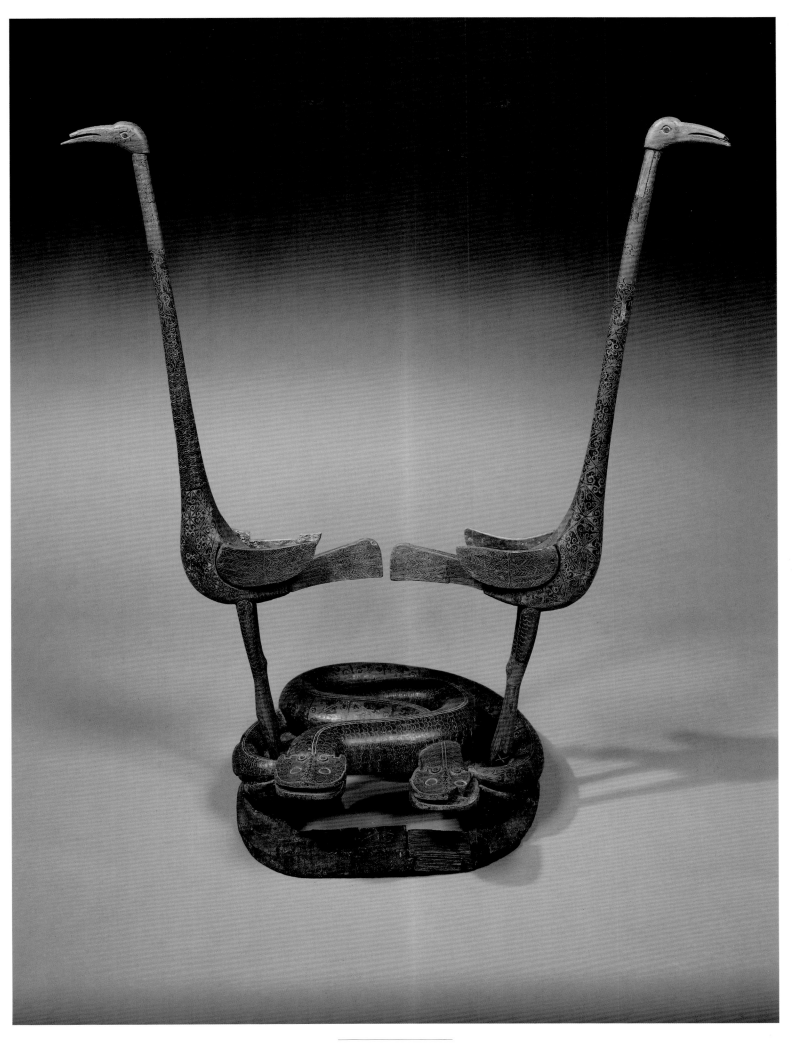

Mat Weight in the Form of a Bear

CHINA, WESTERN HAN DYNASTY, 206 BC–AD 25

GILT BRONZE; H. 15.7 CM

JOHN L. SEVERANCE FUND 1994.203

Engaging functional works of art that represent playful characterizations of real animals are among the greatest achievements of Han dynasty sculptors. This solid gilt-bronze bear, for example, was originally one of a set of weights used to anchor the edges of woven dining mats. Not only used during elaborate formal banquets, such weights were also frequently buried with other luxury goods in aristocratic Han tombs. In one such burial, four comparable gilt bronzes in the form of leopards were found at the corners of a decayed mat bearing containers for a symbolic feast.

The selection and styling of this animal subject may be related to the expansion of the imperial zoological park and hunting reserve adjacent to the palace during the rule of the Han emperor Wudi (ruled 140–87 BC). This huge natural park, designed as a microcosm of the empire, allowed the emperor and his courtiers to observe the various species of plants and animals known at the time. The Asian black bear *(Ursus thibetanus)*—the beast represented in Cleveland's golden weight—may well have been one of the species kept at the park and reserve. Quite ferocious, it figures prominently in Chinese literature of the period. One poem, written by Wudi's favorite court poet, describes hand-to-hand combat with the beast during a royal hunting expedition, while another account tells of how Han emperor Yuandi (ruled 48–32 BC) was almost attacked by a bear that got loose in the palace.

This brilliant animal sculpture perfectly exemplifies the kind of naturalism explored by Han sculptors. Its conception and design suggest that they were, indeed, familiar with their natural subjects. Although simplified and lacking surface texture, the weight deftly captures the mass and characteristic anatomy of its subject, making it almost a kind of paradigmatic image of bearness. Its relaxed natural pose reflects not only a fidelity to observations of the animal's habits but also an effort to create an artistic form that by its shape alone communicates its intended function.

This piece, long owned by the Belgian collector Adolphe Stoclet (1871–1949), is related to a pair of hollow examples purchased by Mrs. Isabella Stewart Gardner of Boston in February 1914. The Gardner bears were said to have been excavated in 1900 near Xi'an, Shaanxi, not far from the Western Han capital. No other examples have been found more recently by Chinese archaeologists. K.W.

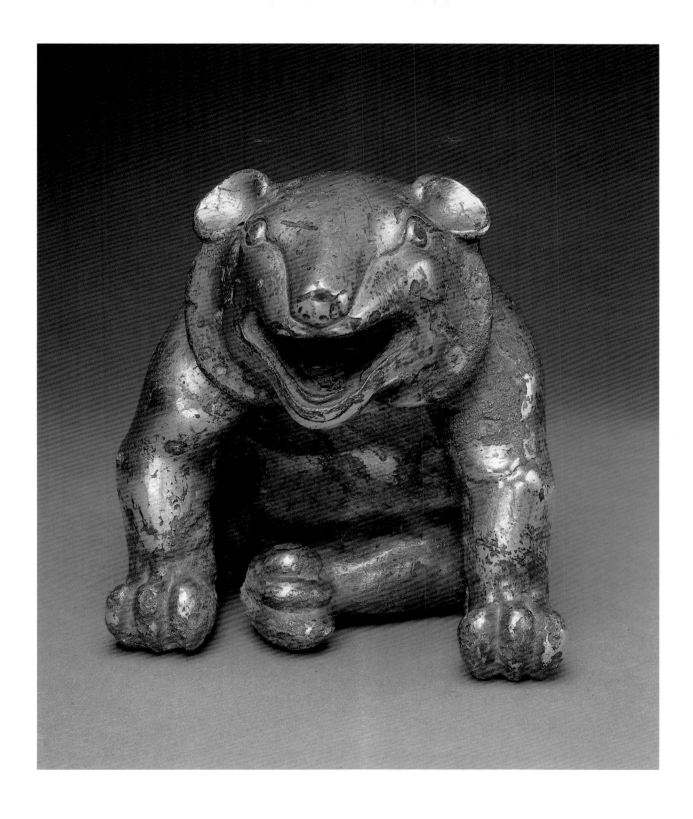

Jar (Hu)

CHINA, MIDDLE OR LATE WESTERN HAN DYNASTY, ABOUT 125 BC–AD 25

EARTHENWARE WITH SLIP AND PAINTED DECORATION; H. 48.2 CM

THE SEVERANCE AND GRETA MILLIKIN PURCHASE FUND 1989.15

Although much of what we know about ancient Chinese art is based on things that have been recovered from tombs, few early objects were specifically made for burial. Most surviving pre-Han dynasty bronzes and jades, for example, had specific functions in the world of the living and were only buried because they also played a role in outfitting the tomb. The practice of burying *mingqi* ("spirit objects" specifically made for the dead) did not begin in earnest until the late Bronze Age. Typically, such works were crafted in cheaper materials to function as substitutes for more luxurious models. Earthenware—glazed, unglazed, or painted—was a particularly popular medium for mingqi since clay is both plentiful and easily molded.

This striking earthenware wine jar with vibrant painted decoration illustrates how early Chinese potters could creatively exploit achievements in other media in their surpassingly inventive products. It is based on the shape of costly bronzes with escutcheon handles and horizontal bands that subdivide its surface. The handles of the ceramic, however, have rings that are fixed to the surface of the pot, rendering them useless, and the orderly registers marked on the jar did not prevent the painter from allowing his design to swim over the surface. As is true of many luxurious lacquers of the time, the painted decoration is applied on top of a black ground that almost completely covers the body of the piece. Although the sweeping design, rendered in blue, white, red, yellow, and black, recalls the freely brushed patterns found on many lacquers, the image is more pictorial than lacquer-painted schemes. The mighty dragon that cavorts over the surface is surrounded by wispy clouds. Encircling his body, these clouds provide more than a setting for the creature: the overlapping forms illustrate an early attempt to portray depth in a painted image.

A similar degree of pictorial sophistication appears on one of the earliest surviving Chinese paintings on silk, the burial banner found in an early Western Han dynasty tomb that is datable to the second century BC. The four dragons depicted on the banner are lively creatures with sinuous bodies surrounded by clouds, plants, and other forms. These spritely serpents are completely different from earlier Chinese dragons that are static and shown without setting. The greater naturalism of Han images is underscored by the conception of the dragon itself. Unlike Bronze Age species, these later imaginary beasts are clearly composites, constructed from parts of a number of identifiable living creatures. In the words of one Han writer, "Dragons have horns like a deer, a muzzle like a camel, eyes like a demon, a body like a snake, a belly like a crab, scales like a carp, claws like a hawk, legs like a tiger, and ears like an ox." Inspired by forms found in nature, dragons such as the one on this wine jar are like mythical beings created by other civilizations that draw from—but at the same time confound—the real world. K.W.

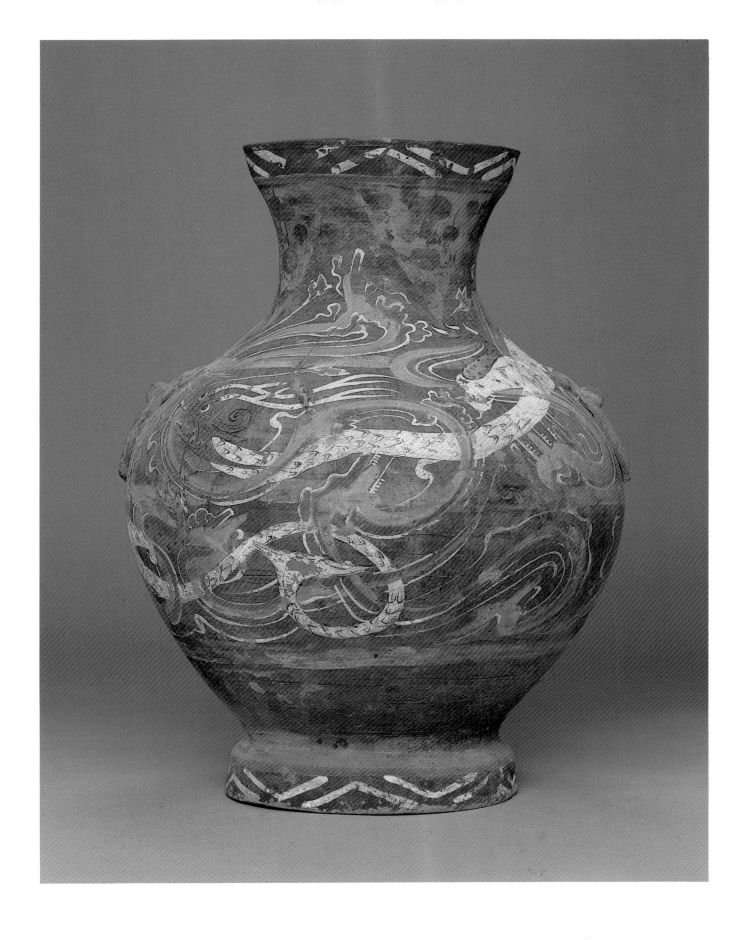

Stele with Shakyamuni and Maitreya

CHINA, SIX DYNASTIES PERIOD, NORTHERN QI DYNASTY, AD 550–577

MARBLE WITH POLYCHROMY; H. 119 CM

LEONARD C. HANNA JR. FUND 1993.108

For much of the sixth century, China was ruled by a series of weak dynastic houses dominated by warfare, assassination, massacre, and economic disorder. For the Buddhist community, this period of worldly chaos coincided with the beginning of *mofa*, 10,000 years of decadence when Buddha's teachings were in decline. By one earthly count, mofa would arrive in 552, 1,000 years after the death of Shakyamuni, the Historical Buddha. In this context, escapist religious doctrines promising rebirth in celestial Buddhist paradises proved more popular than earlier cults based on the long-awaited arrival of the Future Buddha, Maitreya. Such changes were part of a profound religious shift that eventually redefined Buddhism as a religion of faith, not works, and offered the potential of divine assistance.

These promises are illustrated in this radiant marble sculpture, called a stele, originally intended for a Buddhist temple or cave shrine where it would have received the prayers and offerings of the faithful. The stele features a massive image of Shakyamuni with his hands positioned to signify teaching and the relief from fear. The subject of his lesson may well be one of the scriptures concerning paths to salvation promoted by the Dilun sect of Chinese Buddhism. The Buddha is flanked by two pairs of smaller figures, who can be identified as his chief disciples and divine associates, and ringed by other heavenly beings called apsarases, all gathered to hear the teacher's words. The back of the sculpture presents a different, less formal vision, with a large meditative figure seated beneath a pair of tall intertwined trees presiding over one of the paradises open to Buddhist believers. Retaining much of its original painted surface, this remarkable sculpture must have been purposely buried for protection, possibly during the persecution of Chinese Buddhism in AD 854.

Stylistically, the sculpture illustrates the effects of new influences reaching China from Buddhist lands to the west that led to more columnar figures with large, strong physical features revealed through tightly fitting garments. This same style is illustrated by Buddhist sculptures in the cave chapels at Xiangtangshan, a site sponsored by the rulers of the brief but artistically vibrant Northern Qi dynasty. The region of Xiangtangshan, a well-known source for white marble, was also a major center of the Dilun and other paradise sects. Thus, although it is uninscribed, the museum's stele was most likely created in the vicinity of the Northern Qi capital at Anyang, in northern Henan, not far from Xiangtangshan. K.W.

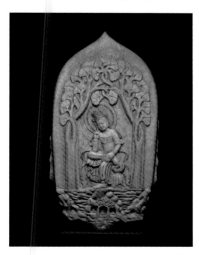

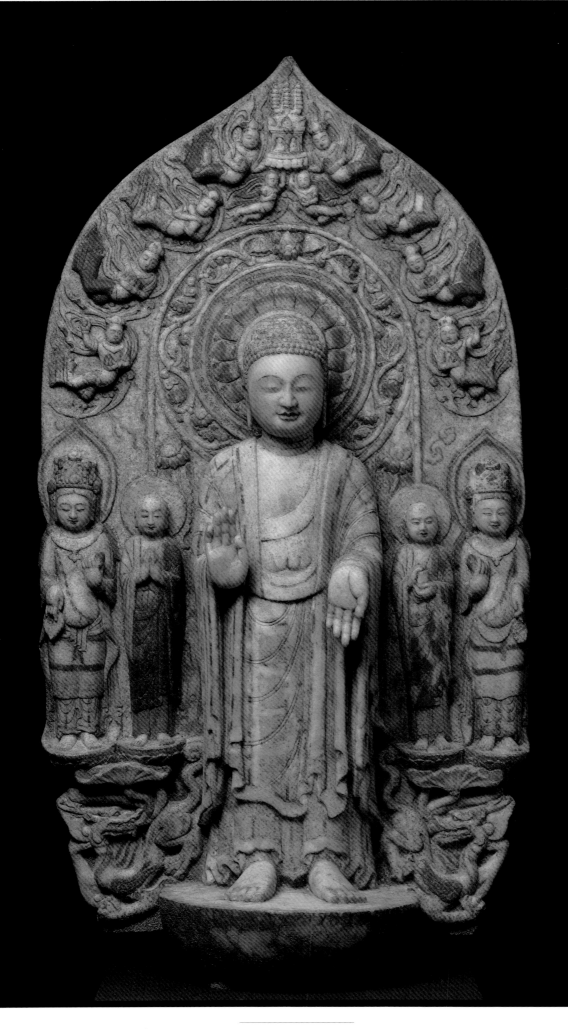

Coffin Platform

CHINA, SIX DYNASTIES PERIOD, NORTHERN QI DYNASTY, 550–577

LIMESTONE; L. 211.4 CM

GIFT OF MR. AND MRS. OSCAR LANGE 1982.260

Increased communication between northern China and lands to the west enriched Chinese beliefs, introduced new symbolic forms, and influenced traditional methods of surface embellishment. The sacred images of Indian Buddhism had the greatest effects on indigenous Chinese art, but even in relatively early examples like the stele with Shakyamuni and Maitreya (see page 37), Far Eastern sculptors found places to insert familiar forms such as dragons within an otherwise imported scheme. Another masterpiece in the museum's collection conversely illustrates the impact of foreign Buddhist forms—specifically the appeal of the Indian lotus—on the well-established realm of Chinese tomb furnishings.

The richly ornamented stone construction is the long, front side of a coffin platform ultimately derived from raised wooden beds that are still popular in China today. Now in five pieces (presumably cut to facilitate transportation after it was excavated earlier in this century), the three legs and horizontal spans may have originally been created as a single massive slab. Sockets cut in the top of the stone (some of which overlap the modern divisions) show how this slab would have been linked to the back with crosspieces also capable of supporting a top surface of flat stone planks.

Like the few examples discovered intact in northern Chinese aristocratic tombs, the most elaborate decoration occurs on the front surface of the coffin platform. The design is dominated by the three large vertical panels, corresponding to the legs, that contain animated high-relief depictions of three directional guardians: the White Tiger of the West (left), the Red Bird of the South (center), and the Green Dragon of the East (right, depicted in the detail on the next page). These three, along with the Snake-Entwined Tortoise of the North and the Yellow Dragon of the Center, were mainstays of Chinese cosmology linked, in a system devised as early as the Han dynasty, to elements (wood, fire, earth, metal, and water), functions, planets, and musical tones, among others. Not only illustrating the persistent appeal of these traditional apotropaic symbols, this scheme suggests that the platform was placed against the back, northern wall of a tomb that would have been entered from the south. The layered carving technique of these principal motifs as well as the shallow relief dragons, masks, and tendrils engraved in the horizontal spans recall forms found in both imperially sponsored tombs and cave chapels of the late sixth century.
K.W.

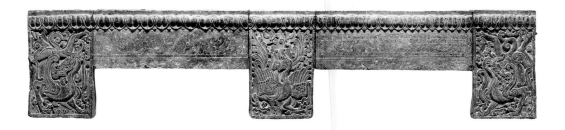

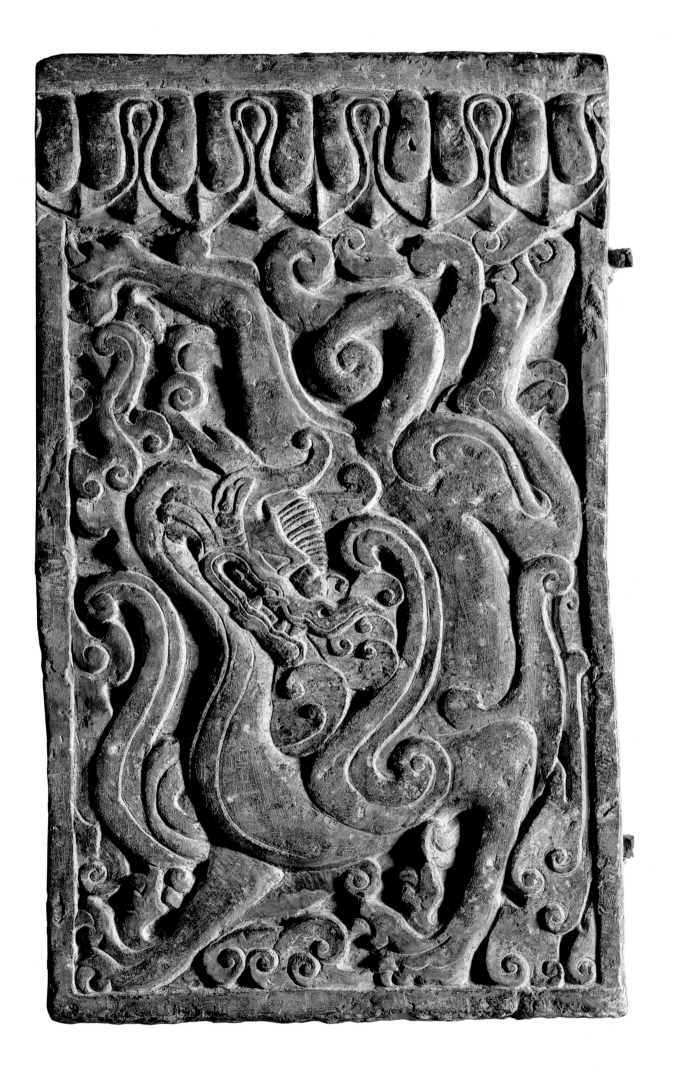

Ewer

CHINA, EARLY TANG DYNASTY, ABOUT 675–725

STONEWARE WITH GREEN GLAZE AND INCISED, MOLDED, MODELED,

AND APPLIED DECORATION; H. 42.1 CM

JOHN L. SEVERANCE FUND 1989.2

Paths across the vast Central Asian desert did more than facilitate the travel of Buddhist missionaries and pilgrims to and from China. They also provided a course for the exchange of goods between China and the West. The fabled Silk Road—actually a series of highways and byways linking settlements and oases from western China to northern India and Iran—was the way that textiles and ceramics reached the West in return for metalwork and glass. These imported luxury goods profoundly influenced indigenous artistic traditions at both ends of the road.

The effects of East-West trade are illustrated in this striking green-glazed ewer. The large ovoid vessel stands on a small ring foot and tapers to a narrow ribbed neck. An exotic bird perching at the top serves as the spout, and its long arched tail functions as the handle. Other birds appear elsewhere on the vessel in the five rings of the main ornamental register. The irregularly shaped spaces between these circles are filled with curly elements arranged to suggest clouds above plants. Plants are also featured in the band above, with each of ten small circular frames enclosing a different botanical type. These two registers are bordered by belts of jewel-like motifs and lotus petals executed in molded clay.

The shape, structure, and decoration of this ewer can be traced to silver vessels manufactured in Sassanian Iran and districts of Central Asia that were influenced by its designs. Unlike early ceramic varieties native to China, these foreign metal types were bulbous and fitted with a spreading ring foot. They were decorated not with subtly outlined forms but with hammered relief patterns frequently featuring large roundels with humans, animals, birds, and plants. The conversion of a foreign metal prototype to the medium of clay may have inspired the particular Chinese potter of the Cleveland ewer to try an unusual decorative technique involving slender rolls of clay. Strangely, the result does not effectively simulate the hammered designs found on metalwork, but instead recalls the more linear decor characteristic of Mediterranean glassware embellished with applied glass strands. Such glassware was known in China and may have influenced the methods of the potter. Possibly because the rolled clay technique was much more time-consuming than molding, it did not gain favor and is virtually unknown elsewhere. K.W.

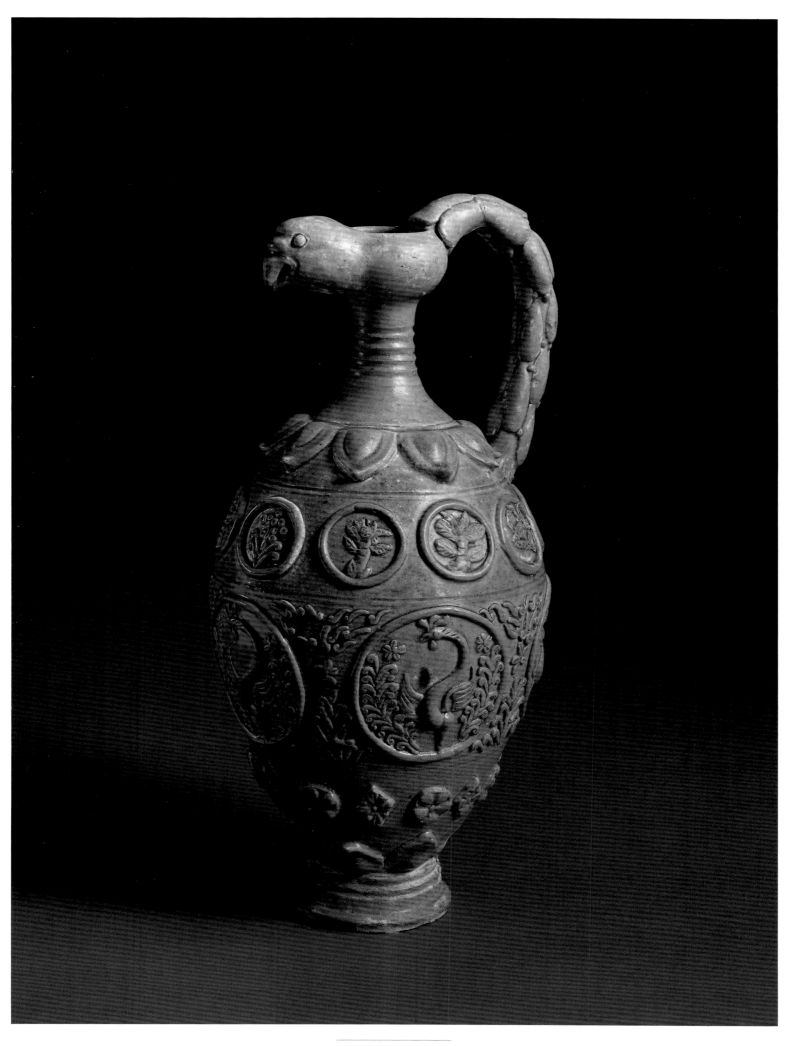

Mirror (Jing)

CHINA, EARLY TANG DYNASTY, ABOUT 700–750

BRONZE WITH LACQUER INLAID WITH SILVER AND GOLD SHEETS; DIAM. 19.2 CM

LEONARD C. HANNA JR. FUND 1973.74

Metal mirrors with a smooth reflective surface and a decorated back were first fabricated in China during the Bronze Age. Decoration, customarily cast along with the mirror itself, is often arranged in concentric rings around the raised central knob that served as the handle. In the early eighth century, this long tradition of casting bronze mirrors was enriched by new kinds of decoration inspired by the luxury goods imported from Persia and western Asia over the fabled Silk Road. At that time, Chinese artisans began to use silver and gold to enrich their decorative designs. Perhaps the most impressive use of these precious materials occurs on mirrors inlaid with designs cut from extremely thin metal sheets. These delicate patterns were set in lacquer that had been spread across the bronze mirror back. When dry, the surface was smoothed and polished, and the inlays minutely detailed with a small chisel.

This mirror, a rare surviving example of a fragile type, is the best preserved and finest example outside the Far East. Primary motifs, the phoenix and large floral sprays, are executed in chased silver sheets, while smaller blossoming flowers are portrayed in gold. The central medallion surrounding the knob is a rich combination of the two colored metals. Originally, this delicate object might have been kept in a similarly inlaid lacquer cosmetic box lined with padded silk for use by a lady of the court. K.W.

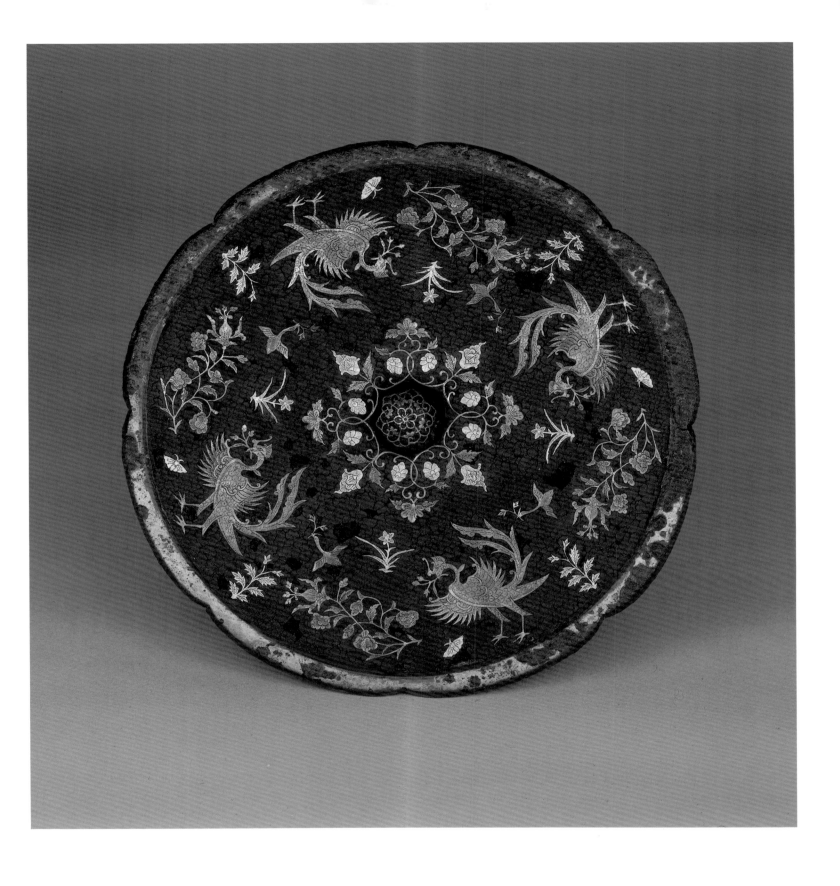

Embroidery with Birds

CHINA, TANG DYNASTY, 8TH–9TH CENTURY

EMBROIDERY: SILK; GROUND: TWILL, LISERÉ: SILK; 25.5 X 156.8 CM

ANDREW R. AND MARTHA HOLDEN JENNINGS FUND 1994.96

This embroidery of birds worked over a patterned silk ground is one of the largest to have survived from the Tang dynasty of China. The birds are arranged in horizontal rows of single and, alternately, paired birds. With one exception (the single bird at the top edge to the right of the central pair), they face away from a central pair flanking a tulip-like flower on a hill. The textile's original function is not known.

At the height of the Tang period, China controlled Central Asia as far west as the eastern borders of Sogdiana, an ancient confederation of states situated between the Oxus (today Amu Darya) and Jaxartes (today Syr Darya) Rivers. Goods, including textiles, moved freely along the trade routes connecting China with the Byzantine and Persian empires. In this way, Persian motifs reached Central Asia and China where they were absorbed into the decorative repertory. Here the forms of the single and paired birds and of the mountain and flower in the central embroidered motif can be traced back to Persian sources.

The superimposition of an embroidered design over a patterned ground was very much in keeping with Tang taste. Traces of the outlines of the birds initially drawn onto the ground fabric can still be seen. Slight discrepancies between the birds indicate that they were drawn by hand and not stamped. Typical of Tang embroideries are the shades of purple, tan, green, blue, and cream of the birds, the hill, and the flower. Likewise, the embroidery consists mostly of satin stitch with juxtaposed blocks of color and no shading; outline stitch is used for occasional details. The design of the ground fabric—a diamond grid enclosing stylized rosettes—was a standard textile pattern used during the Tang. Woven on a shaft loom, the pattern was created by short warp and weft floats.

The naturalistic, spontaneous style of the birds and flower indicates that the embroidery dates from the eighth to ninth century. A.W.

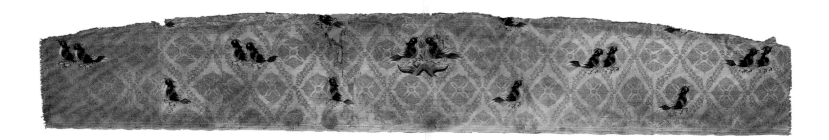

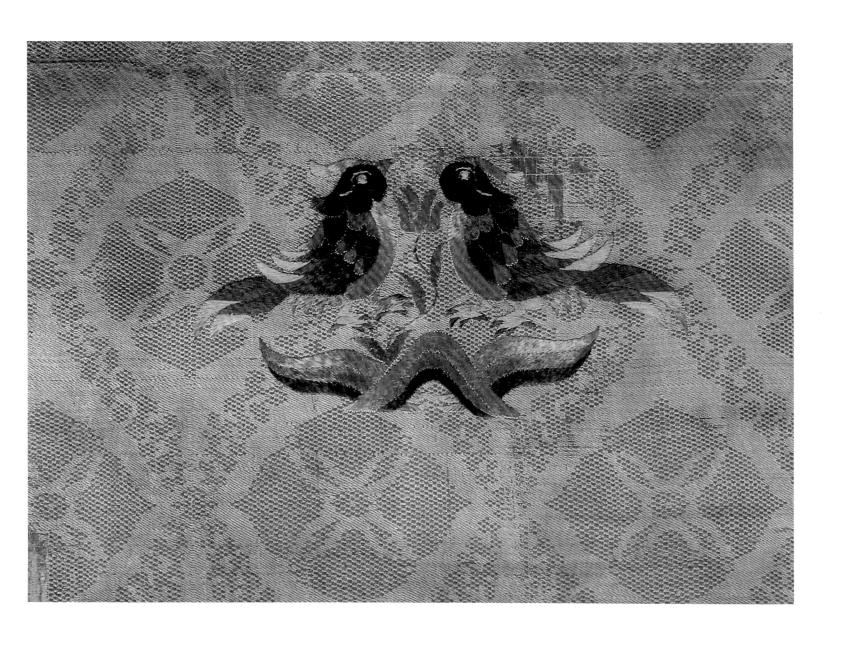

Bodhisattva

CHINA, MIDDLE TANG DYNASTY, ABOUT 750–850

HOLLOW LACQUER WITH TRACES OF PIGMENT AND CUT GOLD; H. 44 CM

GIVEN IN MEMORY OF HOWARD PARMELEE EELLS JR. BY HIS WIFE,

ADELE CHISHOLM EELLS 1983.86

This informal yet supernaturally serene sculpture depicts a bejeweled bodhisattva, an enlightened Buddhist being who has postponed his own passage to Nirvana to help others achieve enlightenment. Originally, it would have flanked a Buddha image on the altar of a temple like the one at Huayansi, near Datong, in Shaanxi Province. Dressed in the Indian fashion that was popular in Chinese religious sculpture of the time, the figure wears a simple upper garment draped over one shoulder and a lower skirt belted at the waist. This thin clingy covering does not obscure the sensuous body beneath but, instead, accentuates its physical features, which are arranged in a gentle swaying pose. The somewhat withdrawn, ethereal effect of the image is enhanced by partially closed eyes directed downward in an attitude of profound thought. Alluring and totally absorbing, the image radiates the quiet assurance of enduring faith.

The true beauty of this image was concealed when it entered the collection. Clumsy repairs and coats of later painting had to be removed before its original appearance was revealed. This smooth, almost liquid surface, a reflective black lacquer, is not simply a decorative veneer but actually represents the medium in which the sculpture was built. A rare surviving example of a technique that was popular among Tang Buddhist sculptors, the image was constructed by draping lacquered hemp—now visible in areas where the outer skin is damaged—over an underlying structure made of clay or wood. After it was dry and hard, the cloth was, in turn, covered with countless additional layers of black lacquer. Physical features and garment folds were subsequently cut into this surface, and additional elements such as the lacy armlets and bracelets were molded in lacquer. Finally, pigment and cut gold were applied to accentuate details of the form, and the figure was fitted with the metal or gilded wood crown befitting a bodhisattva. Upon completion, the inner supports were removed, yielding an extremely light hollow image. While the lacquer surface is tough and impervious to insects, such hollow pieces are not nearly as durable as wooden or stone works, which explains why so few examples survive from early times. Despite the dissimilarities of media, comparisons to works in wood and stone facilitate the dating of this beautiful lacquer sculpture to the late eighth or early ninth century. K.W.

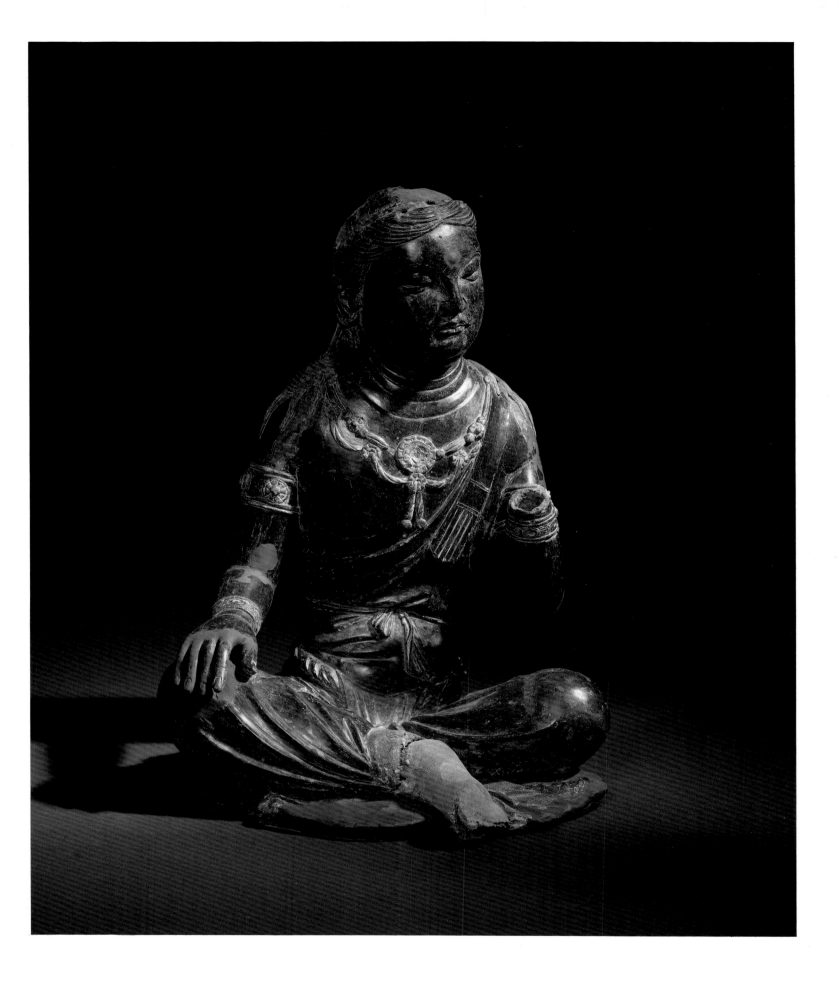

Imperial Boots

NORTHERN CHINA, LIAO DYNASTY, 907–1125

OUTER FABRIC: TAPESTRY, SILK AND GOLD; FACING: GAUZE, SILK;

LINING: TABBY, SILK; SOLE: SELF-PATTERNED TWILL, SILK, AND TABBY, SILK;

SILK BATTING; 47.5 X 30.8 CM EACH

PURCHASE FROM THE J. H. WADE FUND 1993.158.1, 1993.158.2

In the early tenth century, Qidan tribesmen of Manchuria established an empire they called the Liao by taking over northern China and much of Mongolia. Although historical records and wall paintings depicting Qidan life testify to the importance of luxury textiles to Liao culture, relatively few have survived. Among these is a pair of knee-high boots that belonged to a female member of the royal family.

The outer fabric of the boots is silk and gold tapestry, the lining is silk, and the silk batting in between is for warmth. The soles are made of silk, and the opening at the top is finished with a gauze facing. The silk tapestry is woven with a design of paired phoenixes chasing flaming pearls amid scrolling clouds. The tapestry was carefully cut so that a flaming pearl flanked by phoenixes occurs at the center of the shin, another at the center of the calf, while a third is centered on the instep. The design of the latter was reduced in scale in order to accommodate the smaller area of the instep. On both boots, the gold thread has largely disintegrated, leaving traces of gold leaf on the warps.

Boots such as these formed part of a costume that consisted of layers of clothing. One aristocratic woman found in a tenth-century Liao tomb, for example, was dressed in pants that tied at the waist and were tucked into knee-high boots made of silk tapestry. Over these she wore a skirt, a knee-length jacket, an outer full-length robe with wide sleeves, a hat, and gloves.

Although few examples of silk and gold tapestry survive from the Liao empire, it was highly esteemed by the Qidan. The *Liaoshi* (history of the Liao dynasty) describes a red silk-tapestry robe worn by the emperor himself. In the West, where such textiles are little known, these boots are important evidence of the high artistic and technical achievements of tapestry weavers within the Liao empire. A.W.

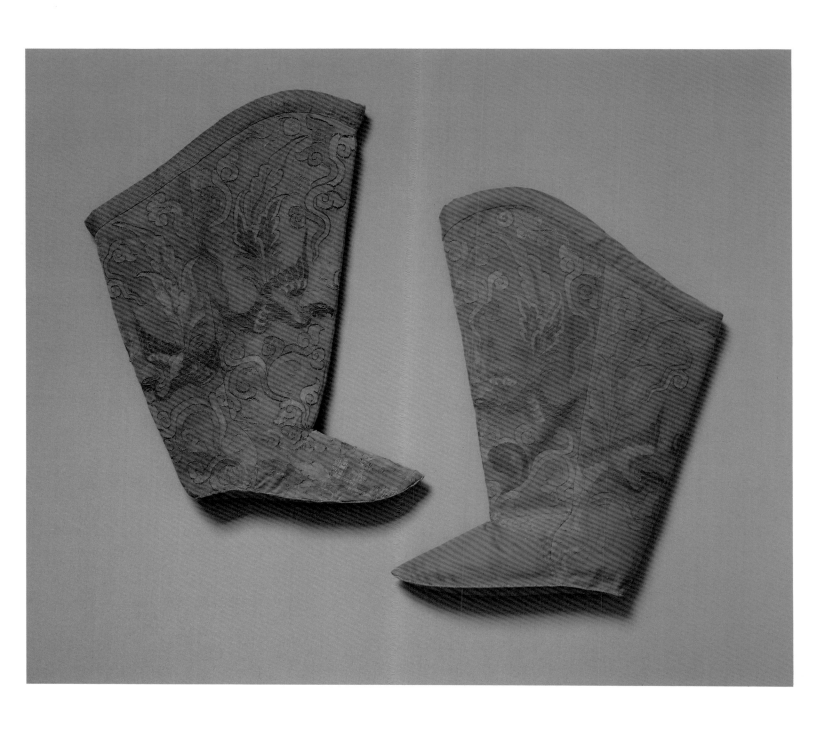

Buddhist Retreat by Stream and Mountains

ATTRIBUTED TO JURAN (CHINESE, ACTIVE ABOUT 960–980),
EARLY NORTHERN SONG DYNASTY
HANGING SCROLL: INK ON SILK; 185.4 X 57.5 CM
GIFT OF KATHERINE HOLDEN THAYER 1959.348

Despite its predominance in later Chinese art, landscape was one of the last painting subjects to develop in China following centuries of picture making that featured famous figures of the past or illustrations of popular stories. It was not until the Six Dynasties period, a time also marked by growing interest in poetry inspired by encounters with nature, that painters began to identify methods of rendering convincing views of the mountains and rivers of the Chinese countryside. Early approaches, based on applications of rich mineral colors within outlined forms, were eventually augmented by other techniques exploiting graded tones of ink applied in distinct strokes or broad washes. By the tenth century, artists working in this tradition were creating overwhelming images of monumental forms logically arranged in an enveloping space filled with palpable atmosphere.

The Cleveland Museum possesses one of the most important and stylistically complex examples of this early Chinese landscape tradition. The composition of the narrow silk hanging scroll is dominated by a massive peak rising in the distance that almost reaches to the top of the panel. Nearer landscape passages that serially lead from low foreground hills to a secluded valley at the back are superimposed on the peak and isolated against the mists that obscure its base. The scale of the earthen forms and the vastness of the view are shown by the miniature trees and even smaller structures that diminish in depth. In classic images like this one, humanity and mortal concerns are dwarfed by the enduring power of the natural world.

Since the eighteenth century, this unsigned masterpiece has been attributed to the tenth-century painter Juran, a southern monk who traveled north to serve the early Song court. Based on the style of the work as well as the inventory note "Ju 5" inscribed in the upper-right corner of the painting, the preeminent connoisseur An Qi (1683–about 1742) argued that it may be one portion of a six-panel landscape first mentioned in the *Xuanhe huapu*, a catalogue of the works in the imperial collection of the Song emperor Huizong (ruled 1101–25). As in other paintings firmly associated with Juran, the mountains in this landscape are drawn and textured with lively calligraphic lines, and summits are rendered as fragmented surfaces composed of clusters of boulders. At the same time, however, other aspects of the painting—such as the exposed sharp-tipped branches drawn with "crab claw" and "deer antler" strokes—resemble the methods and manners of painters schooled in the north such as Li Cheng (919–967), another artist working in the early Song court. Some contemporary commentators suggest that this eclecticism illustrates the influence of the established northern style on the transplanted southerner. Regardless of the accuracy of this interpretation, the mixed idiom of the work testifies to an age in Chinese painting history that predates the rigid codification of styles and the definition of mutually exclusive artistic manners. K.W.

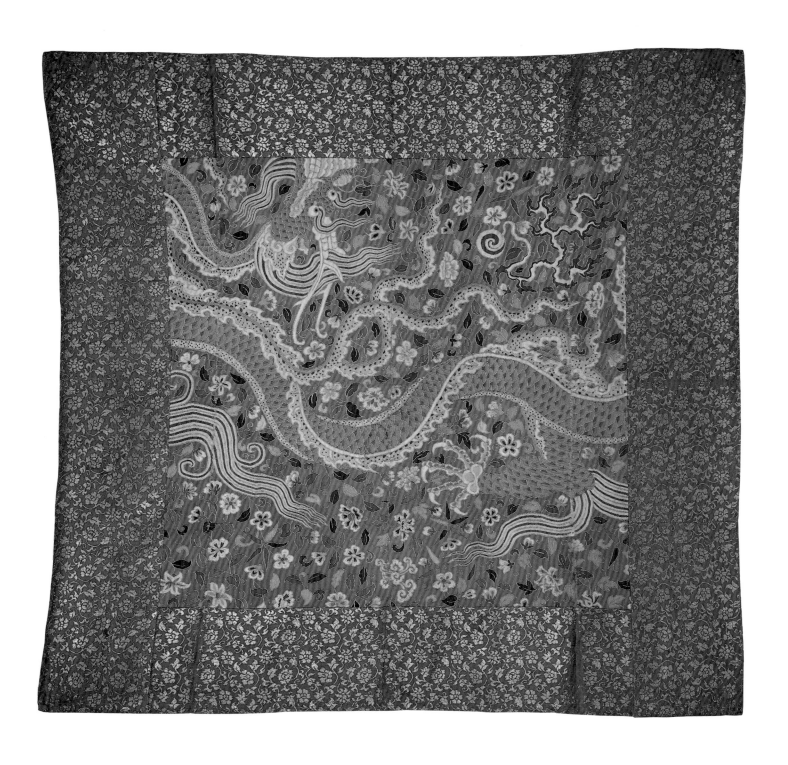

Brush Washer, Ru Ware

CHINA, LATE NORTHERN SONG DYNASTY, ABOUT 1101–1127

GLAZED STONEWARE; DIAM. 12.8 CM

JOHN L. SEVERANCE FUND 1957.40

In the late Northern Song court of emperor Huizong (ruled 1101–25), a new kind of ceramic was sought to serve the needs of the imperial household. The ultimate choice, a bluish-green glazed stoneware named Ru after the site of its manufacture at Ruzhou, near the Song capital, marked a radical departure from the former imperial preference for creamy white stonewares produced near Dingxian, in modern Hebei. Unlike Ding ware, typified by examples with thin transparent glazes, incised surface decoration, and metal-banded lips, Ru ware is usually devoid of distracting ornament and covered with a relatively thick glaze of unsurpassed depth and complexity.

This unassuming brush washer perfectly embodies the beauty of the Ru ware glaze. With the exception of the three sesame seed-like marks left by kiln supports in the foot, its simple rounded shape is encased in variegated color that covers body, lip, and foot. Colored by small amounts of iron in the glaze, the modulation across the surface of the vessel results from air bubbles and irregularly ground particles suspended in the vitrified coating. The web of cracks that pattern the glazed surface add to the visual impact of this variation. Such crackling is produced when body and glaze cool at different rates after firing. Although frequently seen as a flaw in other wares, the Ru potters exploited the natural phenomenon for aesthetic effect. Providing a supremely subtle form of surface enrichment, these aspects are largely accidental and thus vary noticeably from piece to piece.

The recent discovery of the Ru kiln site has proven the close relationship between the imperial ware made there and other northern celadons that were more widely produced for the commercial market. Representing one of the finest achievements of Chinese potters, Ru ware was unfortunately produced for a limited time apparently because of the Tartar invasion and the removal of the Song capital to Hangzhou in the south. Fewer than one hundred examples survive today. Despite its brief history, Ru ware had a tremendous influence on the southern ceramics produced throughout the remainder of the dynasty, obvious in the shapes, glazing, and firing of imperial wares like Guan as well as more popular products of the Longchuan celadon kilns. K.W.

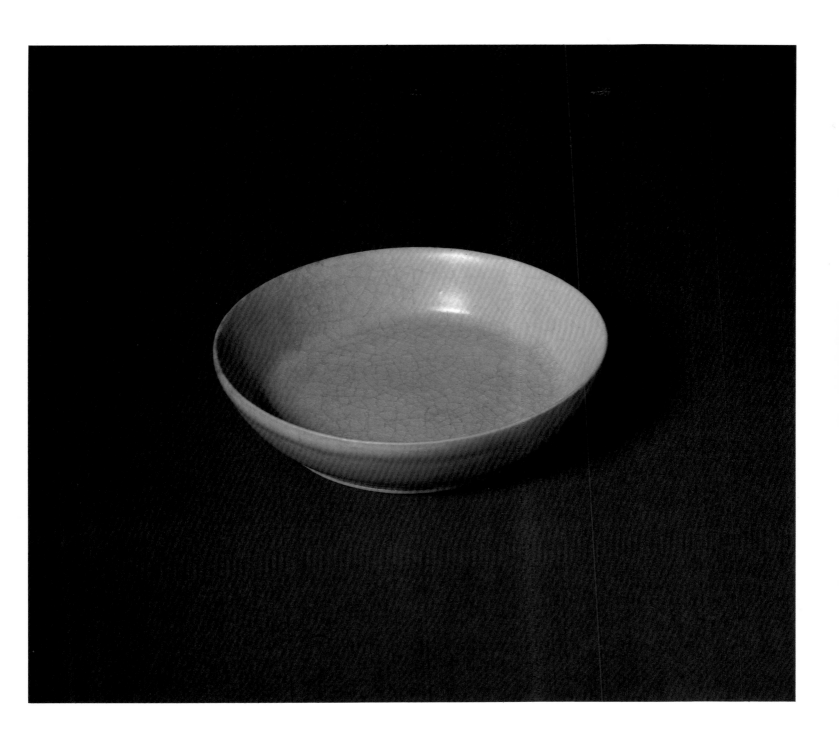

Eleven-Headed Guanyin

CHINA, LATE NORTHERN SONG DYNASTY, ABOUT 1101–1127

WOOD WITH TRACES OF PIGMENT AND CUT GOLD; H. 218.5 CM

PURCHASE FROM THE J. H. WADE FUND 1981.53

The Indian Buddhist deity Avalokiteshvara (Guanyin in Chinese) assumed great importance in Far Eastern Buddhism. As a spiritual attendant to the Historical Buddha Shakyamuni (see page 37), Avalokiteshvara served as one of a number of bodhisattvas, enlightened souls who benefit humankind. In China, Guanyin was thought to be the most benevolent of the bodhisattvas. Hearing the prayers of those in need, Guanyin was described as the divine being that most nearly approached the Buddha in holiness. Envisioned with a mystical third eye to aid in his search for the troubled, Guanyin came to be selected as the primary subject for the paintings and sculptures of Buddhist altars, especially since the Song.

The museum's monumental standing image of Guanyin was carved from a single massive block of willow wood nearly eight feet tall. In the esoteric form seen here, the deity's primary head was enhanced by eleven smaller ones, symbolic of Guanyin's search for needy believers. As in some earlier Chinese sculptural styles, the superhuman yet approachable deity is shown in Indian fashion with bare torso and long skirt anchored at the waist. The pose is foreign, too, and the flexed body—characterized by inclined torso, projecting right hip, and forward left leg—reveals the gentle sway of the Indian *tribhaṅga* (three-bent) posture. In the deeply cut high-relief forms of scarves, sashes, jewelry, and garment, however, the sculptor reveals the Chinese penchant to blend sculptural form with linear pattern. In cases like this, the weight of the heavy cascading cloth is mitigated by the ethereal, almost weightless impression created by the lively hem.

Only traces remain of the surface pigments that once ornamented the sculpture. The flesh was originally gilded, and aspects of the costume were enriched with blue, green, black, and red. Most surprising are traces of cut gold *(jiejin)* on the apron near the waist. In this painstaking method of embellishment, thin strips of cut gold leaf were applied to fine patterns that had been drawn with glue on the surface of the sculpture. After it was attached, the gold would be burnished with a soft cloth. Used to suggest the patterns of embroidered or woven cloth, jiejin was especially popular in Far Eastern sculpture and painting. Despite the prevalence of the technique in early literary sources, however, few early examples of jiejin have survived, no doubt because of the fragility of the medium. K.W.

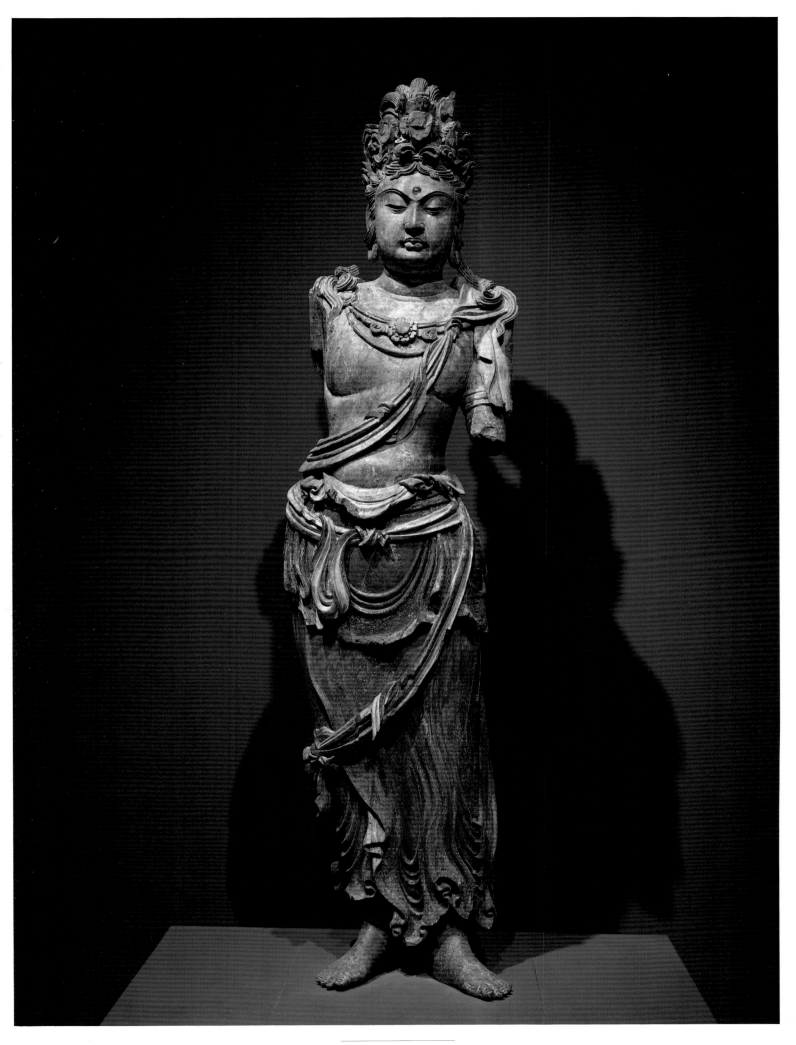

Streams and Mountains without End

CHINA, LATE NORTHERN SONG OR EARLY JIN DYNASTY, ABOUT 1101–1150

HANDSCROLL: INK AND SLIGHT COLOR ON SILK; 35.1 X 213 CM

GIFT OF THE HANNA FUND 1953.126

The narrow horizontal format of the handscroll was one of the first to emerge in Chinese painting. Viewed section by section as they were unrolled, handscrolls lend themselves to sequential subjects such as narrative illustrations. When used for landscapes, they engender a sense of forward progress consonant with journeys through mountains and rivers. In many early examples like this famous scroll, ranges of hills run parallel to the picture plane, frequently removed from the viewer by a band of water coursing along the lower edge of the picture.

The serial method of viewing handscrolls helps to explain the structure of this important painting, characterized by distinct mountain clumps framed at beginning and end by passages with misty valleys and low hills. Across the surface, paths and fortuitously placed boats provide means for forward progress linking populated spatial pockets marked by buildings that invite rest and repose. Framing the pockets and screening recession into deep space, high mountains are amassed by superimposed forms of similar shape and design. Softening jagged mountains and easing transitions from one segment to the next, foliage appears at various scales, from recognizable trees in the foreground to soft, blurred dots in the distance.

The authorship of this scroll continues to elude Chinese art historians. Combining elements drawn from a number of painters active in the tenth and eleventh centuries, the painting cannot predate the late Northern Song. In view of its eclecticism and the miniaturization of its forms, it is possible that it was painted in northern China following the Tartar conquest that forced the removal of the Song capital to Hangzhou in the south. In this respect, it is noteworthy that the earliest surviving inscriptions added at the end of the scroll were written by government officials in the late Jin dynasty. K.W.

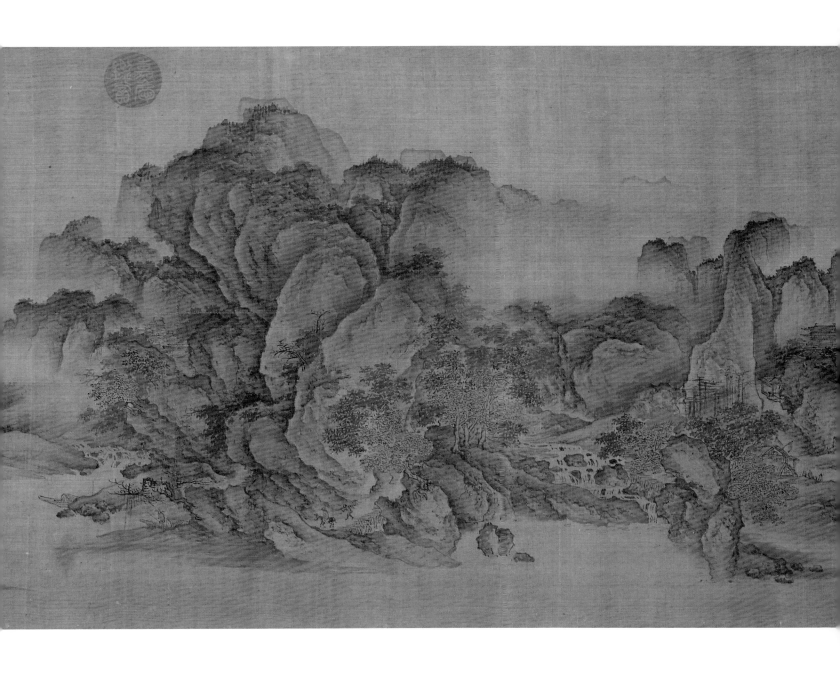

CHINA, JIN DYNASTY, 1115–1234
TABBY WEAVE, BROCADED: SILK AND GOLD THREAD;
WARP 109.8 CM, WEFT 38.5 CM
PURCHASE FROM THE J. H. WADE FUND 1991.4

One of the exciting recent discoveries in the field of early Chinese textiles is a group of silk and gold brocades woven during the Jin dynasty. This brocade of a *djeiran* gazing at the moon is typical of that group. The djeiran is a Central Asian antelope that was absorbed into the art of Song China and of the Jin dynasty. There, it was often associated with the *xiziu*, a mythical rhinoceros. Particularly popular in the Jin culture, it appears in several other brocades as well as on the backs of mirrors and on mirror stands.

Here, the djeiran, recumbent among flowers and fungi, looks back and up at the full moon in the clouds. This scene is repeated in gold-brocaded units arranged in staggered horizontal rows. The orientation of the scenes to right or left alternates from one row to the next.

Jin brocades have a particular structure that sets them apart from those woven elsewhere. The gold wefts used for the brocaded units were made of treated animal skin that was gilded and cut into flat strips. They were much heavier than the silk wefts used for the ground fabric. In order to prevent the silk ground around the brocaded areas from puckering as the gold wefts were inserted into the weave, silk wefts were floated from time to time across the reverse side of the brocaded areas.

Brocades such as this one were used for clothing worn by the Jin court. Their designs and brocading technique are very similar to the brocades found in the tomb of Prince Qi (dated 1162), a member of the Jurchen imperial family. A.W.

Thangka of Vighnantaka

CHINESE CENTRAL ASIA, FORMERLY TANGUT XIA EMPIRE, EARLY 1200S

TAPESTRY: SILK WITH PEARLS; 105 X 74 CM

PURCHASE FROM THE J. H. WADE FUND 1992.72

The Buddhist deity Vighnantaka plays a protective role, destroying obstacles that stand in the way of spiritual enlightenment. Fierce and extremely powerful in appearance, he holds a noose in his left hand and a sword in his right, while standing on the prostrate bodies of the god Shiva and the elephant-headed god Ganesha. Engulfing all three is an aureole of flames through which members of Vighnantaka's entourage charge, brandishing weapons. The scene, including the aureole, is supported on a lotus throne and set within a floral vine scroll. Beneath the lotus throne are five dakinis (demigoddesses embodying wisdom) flanked by smaller figures of Vighnantaka. Above the central scene are the Five Transcendent Buddhas. A scrolling floral vine with flowers supporting Buddhist symbols borders the entire thangka (icon).

The Tibetan style of this work reflects the close ethnic and cultural ties that linked Tibetans with the Tangut peoples of Tangut Xia. Not only did Tibetan Buddhism predominate in these regions, but during the late twelfth and early thirteenth centuries, Tibetan clerics served as imperial preceptors at the Tangut court.

Tangut *kesi* (silk tapestry) are exceedingly rare. One, very similar in both design and style, includes the portrait of a known Tibetan historian who died in 1216. Because an inscription states that it was woven as a gift for him, it was probably made before his death. A third kesi with the figure of Green Tara was excavated in the former Xixia territories, from the ruins of the garrison city of Khara Khoto. Not only does it share a number of decorative elements with this Vighnantaka thangka, but the trapeze shape common to the two typically occurs in Tangut painted icons as well. A.W.

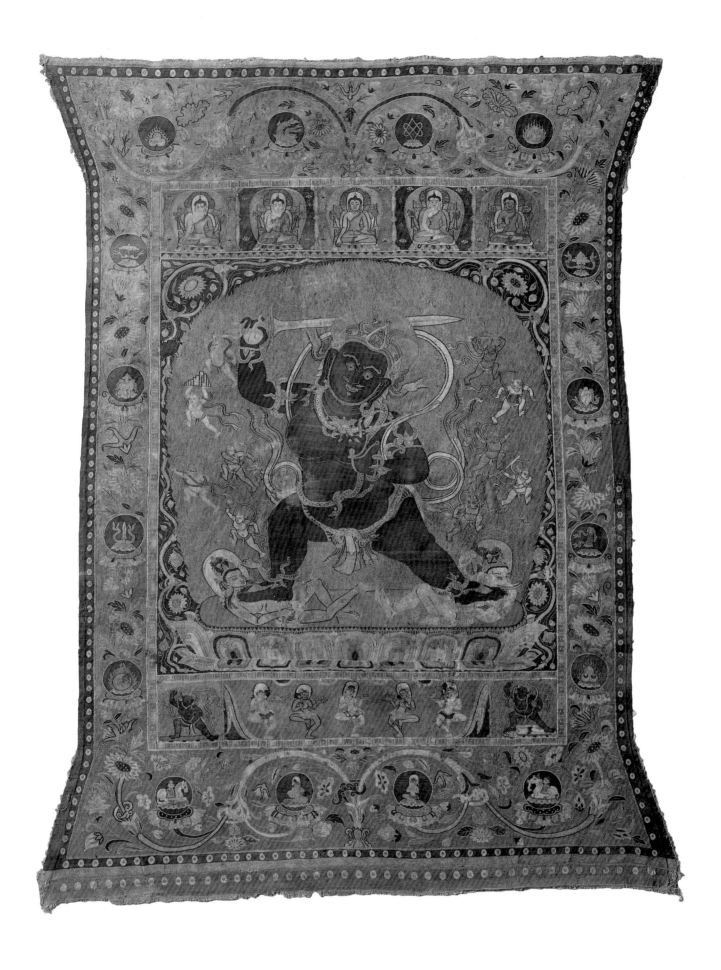

CHINA, SOUTHERN SONG DYNASTY, DATED 1244

HANGING SCROLL: INK ON PAPER; 74.6 X 32.4 CM

JOHN L. SEVERANCE FUND 1970.2

Early Buddhist paintings in China, like those in India—land of Shakyamuni's birth and source of the faith—featured compelling narratives, elaborate icons, or paradisiacal scenes of the celestial heavens. Such images were typically drawn in thin unmodulated lines that were subsequently filled with rich mineral pigments that enhanced the splendor and attraction of the religious visualizations. Unlike those paintings, favored by both Theravada and Mahayana Buddhist sects, this religious image is sparely painted in tones of gray and black and exemplifies a tradition of Buddhist art unique to Chinese Chan and Japanese Zen sects.

The subject is the Historical Buddha, Shakyamuni, shown after six austere years spent in virtual seclusion in the mountains seeking enlightenment. The success of his quest has been debated by theologians and commentators throughout time, but the quatrain on the Cleveland painting suggests that Chan and Zen Buddhists believed that Shakyamuni did achieve enlightenment:

> Since entering the mountain, too dried out and emaciated
> Frosty cold over the snow
> After having a twinkling of revelation with impassioned eyes
> Why then do you want to come back to the world?

Seeking enlightenment like Shakyamuni, Chan and Zen believers in East Asia adhered to a kind of Buddhism that diminished the importance of other intervening Buddhist deities. Underlying their faith was a belief in personal responsibility and individual effort. To illustrate this conviction, they choose to represent the Buddha as both divine and human, enlightened yet frail, central but oblique. The use of the monochrome ink medium both distinguished their paintings from the images of other Buddhists and associated them more closely with indigenous traditions of monochrome ink painting. It is thought that the sparse but energetic brushwork of such depictions served as the metaphor for a faith in which enlightenment may come quickly at any time, catalyzed by almost any stimulant. Like secular paintings, images are frequently joined by written inscriptions, in this case by the poetic passage created by the abbot Chijue Daochong (1170–1251) of Mount Taibao in 1244. K.W.

入山太枯瘦
雪上常帶霜寒
冷眼倚一星
何一耳出人間
淳祐甲辰八月二日
太白右山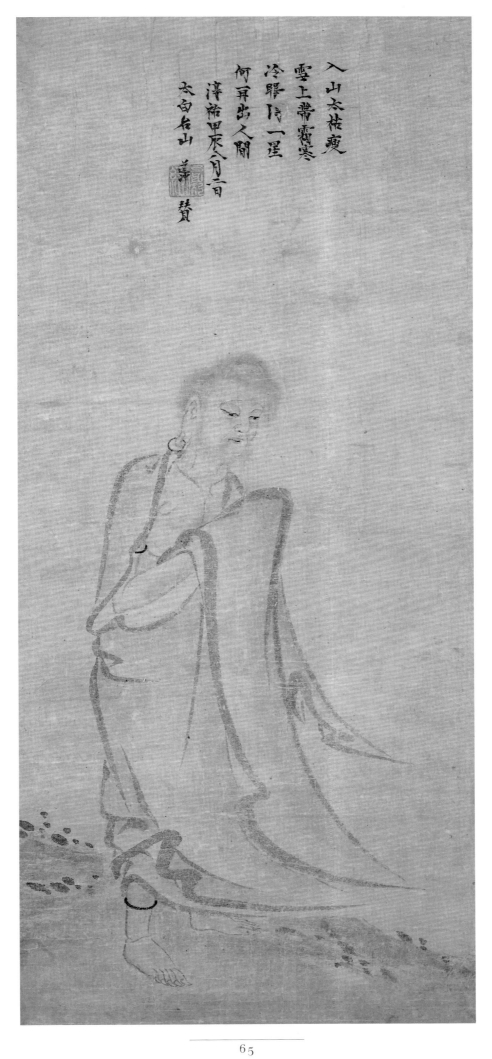
　賛

EASTERN CENTRAL ASIA, MID-13TH CENTURY
LAMPAS WEAVE: SILK AND GOLD THREAD; H. 134.5 CM
PURCHASE FROM THE J. H. WADE FUND 1989.50

Beginning in 1211, Genghis Khan invaded the Jin Empire, then proceeded across Central Asia to conquer eastern Iran and the territories east of the Oxus River (today Amu Darya) known as Transoxiana. The artisans and master craftsmen from conquered cities were enslaved and distributed among members of the Khan's family and distinguished generals. The nomadic Mongols took these artisans, who fashioned luxury items and other highly desirable articles, to cities in Mongolia and eastern Central Asia. Historical accounts and travel narratives of the period mention them, yet little has survived of the objects, particularly the textiles, they produced.

This magnificent cloth of gold is one of the few silk and gold textiles that can be associated with those craftsmen. It is woven with pairs of winged lions within aligned, tangent roundels and pairs of griffins in the interstices. The background is densely filled with scrolling vines and palmettes. Both the overall design and the animals are Persian; yet the cloud-like ornamentation of the lions' wings, the cloud scrolls at the terminals of the vines filling the background of the roundels, and the dragons' heads at the ends of the lions' tails are based on Chinese models. The synthesis of Eastern and Western elements is purely Central Asian, which is not surprising considering that captive craftsmen from the former Jin territories were working in the same cities as the captured artisans from eastern Persia and Transoxiana. The density of its design and the fact that the design was entirely woven with gold thread are characteristic of textiles produced during the Mongol period.

The artistic and technical quality of this textile is unsurpassed among the silk and gold textiles that have survived from the early Mongol period. Given that it was once preserved in a Tibetan monastery, this textile was probably woven during the middle of the thirteenth century. The Mongols only began to make contact with Tibet in 1240 and did not sign a treaty until 1247. In honor of that occasion, gold, silver, and two hundred precious robes were given as imperial gifts to Tibetan monasteries. A few years later, starting in 1251, members of Genghis Khan's family began to patronize different Tibetan sects, which involved presenting gifts that, in those days, always included precious textiles. A textile of the extraordinary quality and value of this cloth of gold would almost certainly have reached Tibet as an imperial gift. A.W.

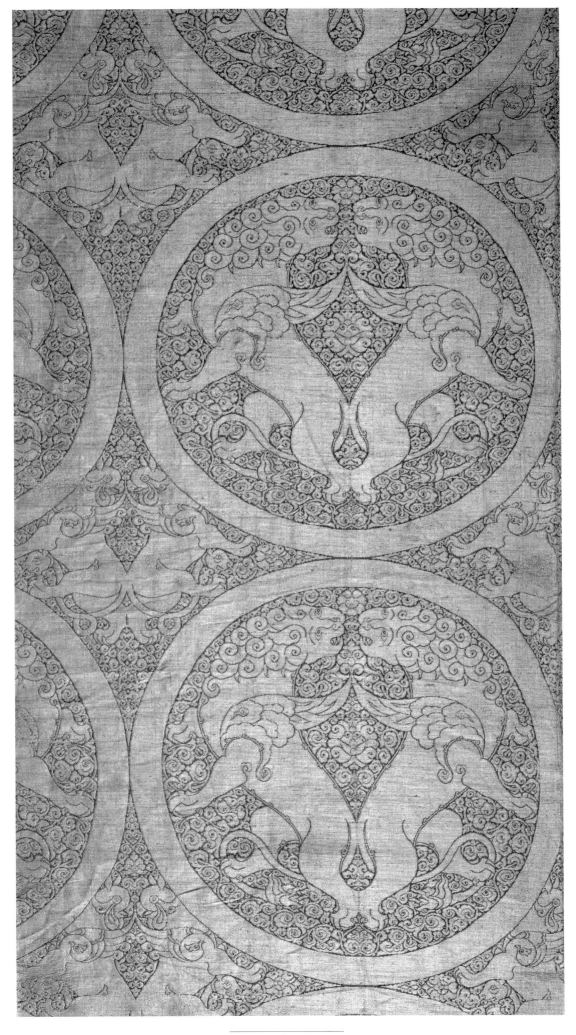

Fluted Cup with Dragon Handle, Qingbai Ware

CHINA, YUAN DYNASTY, EARLY 14TH CENTURY

GLAZED PORCELAIN; DIAM. 9 CM

SEVERANCE AND GRETA MILLIKIN COLLECTION 1964.163

Porcelain is one of China's greatest contributions to the world's material culture. The ceramic is composed of two elements, kaolin (an English word based on the Chinese term *Gaoling*, literally "High Ridge," one of its primary locations in China)—a white-firing clay—and petuntse (an English word based on the Chinese term *baidunzi*, "little white bricks")—a feldspathic substance derived from granite that must be refined before use. Properly combined, the two produce a vitrified or glassy body when fired to about 1,200 degrees Celsius. Porcelains are usually coated with feldspathic glazes, which easily bond to the ceramic body in the heat of the kiln and provide an attractive, slightly bluish shiny surface. The earliest southern Chinese examples were probably being produced in Raozhou, Jiangxi Province, by the year 1000. In an effort to generate revenue through trade and taxation, the central government encouraged increased porcelain production at these independent kilns, thus contributing to the creation of large industrial-style facilities. By the fourteenth century, when this cup was made, fine porcelains were being manufactured in startling numbers at huge factories for the large national market as well as for export to Korea, Japan, Southeast Asia, India, and the Near East.

This cup, created just before underglaze painting in blue and red came to dominate porcelain decoration, owes its aesthetic effect to other factors. Very thinly potted, the subtly lobed body is almost translucent. The thin, slightly opaque glaze lends a sugary shine. Applied elements, including handle, beaded borders, and sculptural floret, are constructed and glazed with the same materials as the body, providing a seamless blend of form and decorative embellishment. The result is an evocative reminder of slightly earlier silver cups, also created in the form of flowers. This pristine, natural construction is challenged, however, by the archaic dragon that acts as the handle. Borrowed from the decoration found on much earlier bronzes, this added form illustrates the eclecticism of the Yuan, the attempt to blend present vision with interest in the past. K.W.

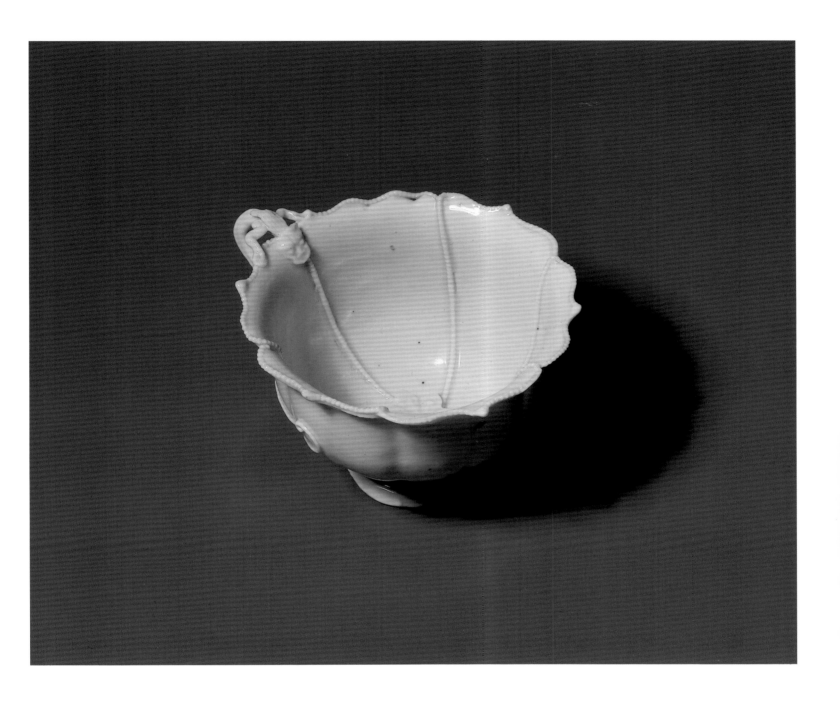

ZHAO MENGFU (CHINESE, 1254–1322), YUAN DYNASTY
FAN PAINTING MOUNTED AS ALBUM LEAF: INK AND COLOR ON SILK; 28.6 X 30 CM
LEONARD C. HANNA JR. FUND 1978.66

The Mongolian conquest of China, taking place in stages, was virtually completed with the surrender of the Southern Song capital at Hangzhou in 1276, ultimately leading to the fall of the dynasty in 1279. The Mongol khans proceeded to introduce a series of administrative changes that directly affected the future course of artistic development in the newly reunified state. They closed the Song imperial painting academy and redesigned the traditional civil service system to diminish the involvement of their Chinese subjects in government. As a result, wealthy, cultivated yet unemployed scholars previously destined to take up posts in the bureaucracy were free to occupy themselves with creative pursuits, eventually coming to assume unchallenged primacy in the visual arts.

Zhao Mengfu, a masterful painter and calligrapher as well as a relative of the ruling family of the fallen Song, was directly involved in these changes. He had been a young student at the national university in Hangzhou before the city was overrun. After ten years of unemployment spent practicing the arts of the brush, he chose to travel north and serve the government of China's foreign rulers. Once resident in Beijing, Zhao rediscovered northern Chinese artistic traditions that assisted in his efforts to redefine the nature of Chinese painting.

The overt subject of Zhao's fan is the simple yet perfect life led by people in a small river village. In his idealized view, landscape elements are reduced to a few trees, some rocks, an eroded shoreline, and distant hills, allowing charming narrative details to assume greater importance in the scene. Underlying the work, however, is a more significant subject rooted in a complex web of artistic references. Rejecting Song academic interests in representationalism and respectful of the achievements of ancient masters, Zhao mixed references to earlier artists in an attempt to synthesize the northern and southern traditions of Chinese landscape painting. The use of rich blue and green mineral pigments set within outlined forms recalls the archaic manner of the Tang dynasty poet-painter Wang Wei (700–761), while the expressive spiky strokes that enliven the wintry trees are borrowed from the early Northern Song landscapist Li Cheng (919–967). Juxtaposing these earlier manners, Zhao created an appealing yet encoded image—well understood by other informed artists and collectors of his day—that is more art historical than natural and suggests the new basis of Yuan painting. E.W.

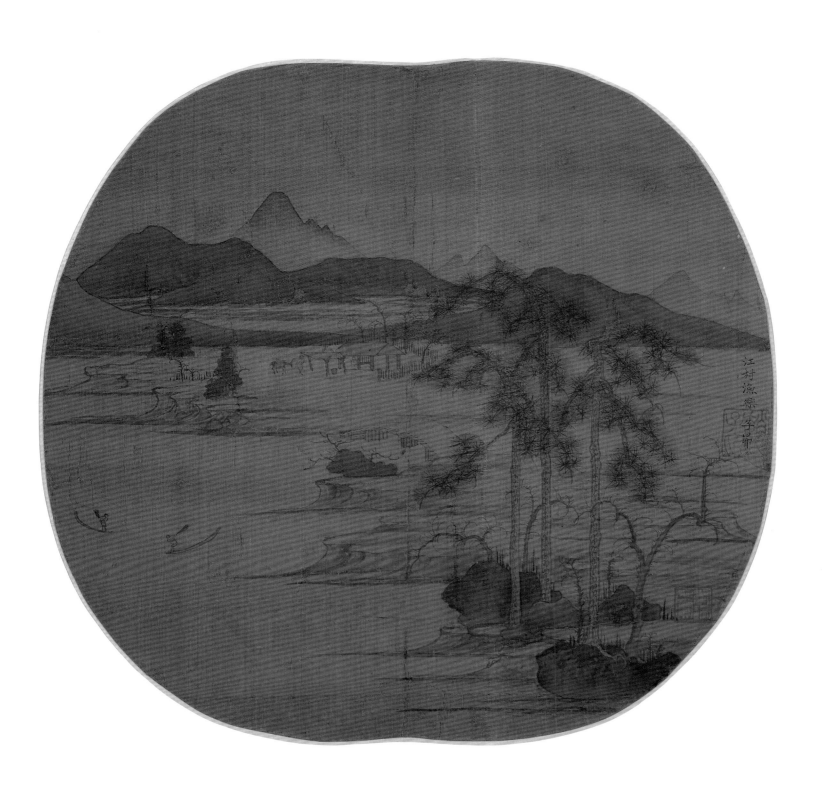

"Summer Mountains," after Dong Yuan

ATTRIBUTED TO HUANG GONGWANG (CHINESE, 1269–1354), YUAN DYNASTY
HANGING SCROLL: INK AND SLIGHT COLOR ON SILK; 131.7 X 55.6 CM
CORNELIA BLAKEMORE WARNER BEQUEST, BY EXCHANGE, AND MR. AND MRS.
WILLIAM H. MARLATT FUND 1992.1

In 1599, Dong Qichang (1555–1636)—the preeminent collector, connoisseur, art theoretician and painter of his day—acquired this important early painting, which he believed was painted by the fourteenth-century master Huang Gongwang. In notes written on another of Huang's works, Dong stated his belief that this was one of the artist's two surviving paintings based on the ancient master Dong Yuan (active about 937–975) and thus combined the best of earlier painting styles. Ever since, this landscape has been accepted as one of the most important monuments of Yuan dynasty painting, inspiring a host of copies including one in the famous *Seeing Large within Small* (Xiaozhong xian da huace) album now in the National Palace Museum, Taiwan.

The landscape features a deep eroded valley beside a rounded monumental peak. Throughout, elements are composed of blended units with strong contours, soft rope-like strokes, and subtly colored transparent washes. Drawn in soft snaky strokes, darker lines are frequently applied on top of lighter ones. Built up, layer upon layer, the brushwork imbues the painting with an authentic organic quality, full of forms that appear to have taken shape over time. Ink, whether saturated or diluted, was applied with a wet brush that blurred edges and enriched surfaces. The depth captured in the view is enhanced by luminous layers of obscuring mist that seem to rise from the river as it recedes into the distance.

Qualities of the Cleveland painting recall several of the "Secrets of Landscape Painting," a collection of observations and artistic suggestions that Huang himself composed. At one point he states:

> The most difficult thing in painting is using the ink. One begins by using dilute ink and builds it up to the point where it begins to look right; then one uses roasted ink [dense black, applied fairly dry] and washes of deeper-toned ink. Thus one distinguishes the fields from the paths, the far from the near.

Huang may have learned this technique from observing nature through the eyes of his model, Dong Yuan, for another of his "Secrets" reads:

> Dong Yuan's small mountain boulders are called "alum rocks." Among the mountains he placed mists. These are both aspects of the Jinling [Nanjing] mountain scenery. The texture strokes must be done with dilute ink by sweeping the brush in wavering strokes. Over these one adds more dilute ink to break [the flatness].

K.W.

Raft Cup *(Chabei)*

ZHU BISHAN (CHINESE, ABOUT 1300–AFTER 1362), YUAN DYNASTY, DATED 1345
HAMMERED SILVER PIECES SOLDERED TOGETHER, WITH CHASED
DECORATION; L. 20.5 CM
JOHN L. SEVERANCE FUND 1977.7

Increasingly inspired by natural forms, the potters, silversmiths, and lacquer makers of Song China frequently created beautiful functional objects in the shapes of living things. This representational trend is most impressive in the amazing silver work made by Zhu Bishan in the fourteenth century. Exemplified by this remarkable cup, Zhu's sculpting interests frequently obscured the functional purpose of his pieces. This cup, in the form of an unfettered figure sitting in a hollow log, can be filled through a hole in its upturned tip, and emptied at the softly rolled lip in front of the man. Confronted with every sip, this individual is identified by inscriptions on the bottom of the cup and on the tablet in his right hand as a traveler who began a transcendental trip in a raft on a river but ended up in the Milky Way. The legend offered a powerful image of escape and release that would have been popular among the educated members of the Chinese cultural aristocracy who were in large part barred from finding employment in the traditional civil service by the Mongol rulers of the Yuan.

Zhu Bishan, creator of the cup, may have understood the poignancy of the theme only too well. Unlike most silversmiths of the time who simply marked their products with the name of their workshop, Zhu signed his cups with his literary nickname, Huayu, suggesting that he was not an ordinary artisan but a literate member of the gentry dislocated by the political, social, and economic upheaval of the time. Born in Weitang, Zhejiang Province, Zhu eventually moved to the prosperous cultural and commercial center of Suzhou in neighboring Jiangsu, where he studied silversmithing before opening his own shop in Mudu, a thriving art and craft center just outside the city on the route to scenic Lake Tai. The location ensured him a steady stream of customers. In fact, one early source states that his works were all the rage at the time. His clients must have included rich, well-educated gentlemen who would have appreciated the historical and literary subjects that inspired his singular creations. Strangely, few of his silvers survive. Only two others, both formerly in the imperial collection of China's Qing dynasty emperor Qianlong (ruled 1736–96), are known. K.W.

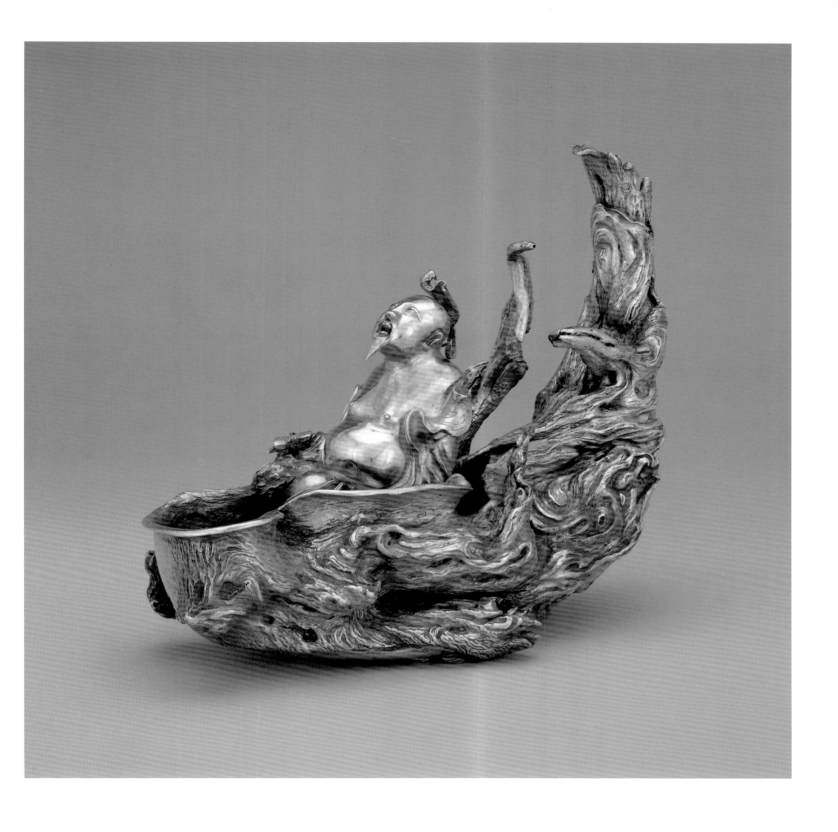

The Nine Songs

ZHANG WU (CHINESE, ACTIVE ABOUT 1335–1365) AND CHU HUAN
(CHINESE, ACTIVE MID-14TH CENTURY),
YUAN DYNASTY, INSCRIBED BY THE CALLIGRAPHER IN 1361
HANDSCROLL: INK ON PAPER, 28 × 438.2 CM
PURCHASE FROM THE J. H. WADE FUND 1959.138

The subject of this narrative scroll is a lyric work composed by the poet Chu Yuan (343–278 BC) who lived in the southern state of Chu during the late Bronze Age. Based on popular ritual incantations, his songs name eleven different spirits. They eventually became one section within a larger compilation entitled the *Chuci* (Songs of the South), a book of poetic writings that enjoyed great popularity throughout Chinese history. Chu Yuan's contributions had particular appeal among scholars and civil servants in large part because of his biography. Unfairly dismissed from governmental service, Chu Yuan, a virtuous statesman, was exiled and, in his despair, eventually drowned himself in the Mile River. The songs, actually appeals to the spirits, are imbued with the sadness of an unjust fate.

This scroll was created while China was ruled by Mongol khans, a time when the *Nine Songs* must have had particular significance since many educated scholars were unjustly barred from careers in government. It is a collaborative work that united two great masters of the brush, the painter Zhang Wu and the calligrapher Chu Huan. Divided into eleven sections, the scroll contains illustrations of the primary subject of the lyric, frequently joined by attendants, each followed by a transcription of Chu's verse. Befitting the archaic flavor of the subject, Zhang isolates his figures and renders them in the linear *baimiao* technique with added washes of ink. For this method of painting, the painter must control the natural flexibility of the brush, maintaining an even pressure on its head while guiding its tip along the spine of each stroke. Suggesting both their appearance and the powerful strength required for their creation, these polished strokes are popularly known as *tiexian* (iron wire lines), a term first used to describe certain examples of archaic calligraphy. A similar degree of brush control is evident in Chu Huan's inscriptions where rounded, centered-tip strokes terminate with plump full ends. Although a note written at the end of the scroll states that it was based on a work by the Northern Song scholar-amateur painter Li Gonglin (about 1041–1106), the painting is both fresh and spontaneous, reflecting the power and exhilaration that could be inspired in the Chinese tradition by the earlier works of great masters. K.W.

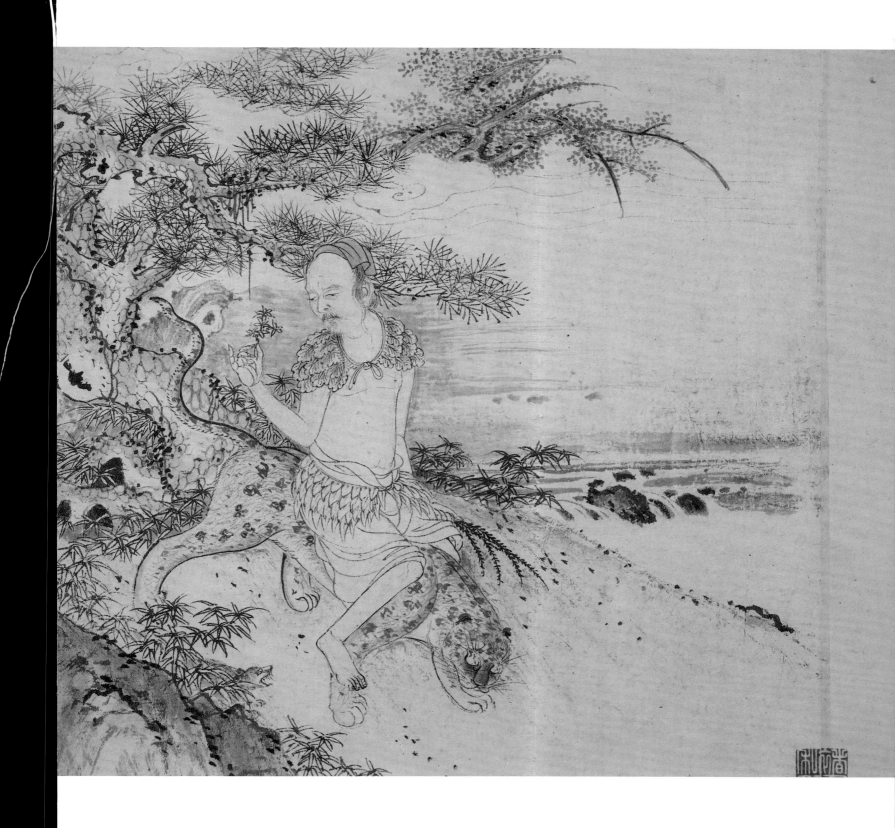

Ink Flowers

ZHAO ZHONG (CHINESE ACTIVE LATE 14TH CENTURY), YUAN DYNASTY,

DATED 1361

HANDSCROLL: INK ON PAPER; 31.8 X 153.2 CM

JOHN L. SEVERANCE FUND 1967.36

This elegant work was painted by an artist who, like Zhang Wu, illustrator of the *Nine Songs* (see page 77), acknowledged his familiarity with the linear *baimiao* technique advanced by the Song master Li Gonglin. As stated in his inscription, however, other earlier masters inspired the painting:

> I did this scroll, using Tang Zhengzhong's [active in the Southern Song court of Ningzong, 1195–1224] method of "ink-flower painting." I also composed poems in the style of Li He in praise of the flowers. My poems and painting may not be very good; they are nonetheless all derived from the heritage of the ancients. It is just as if one wants to draw a square or circle, one must first know how to use the ruler and the compass. May the connoisseur kindly refrain from laughing at them.

By specifying his artistic model, adding poetry based on an earlier writer written in his own hand, and articulating explicitly his method of creation, Zhao Zhong assembled a paradigmatic image of Yuan personal expression.

Isolated against the luminous surface of this especially powdery, sized *fengjian* paper, Zhao's sprays of lily, narcissus, and peony—each paired with his poem—appear frail and ghostly. Closer examination, however, reveals the strength of his precise brushwork that transforms these horticultural studies into brilliant vehicles of expressive painting. The choice of flowers is unusual as the three belong to no known seasonal or symbolic system current in the fourteenth century. The selection could be unique and influenced by his professional interests as a medical doctor and herbalist. It is known, for example, that lilies could be used to form a powder that dispelled grief; the young leaves, eaten raw, produced an intoxicating effect. The rough bark of tree peony roots on the other hand, is prescribed to cure various blood disorders. K.W.

CHINA, EARLY MING DYNASTY, REIGN OF THE HONGWU, JIANWEN, OR
YONGLE EMPEROR, 1368–1424
EMBROIDERY: SILK AND GOLD ON SILK SATIN GROUND; 41.3 X 19.4 CM
PURCHASE FROM THE J. H. WADE FUND 1991.2

This small thangka, or icon, was embroidered in China but preserved in a Tibetan monastery. In the middle of its three registers is a bodhisattva, a person who according to Buddhism has achieved a high state of spiritual enlightenment but has refrained from attaining the final, perfected state of a buddha in order to benefit humanity. He is seated on a lotus throne between two columns, each supported by a vase and surmounted by a makara (a fanciful water creature). The beasts' tails become lotus scrolls forming an arch over the bodhisattva. The red color of the figure together with the jar supported by a lotus next to his right arm identifies the bodhisattva as Amitaprabha. In the lower register is a vase from which issue lotus flowers supporting Buddhist symbols.

The brightly colored silk floss and gold thread against the dark blue of the silk ground fabric give the thangka a jewel-like appearance. The embroidery is worked in a technique known as needle painting. Delicate shading and modulation from one color to another, resembling painting, have been achieved by predominantly satin, interlocked satin, and long and short stitches.

This icon was originally part of a set. On the back is a Tibetan inscription identifying the figure as the Seventh Bodhisattva. Another from the same set, now in the Indianapolis Museum of Art, is similarly identified on the back as representing the Tenth Bodhisattva. Because tantric Buddhist texts classified bodhisattvas into groups of six, eight, and sixteen, these two embroideries must have belonged to a set of sixteen that may have been created as consecration material for a Tibetan Buddhist temple. Parts of a painted set dating from the late fourteenth to early fifteenth century are similar in size to this embroidered example. Consecration thangkas were typically hung inside a temple along the beams and side walls. A.W.

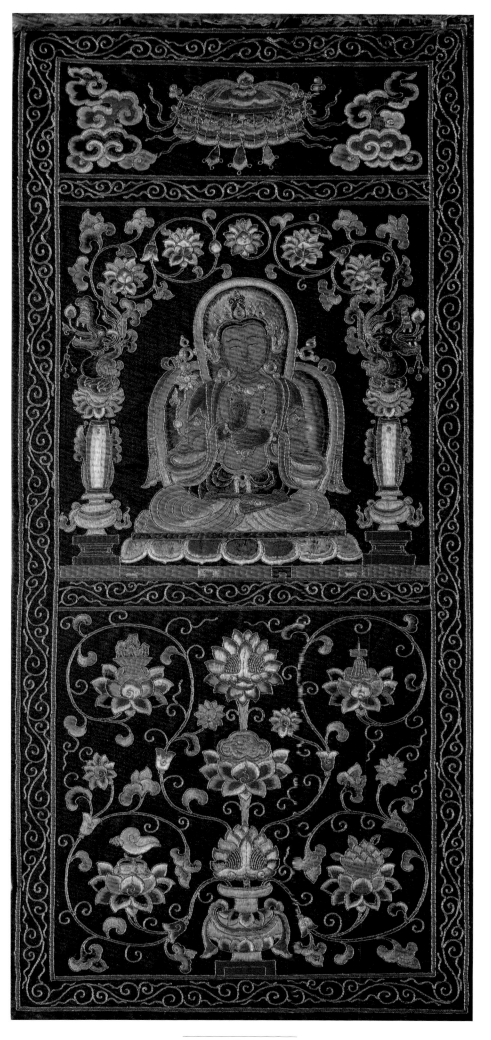

Ritual Disc

CHINA, MING DYNASTY, EARLY 15TH CENTURY

CLOISONNÉ ENAMEL; DIAMETER 30.8 CM

PURCHASE FROM THE J. H. WADE FUND 1987.58

Cloisonné enameling, a method of applying varicolored decoration to the surface of metal objects, was developed in western Asia and introduced to China during the Yuan dynasty when the Pax Mongolica facilitated cultural and artistic exchanges across the continent. Choosing to decorate cast bronzes, Chinese artisans created their patterns with applied copper or bronze strips that served as enclosures, called cloisons, for colored glass pastes derived from various metallic oxides. The pastes, applied with a brush, filled the cloisons, and were fused and fixed to the metal through firing. This technique allowed entire objects to be encased in a colorful decorative skin and thus differed from traditional Chinese methods of metal inlay involving sheets or metallic powders applied only to selected portions of objects.

Developed at the same time as cobalt blue underglaze painting on porcelains, cloisonné enamels frequently exhibit patterns like those found on contemporary ceramics. Thus, this richly decorated disc is covered in a sweeping lotus scroll similar to those on late fourteenth- and early fifteenth-century porcelains. Typical of the ceramic and metal objects required for Buddhist ritual, the lotus design is enhanced by the Eight Symbols of the faith, with the inner circle of blossoms supporting the fish, canopy, mystical knot, wheel, conch shell, umbrella, jar, and lotus.

Like many other Buddhist cloisonné enamels, this disc was created for a specific Tantric rite of Tibetan Buddhism. In a meditation ritual known as Offering the Universe, the top of the disc functioned as a mandala or cosmic diagram. During the ceremony, offerings of grains of rice were placed on the disc to the accompaniment of chanted prayer, preparing initiates for more advanced meditative practices by purifying their mind of obstacles The grains of rice placed in mounds represented Mount Sumeru (the *axis mundi*) and the four continents of traditional Buddhist cosmology. K.W.

Buddhist Ceremonial Robe

CHINA, EARLY MING DYNASTY, RULE OF THE YONGLE EMPEROR, 1403–24
EMBROIDERY: SILK AND GOLD THREAD ON SILK GAUZE GROUND; 118.7 X 229.1 CM
LEONARD C. HANNA JR. FUND 1987.57

Kashaya are rectangular robes worn by ordained Buddhist priests. Typically, they are pieced together to symbolize the vow of poverty taken in the sixth century BC by Shakyamuni, the founder of Buddhism. In this kashaya, the vertical bands of applied buddhas and clouds were sewn onto the rectangular gauze ground. Also applied were the small buddhas between the bands, the four Guardian Kings in the corners, the Wheel of the Law in the bottom center, the Three Precious Jewels in the top center, and the Five Transcendent Buddhas that are repeated around the outer edges. The lotuses and swastikas in the interstices were embroidered directly onto the gauze ground.

Worn draped about the body, kashaya were secured with ties. The buddhas and king in the upper-left corner of this example are upside-down when the garment is viewed flat. When draped, however, these figures appear right-side up. The decorative program is based on the branch of Buddhism known as Mahayana. The myriad buddhas refer to the idea that the cosmic consciousness of Buddha can eventually be attained by everyone and, hence, is limitless. The Four Heavenly Kings, believed to live on the slopes of Mount Sumeru, the center of the universe, bestow wealth, success, and victory. They are also the guardians of the four quarters: Vaishravana (north) in the upper-right corner (shown in the detail on the next page), Dhritarashtra (east) in the lower right, Virudhaka (south) in the lower left, and Virupaksa (west). The Three Jewels (centered at the top) symbolize the teacher, the teaching, and the Buddhist community, and provide refuge from the endless suffering of repeated births and deaths. The three revolutions of the Wheel of the Law (centered at the bottom) refer to the teachings given to the early disciples and the two principal philosophical schools of Mahayana Buddhism. Finally, the Five Transcendent Buddhas repeated in the outer border symbolize the purity of the five elements, directions, colors, addictions, and wisdoms.

The theme of the thousand buddhas used as the decorative program of a garment first occurs in the fifth-century carving of Vairochana at Yungang, a Buddhist site in northern Shaanxi Province. The earliest surviving embroidery with this theme dates from the Tang dynasty and was found by Sir Aurel Stein at Dunhuang. Other known kashaya were preserved in Tibet, although they appear to have been made in Central Asia or China. The Cleveland robe, produced in China, may have been commissioned by a powerful Tibetan monastery; or, it may have been sent as an imperial gift by the Chinese court to an important Tibetan lama. A.W.

Brush Washer

CHINA, JIANGXI PROVINCE, JINGDEZHEN KILNS, MING DYNASTY,

XUANDE PERIOD, 1426–35

PORCELAIN WITH UNDERGLAZE BLUE DECORATION; DIAM. 18 CM

SEVERANCE AND GRETA MILLIKIN COLLECTION 1964.166

Southern Chinese potters began to decorate their porcelains with underglaze blue painted designs during the late Yuan dynasty. Adapted from existing methods of ornamenting Persian ceramics, the technically superior Chinese products were readily marketable in the Near East. In fact, foreign demand encouraged increased production in China and directly affected manufacturing techniques, chiefly the expanded use of molds and templates for shaping. Compared with earlier southern porcelains (see page 69), these new wares were heavy and covered with more thickly applied glazes. Be that as it may, these sturdy white vessels embellished with rich cobalt designs were the finest ceramics the world had ever seen.

Although selected shapes were manufactured for the domestic market as early as the mid-fourteenth century, the popularity of the new ware did not flourish in China until the early Ming. At that time, a wider array of traditional forms decorated with appealing indigenous motifs—beautifully exemplified by this blue-and-white brush washer with imperial dragons—were made for the royal household as well as the indigenous commercial market. Such Chinese desk items had been created in clay for centuries (see page 55), and earlier examples of foliated brush washers exist among surviving Song imperial wares. Filled with water, they were used to clean ink out of writing and painting brushes. Such beautiful pieces reflect not only the cultivation of their owners, but also the importance of everything connected with the art of writing. While Chinese emperors, scholars, and officials may have always prized their special brush or ink grindstone, interest in all the accouterments of the desk rose in tandem with the social and economic fortunes of the educated class.

The dragon, seen here both inside the basin and in the recessed foot as well as in ten roundels around the exterior, was a favored motif from its first appearance on archaic bronzes through its selection as the paramount imperial symbol. For its depiction here, the painter varied the intensity of his color by altering the cobalt content of the pigment he applied directly to the ceramic body, thereby enhancing the three-dimensional effect and spiny character of his design. Whether made strictly for the imperial household or not, the presence of the dragon on pieces such as this one signals increasing palace involvement in production at the Jingdezhen factories. In fact, as early as 1433—at about the same time this brush washer was created—the palace was ordering more than 400,000 porcelains decorated with underglaze blue dragons and phoenixes.

Although it does not bear an imperial reign mark, the attractive tonal range found in the painted decoration, resulting from the irregular size of cobalt bits in the pigment, and the pocked glaze surface are characteristic of the stunning objects made at the royal Jingdezhen kilns—still in the first century of their operation—during the reign of the early Ming emperor Xuande (1426–35). K.W.

The Hermit Xu You Resting by a Stream

DAI JIN (CHINESE, 1388–1462), MING DYNASTY

HANGING SCROLL: INK AND COLOR ON SILK; 138 X 75.5 CM

JOHN L. SEVERANCE FUND 1974.45

With the founding of the Ming dynasty, native Chinese rule was reestablished over the country. While this political event did not have an immediate or profound effect on many of the artistic traditions inherited from the Yuan, the new emperors were encouraged to reevaluate the role of creative institutions established during previous Chinese dynasties. The most influential of these was the imperial painting academy of the Song (960–1279). The Ming emperors did not, in the end, revive the academy as it had been, but replaced it with a pattern of court sponsorship that granted official rank to painters who served the palace. Responding to decorative and documentary needs, these painters produced great numbers of large paintings for use in the public halls and grand residences of the Forbidden City.

Most of these painters entered imperial service as well-established artists. Based on his talents, Dai Jin, painter of this large hanging scroll, had been recommended to the Xuande emperor (ruled 1426–35). Although not immediately accepted, he was eventually successful in Beijing and is credited with defining the Ming academic painting style. Like many court painters of his day, Dai Jin painted images that were conservative in both content and style. In this work, his subject is Xu You, a legendary figure who supposedly lived at the time of the emperor Yao in the mythic past. According to tradition, the emperor offered his throne to the worthy Xu You, who refused it. Xu You also turned down the post of governor of the provinces. Such stories were consonant with established Confucian notions of selective government service and appropriate kinds of ambition, reflecting the current scholarly fashion of reclusion and self-development.

The painter's influential style, brilliantly illustrated in this historical painting, is based on the methods of the earlier Song academy. Axe-cut strokes, made by obliquely dragging the side of the brush across the silk, create the impression of roughly hewn surfaces. Dai Jin frequently accompanied these especially strong, prominent strokes with softly colored diffuse washes. Thus brushwork, ink, and pigment, as well as the compositional structure, give the painting its beautifully decorative surface. By pressing his forms closer to the front of the picture and arranging them artfully around the pivotal figure, the painter ensured that his subject, a worthy, self-confident man awaiting an appropriate invitation to official service, was both attractive and memorable. K.W.

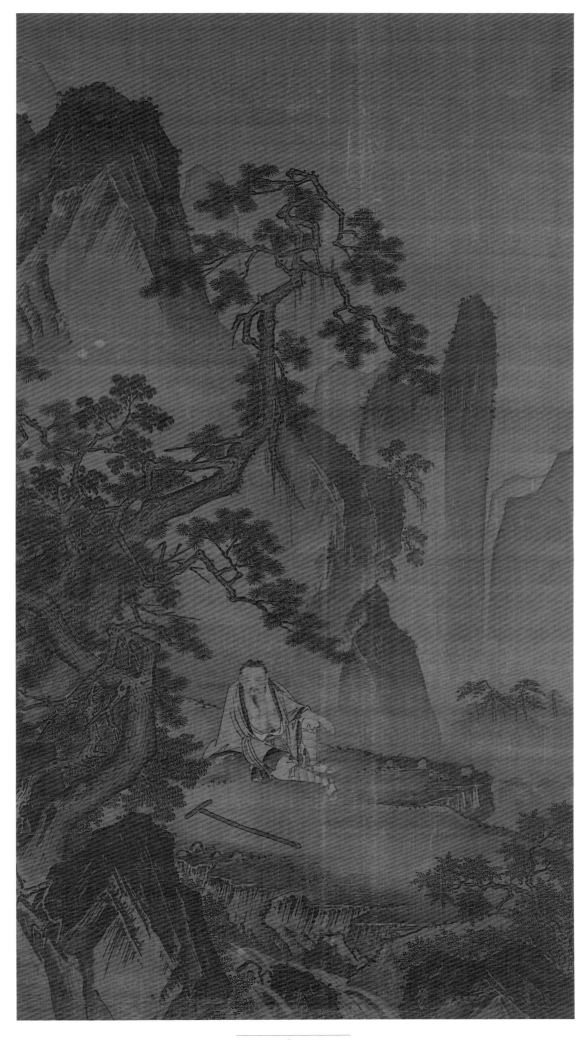

The Garden for Self-Enjoyment

QIU YING (CHINESE, 1494–1552), MING DYNASTY
HANDSCROLL: INK AND COLOR ON SILK; 27.8 X 381 CM
JOHN L. SEVERANCE FUND 1978.67

This visually complex handscroll succinctly suggests the cultural, historical, and artistic sophistication of middle Ming painting. Conceived as a linked series of discrete views, the painting is an illustrated tour of favored spots of privacy and relaxation in a residential garden. Surrounding the garden owner, who appears in each scene, are esteemed elements of traditional Chinese gardens, with paths, structures, and formal plantings of human design contrasted against passages of lush growth, roiling waters, and grand vistas of untamed nature. In the various activities of the garden owner, the painter Qiu Ying presents orthodox occupations of the leisured gentry.

The illustrated garden was not one that Qiu Ying knew from personal experience, however. It was, instead, a garden built by the famous Song statesman and scholar Sima Guang after he retired in 1073, nearly 500 years before the date of the painting. The guiding inspiration for the image came from descriptions written by the owner. To illustrate Sima's essay and seven poems, Qiu borrowed stylistic aspects from the repertoire of the Song painter Li Gonglin (about 1041–1106), an artist living at the time of the garden, and Ma Hezhi, a Li Gonglin follower living in the twelfth century.

Each of the seven spots described in a poem and depicted in the painting was originally designed by Sima Guang to evoke a respected individual of the past. Thus, the painting depicts a vanished garden that was, in turn, inspired by more ancient subjects. The first passage, showing Sima Guang washing his hands in an open pavilion, celebrates the Tang poet Du Mu (803–852), who regularly washed his ink stone in the water near his study. The second scene, Sima Guang lost in thought in his study, is meant to evoke the memory of Dong Zhongshu (179–83 BC), a Western Han scholar who grew so engrossed in his study that he neglected his garden. The subsequent view of the garden owner fishing recalls Yan Guang (first century AD) who chose to fish and farm rather than serve in the Eastern Han government. The fourth scene, celebrating the famous bamboo-lover Wang Huizhi (died in 388), son of a famous calligrapher, presents Sima Guang supervising his gardeners in the bamboo patch. The elaborate botanical garden surrounding the owner in the next scene was inspired by Han Kang, another Eastern Han figure, who sold herbs at honest prices in the marketplace. In the last two passages, Sima Guang is shown in situations designed to remind viewers of Bo Juyi (772–846) of the Tang and Tao Yuanming (365–427) of the Liang, writers who retired from government to enjoy nature and the simple life. Such subjects continued to be powerful long after Sima Guang, and this garden image was particularly poignant in Ming Suzhou, the adopted home of Qiu Ying and center of retired scholars who occupied themselves with scholarly and creative pursuits like those of their Song predecessors. K.W.

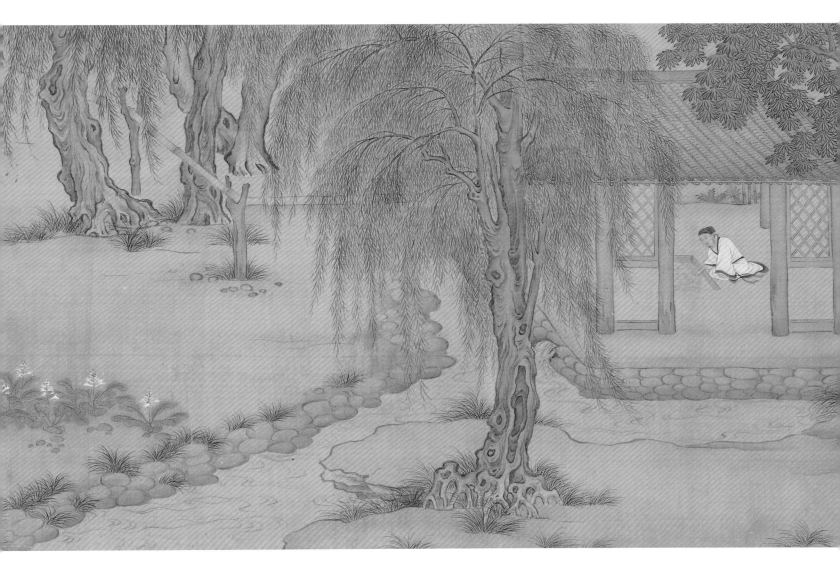

Hundred Birds Admiring the Peacocks

YIN HONG (CHINESE, LATE 15TH–EARLY 16TH CENTURY), MING DYNASTY

HANGING SCROLL: INK AND COLOR ON SILK; 240 X 195.5 CM

PURCHASE FROM THE J. H. WADE FUND 1974.31

This attractive image was created by an obscure early Ming professional painter represented by only a handful of surviving works. The painting focuses on a corner of a garden separated from a more distant misty grove by a swiftly flowing river. In the compressed foreground, pairs of birds—almost exclusively males—enliven a large weeping tree (a prunus), various peonies, and a fantastic rock, most probably one retrieved from Lake Tai where the action of the water eroded its surface. The birds, accurately drawn from nature are readily identifiable and include orioles, grosbeaks, hoopoes, woodpeckers, finches, pheasants, and magpies in addition to the prominent peacocks. Painted with outlined passages of brilliant color, the birds and flowers are sharp-edged forms that prefigure the scientific studies undertaken centuries later in the West.

Large decorative paintings such as this one were extremely popular among early Ming court and professional painters. Created to ornament the walls of enormous private dwellings, such paintings were often produced as pairs or sets. A richly colored painting on silk now in the Sichuan Provincial Museum has approximately the same impressive dimensions as the Cleveland painting. Because the two share the subject of pairs of male birds in a compressed corner foreground isolated against a river and distant grove, they may have been created to hang together. Since the Cleveland work celebrates the flowers of late spring while the Sichuan painting features the lotus blossoms of high summer, both may belong to a larger group that chronicled the flora and fauna of the four seasons. With each painting measuring roughly eight feet by six feet, the set, when mounted in appropriate silk frames, would have been impressive indeed. K.W.

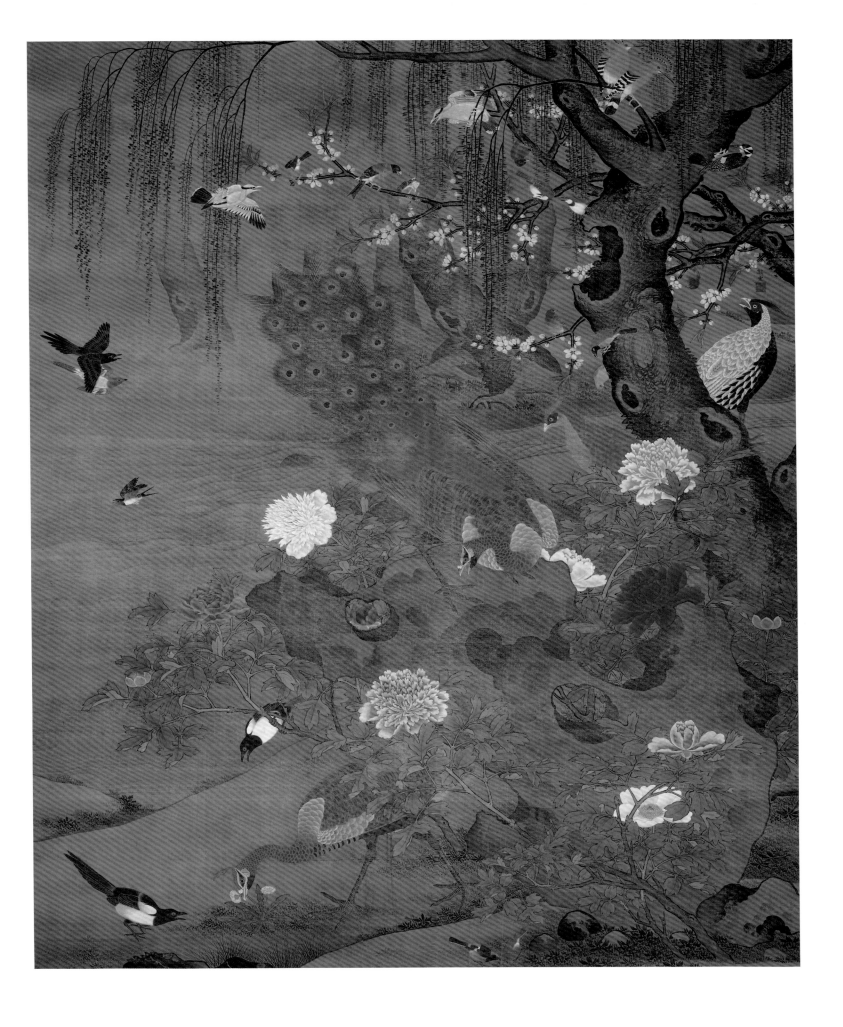

DONG QICHANG (CHINESE, 1555–1636), MING DYNASTY

HANGING SCROLL: INK ON PAPER; 224.5 X 67.2 CM

LEONARD C. HANNA JR. FUND 1980.10

Dong Qichang is the most important figure in the history of later Chinese painting and calligraphy. A masterful scholar-artist, he was also a discriminating connoisseur and collector. Through his collection and his comments on paintings and pieces of calligraphy, Dong established a canon of ancient works for others to revere and study. For his own painting style, he favored the literati painters of the Yuan dynasty and their antecedents Dong Yuan (active about 937–975) and Juran (active about 960–980; see page 51).

Like all members of the Chinese official class, Dong traveled a great deal and also drew inspiration for paintings from nature. On at least one of his trips, he visited the Bian Mountains, subject of this extraordinary painting. The mountains are actually a relatively low range located not far from Wuxing and Lake Tai, in the southern province of Zhejiang. Traditional sources say they are remote and wild, the perfect site for communion with nature. Indeed, the great scholar-artist Zhao Mengfu (1254–1322; see page 71), who lived nearby, liked walking in the Bian Mountains and designed his studio so he could see them. He painted at least one picture of the mountains, as did his equally famous grandson Wang Meng (about 1308–1385).

Dong knew and eventually owned depictions of the Bian Mountains by both men. His familiarity with those pictures surely affected his experience of the place. After visiting the site, the artist wrote:

> Zhao Mengfu and Wang Meng both painted depictions of the Bian Mountains. I have traveled to those mountains and moored my boat beneath them. There, I realized that the paintings by the two masters transmitted the spirit of the place. But the soul of those mountains and streams is inexhaustible. I went beyond the work of the others to fashion another scene of my own which is not without merit.

His painting shows a monumental mass sandwiched between a brief foreground land spit and a distant misty peak. Like Wang Meng before him, Dong Qichang created a seething landscape with textured hills and patches of stark unpainted white paper. The structure here, however, is analytical, not intuitive. Blocks representing forms seen from different points of view are combined to achieve a complex three-dimensional vision. The overall effect is not unlike that found in cubist works painted centuries later in the West. Although echoing earlier paintings and alluding to ancient masters, the picture is far more than a summing up. It is both a radical synthesis of what came before and an illustration that tells far more about a place than can be seen with the eye. K V.

青卞圖倣北苑叢
丁巳夏五晦。寫
張愻真與文
敏庵丈

積灘亂石紫崒
雲端雜犬見邗塘
林岸月雲塢消日
溪洞亭中起居士

其昌跋

Fish and Rocks

ZHU DA (CHINESE, 1624–1705), QING DYNASTY

HANDSCROLL: INK ON PAPER; 29.2 X 157.4 CM

JOHN L. SEVERANCE FUND 1953.247

As occurred when the Chinese rulers of the Song finally capitulated to the Mongols in 1279, the Manchu conquest centuries later led large numbers of scholarly members of the Chinese official class to opt to finish their lives in quiet retirement. The dislocations of dynastic change were particularly difficult for those related to the former ruling house who were forced to seek obscurity to save their lives. They, like famous literati of the day, frequently chose to rededicate their time to creative pursuits, including literature, calligraphy, and painting, using the arts as an outlet for intense emotions. This was certainly the case for the youthful Zhu Da, an imperial descendant of student age in 1644. Originally named Zhu Zhongkui, he changed his name, sought refuge in Buddhist monasteries, and at times feigned dumbness or madness to avoid discovery.

The difficulties of his life may help to explain the creative tensions and surrealism of paintings like this short handscroll. The painting features strangely juxtaposed vignettes—including (right to left) a rock cliff with pendant chrysanthemums, a fantastic stone that seems to float, and two fish followed by what may be a lotus—all shown devoid of context. These elements are accompanied by three of the artist's poems, which are similarly opaque and difficult to understand:

> A foot and a half from heaven
> Only white clouds are moving
> Why are yellow flowers painted?
> Amid the clouds is the city of gold.
>
> In the Twin Wells is water formerly from mid-stream,
> Above which the bright moon shines and lingers.
> The two golden carp of the Huang family,
> Where have they gone, to become dragons?
>
> Under these thirty-six thousand acres of lotus
> Day and night fish are swimming.
> Arrived here is a single "yellow cheek,"
> Ocean tide rises with the soaring notes of the flute.

It is thought that the three poems and the peculiar images that may be designed to illustrate them are messages of Ming loyalism encoded to defy general recognition. Whatever its specific symbolic meaning, Zhu Da's painting can be appreciated for its spontaneous and rapid brushwork and balance of wet and dry ink. K.W.

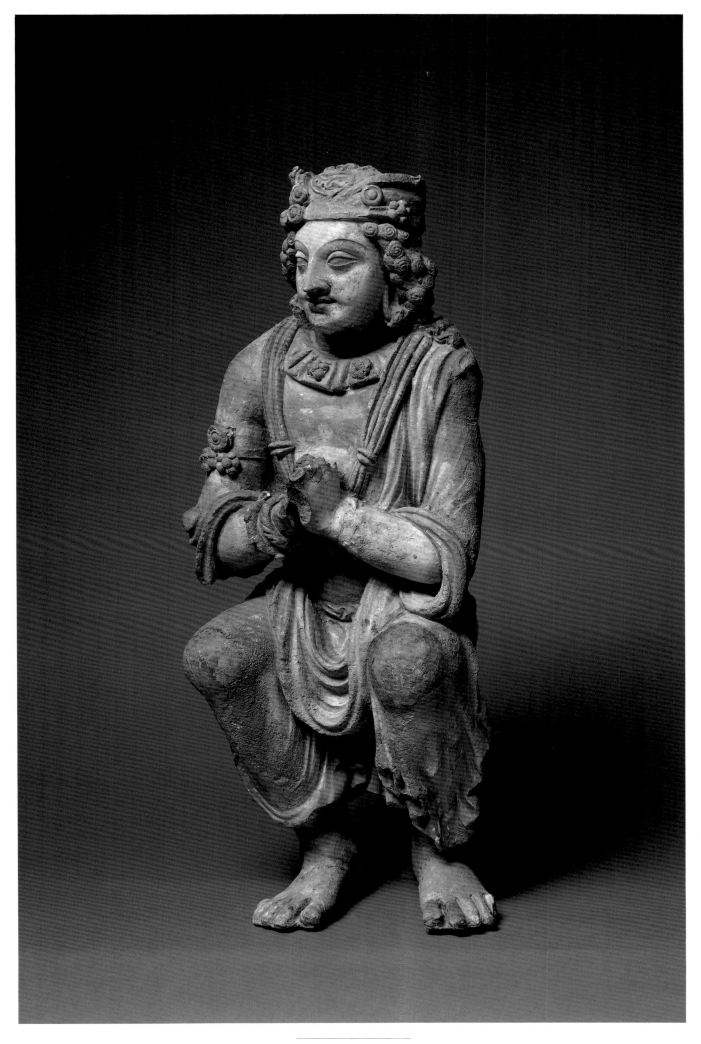

Railing Pillar

INDIA, KUSHANA PERIOD, MATHURA STYLE, 2ND CENTURY AD

RED SANDSTONE; H. 80 CM

JOHN L SEVERANCE FUND 1977.34

Contemporary to the Gandhara style in the north was the indigenous school of sculpture that flourished in the Ganges Valley known, after its main center, as the Mathura style. It continued earlier Maurya and Shunga traditions but remained under the control of the same Kushana dynasty that was responsible for the Gandhara style.

This double-faced corner railing pillar from a Buddhist stupa provides a spectacular example of the Mathura school. It belongs to the category of *madhupāna* (bacchanalian sculptures). Libation scenes such as this, which owe a great deal to Hellenistic influence, were popular in Kushana times.

The center portion of the pillar is decorated with two scenes, each showing two young women. The first pair play the pan pipes and the clapper; one of the women in the second pair coquettishly lifts her robe, while the other balances a cup on her head. They seem to be intoxicated and dancing. On the ground is a large vase with two handles of the Hellenistic kantharos type associated with the Greek Dionysos or the Roman Bacchus, the youthful god of wine, appropriate to the libation taking place. Similar vessels of Hellenistic inspiration, including a partially broken rhyton, are also visible on the ground in the first scene. In the upper register are busts of celestial musicians among grapevine foliage, further bacchic connotations. The instruments the celestial musicians play include a lyre *(kacchapi)*, castanets (similar to the modern North Indian *manjira)*, and a triangular harp *(trigonus)*.

The base is decorated with two scenes set against a rock background: the first one shows a hunchbacked woman pouring a drink for a corpulent yaksha (nature spirit), and the second one probably illustrates the ogress Jataka *(pādakusala-māṇava jātaka)*, who ate her victims. She fell in love with a handsome young brahmin, whom she chose for her husband but kept him imprisoned. Out of this relationship a bodhisattva was born who eventually rescued his father.

The most unusual feature of this relief is the obvious blend of Hellenistic elements with indigenous Mathura characteristics. The costumes, the treatment of the drapery, the presence of Hellenistic vessels, and the foreign musical instruments— not to mention the presence of the grapevine, which was cultivated only along the northern frontiers of India where the climate permitted it—all indicate strong Gandharan influence. Yet the very material of which the pillar is made, red Sikri sandstone, suggests a Mathura atelier as the workshop. Thus, one is inclined to think that it was the work of a Mathura artist familiar with Gandhara style.

The unusual mingling of the two traditions can be traced to the classical subject that involves the cult of Dionysos, expressed here by voluptuous Indian bacchantes. Like Dionysos and his entourage, the Indian Kubera with his yakshas and yakshis derived from ancient folklore and essentially represented demigods of all "wet and gleaming" nature: rain, dew, sap, blood, semen, and spirituous liquor. It seems most probable that the Mathura sculptor who executed this work used Gandharan imagery in order to depict more authentically the exotic yaksha paradise far away among the snowy peaks of the northwest where grapevines flourished. s.c.

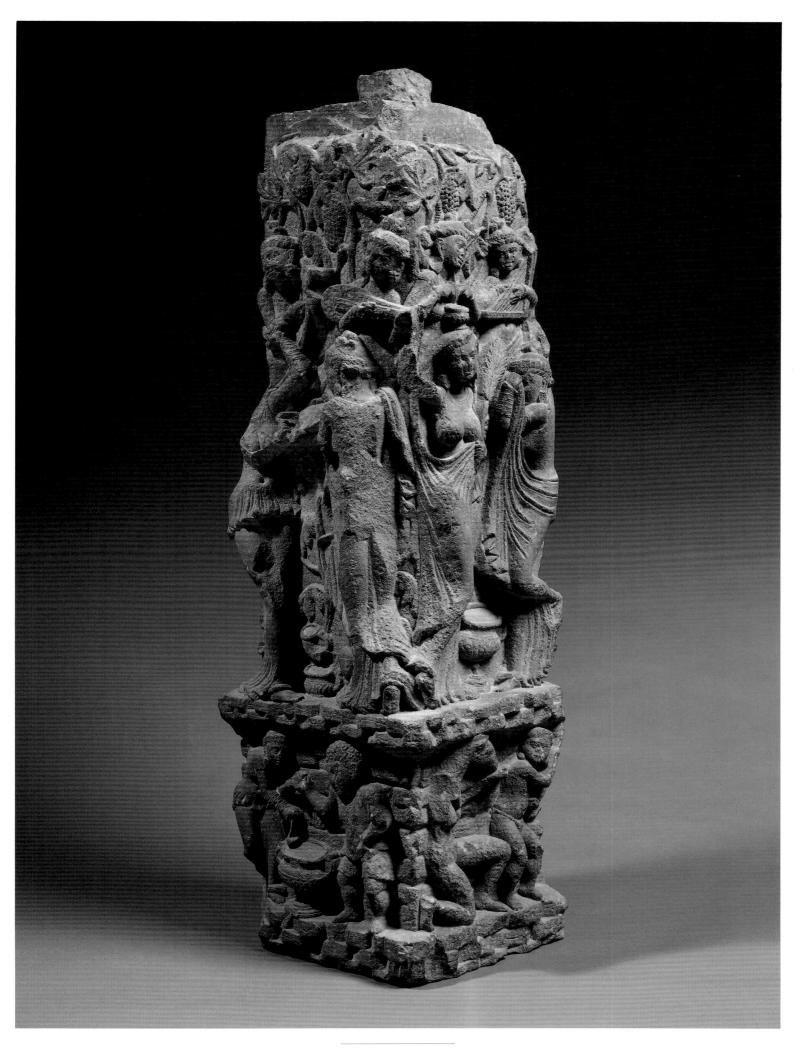

Double-Sided Torana Bracket with *Śālabhañjikā* Figures

INDIA, KUSHANA PERIOD, MATHURA STYLE, SECOND HALF OF 2ND CENTURY AD

RED SANDSTONE, H. 71.1 CM

JOHN L. SEVERANCE FUND 1971.15

The sculptures executed in very deep relief on both sides of this architectural fragment show a lavishly bejeweled women under blossoming Sala trees. Dryads or tree goddesses, known as *dohada* or *Śālabhañjikā* (woman and Sala tree), are very popular in Indian folklore and are frequently represented in Mathura sculptures. By touching the tree, they spur it to bloom, thus symbolizing the transfer of the woman's fertile energy to nature, which is awakened from its dormancy. The sculpture's monumental size and the addorsed carving may indicate that it was an upper part of a stupa gateway *(toraṇa)* pillar or bracket.

The sculpture once portrayed a full-size figure whose remaining arm holds a tree branch overhead, while the missing arm probably rested on the hip. The goddesses wear heavy earrings, necklaces, armlets, and bangles. Their hairdos, with the texture of the hair indicated by finely incised lines, are a standard Kushana type, except that the knots of twisted hair are placed higher on the heads and are even more elaborate than usual. One of the figures also wears a jeweled band around her head. Strands of hair fall over the shoulders and onto the ample breasts. The faces, although partially damaged, display a perfect oval shape and regular, carefully executed Kushana facial features.

Particularly striking is the vitality of the movement shown in the twist of the torsos, provoked by the high raised arms. In truly indigenous Indian fashion, there is no angularity of forms, as exemplified by the curvilinear outline of the arm and the gently curving branches of the Sala tree. Indeed, in their posture these figures have a rhythmic quality that recalls a dance pose, so characteristic of Indian sculpture at its best. S.C.

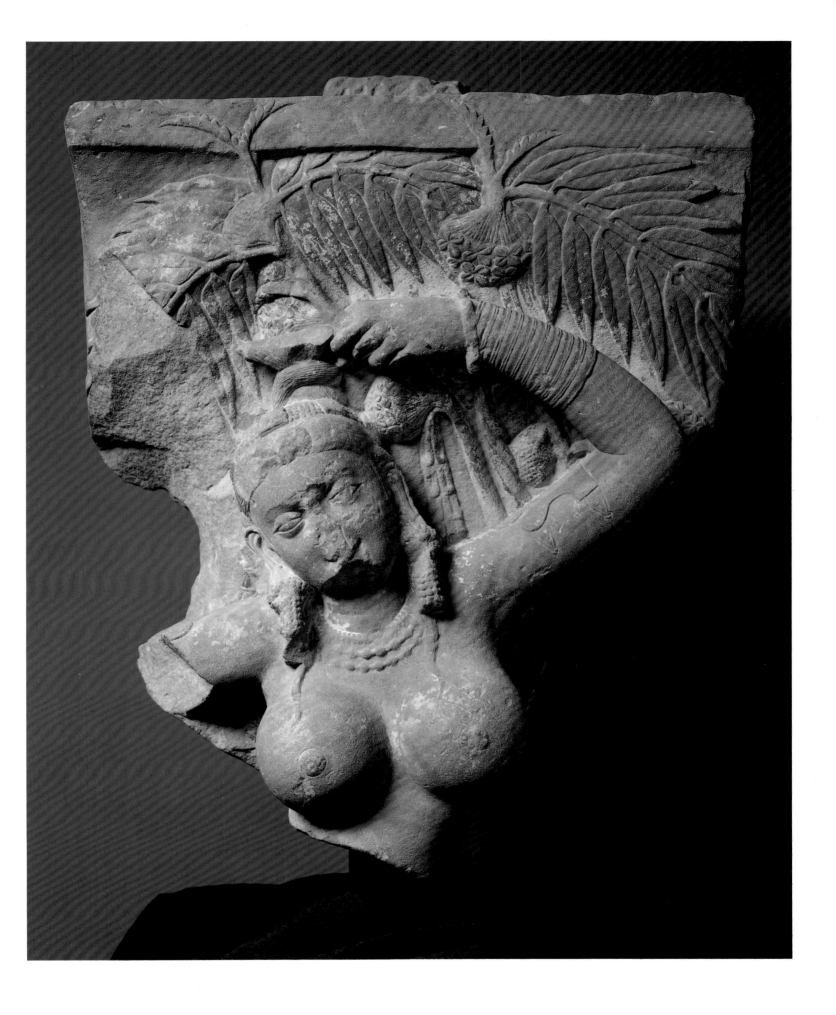

Ladies Entertained by Dancers

AFGHANISTAN, BEGRAM, KUSHANA PERIOD, 1ST–2ND CENTURY AD

IVORY; H. 7.5 (CENTER FIGURE), W. 17 CM

LEONARD C. HANNA JR. FUND 1985.103

Ivory is a more perishable material than stone, bronze, or even terracotta, yet it was one of the more popular media used in India without interruption from ancient times to the present. It was not until 1937 and the discovery of the Begram treasure by Joseph Hackin that we gained substantial knowledge concerning ancient Indian ivories.

Begram, ancient Kapisa, some forty-five miles north of Kabul on the banks of the Panjshir River, is surrounded by the massif of the Hindu Kush. This scenic city was a royal seat of the Indo-Greek kings as early as the second century BC, and later became the summer capital of the Kushana kings. The ruins of the palace, dating to the Kushana period, revealed a treasure trove of numerous artifacts sealed in several chambers, possibly hidden there from invaders. Among various other objects, a large number of ivories of Kushana workmanship were found. Ever since Hackin's discovery of them and their extensive publication, the dating and origin of Begram ivories has become a subject of scholarly dispute.

Most of the ivories are, like this one (and three other fragments in the collection), filigree panels depicting figures, usually voluptuous elegant ladies of the court performing various functions. Most likely these ivories were meant to embellish furniture such as low stools, small tables, chests, and boxes—items often represented on the ivories themselves. Devices such as the intertwining of elements or overlapping of figures through touching hands or embraces were used to form unified filigree panels. Some of them still retain occasional metal pins by which they were attached to furniture. The Begram ivories, one of the few categories of secular art, frequently show scenes of courtly life that reflect contemporary lifestyles and fashions.

This panel, flanked on the sides by ladies seated on low stools in relaxed poses and three female dancers in the center, shows what must have been favorite pastimes of courtly beauties: dancing, listening to music, and drinking. On the interior side of the seated figures are high stands in the shape of an hourglass or modern Indian low wicker seats known as *murha*. They may have served as flower stands because remains of foliage are visible above them. At the extreme right of the panel stands a tree next to the seated figure. The bare-breasted ladies are clad in transparent skirts, have elaborate hairdos and are adorned with rich ornaments. The base of the panel is decorated with rosettes, which are frequently found on the bases of Gandharan images. Traces of red lacquer suggest that they were enhanced with lacquer inlay. The plaque has been published along with other similar plaques believed to be part of the same ivory throne.

The Begram ivories have been variously dated from as early as the first century BC to as late as the third to fourth centuries AD. While obviously the scope of the entry for this publication does not allow a more involved discussion of this complex problem, the ivory figurine found in Pompeii that is related in style to the Begram ivories provides the terminus date as the year AD 79 (or the eruption of Mount Vesuvius), and in view of the Begram ivories' close similarities to Kushana sculpture in general, they can be dated to the first to second centuries AD. S.C.

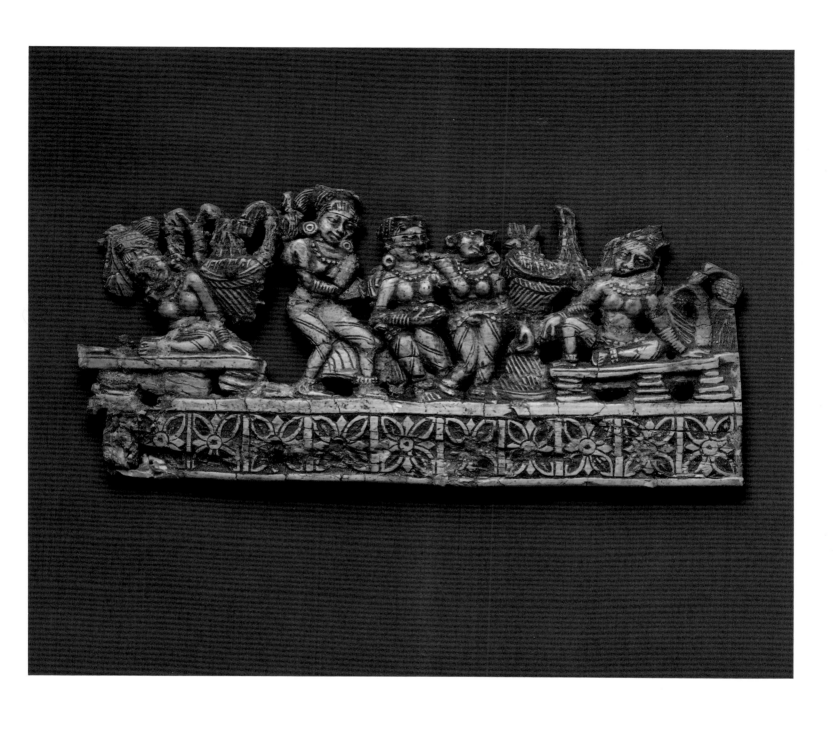

Adoration of the Bodhi Tree

INDIA, ANDHRA PRADESH, AMARAVATI, SATAVAHANA PERIOD, 2ND CENTURY AD

LIMESTONE; H. 80, W. 57.1 CM

PURCHASE FROM J. H. WADE FUND 1970.43

While the Gandhara and Mathura styles flourished in north and central India, another style developed in the south: the Andhra style, named after Andhra Pradesh province, or Satavahana, after the name of the ruling dynasty. Like the contemporary northern styles, it served predominantly Buddhism. Its major monument, no longer extant, was the stupa of Amaravati. That monument was richly decorated with sculptural reliefs depicting scenes from jatakas (previous lives of Buddha) and images of the master.

The relief here represents what is referred to as an aniconic scene, depicting the worship of the bodhi tree under which Buddha achieved his enlightenment. In aniconic depictions Buddha is not shown in anthropomorphic form, but represented by various symbols, such as the bodhi tree, royal umbrella, imprint of his feet, or his throne. Three figures (two males and one female) are shown adoring the tree. They carry vases with flowers as offerings, pouring flowers at the base of the tree. The male figure on the right of the panel is badly mutilated and a section of the tree on the top is missing.

The relief presents the new sense of realism and elegance that characterize the Andhra style. Figures are deeply carved in a variety of postures and they overlap, creating a sense of perspective and giving the impression that they exist within space. Compositions are usually crowded with figures who are slim and elegant in their elongation and convey vitality and movement.

The stone used by Andhra sculptors is a white-green limestone that looks like marble and distinguishes sculpture of this school from all others. Sculptures in the Amaravati style are relatively rare. The largest group survives in the British Museum in London (more than 120 pieces) and others are in the Madras Museum, and the Musée Guimet in Paris. In the United States, museum collections in Boston, Kansas City, Los Angeles, the Metropolitan in New York, and Cleveland have some examples. In addition to this relief, the Cleveland museum has another one of aniconic subject, the pillar of fire. S.C.

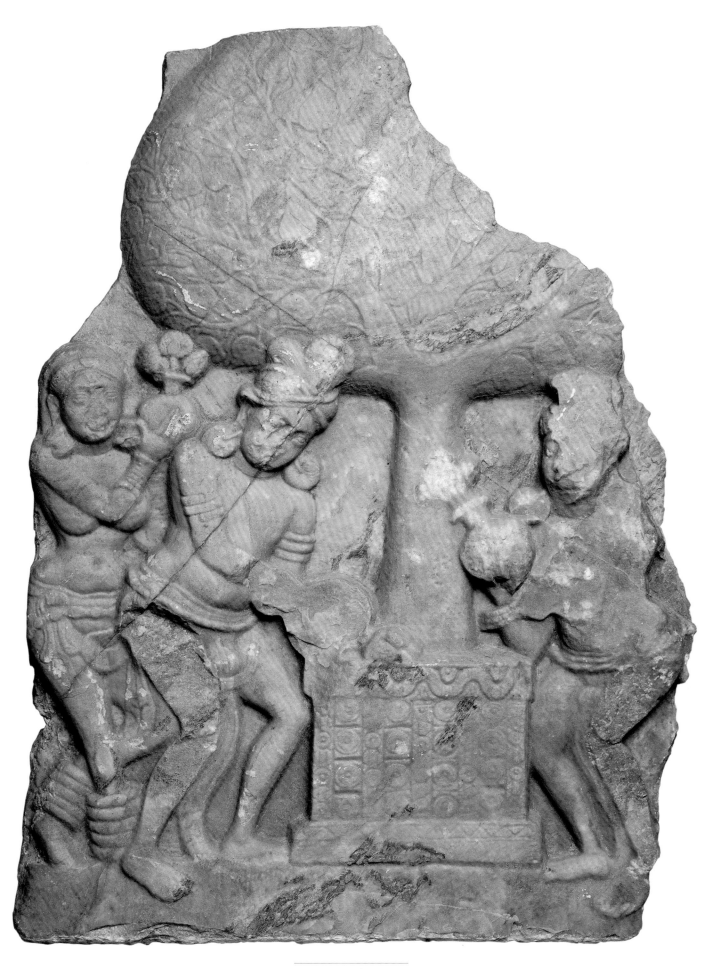

Standing Buddha

INDIA, SARNATH, GUPTA PERIOD, 5TH CENTURY

BUFF SANDSTONE; H. 76 CM

PURCHASE FROM THE J. H. WADE FUND 1943.278

The Gupta period is known as the renaissance or golden age of Indian art. These terms signify the highest level of accomplishment in the plastic arts, both in physical perfection and in spiritual content.

The tendency of the Gupta age, similar to that of the Western classical tradition, is to emphasize physical beauty; thus the interest in depicting the human form as youthful and idealized. The transparent clothing of the figures reveals the body, the proportions are elongated and elegant, and the postures relaxed and graceful. The images are rendered three-dimensionally with the stress on plasticity and volume. The Sanskrit term frequently used to describe this characteristic of Gupta sculpture is *prāna* (breath), referring to the inner energy and vitality combined with three-dimensionality and plasticity. The sculptures seem alive, swelling with "inner breath," voluminous and vibrant at the same time. Consequently, *prāna* refers as much to the spiritual as it does to the physical aspects of Gupta sculpture. This spirituality in sculpture is further emphasized by the facial expression, here unfortunately impossible to appreciate as the head of the statue is missing.

This sculpture depicts an incomplete image of Buddha from the Sarnath school. Distinguishing marks of Sarnath sculpture are the buff-colored sandstone (known as the Chunar stone) and transparent clothing. Were it not for the hem of the *sanghāti* (monastic garment) around the neck, wrist, and ankles, the figure could have passed for being unclothed. The excess fabric of the garment is gathered on both sides of the image. Evident at the waist is the line signifying the *antarāvāsaka* (undergarment) worn under the monastic garment. There was once a halo around the image decorated along the edge with scallops and beading, of which only a fragment remains on the left side.

The body of Buddha sways to the side in a graceful *tribhanga* (three-bent) posture. The proper right arm is outstretched along the side of the body in a *varada* mudra (gesture of bestowing) while the other is bent at the elbow; the hand, which once held the hem of the robe, has broken off. The sequence of the arms in this instance is reversed. Usually the right hand is lifted while the left remains pendant (see page 131). S.C.

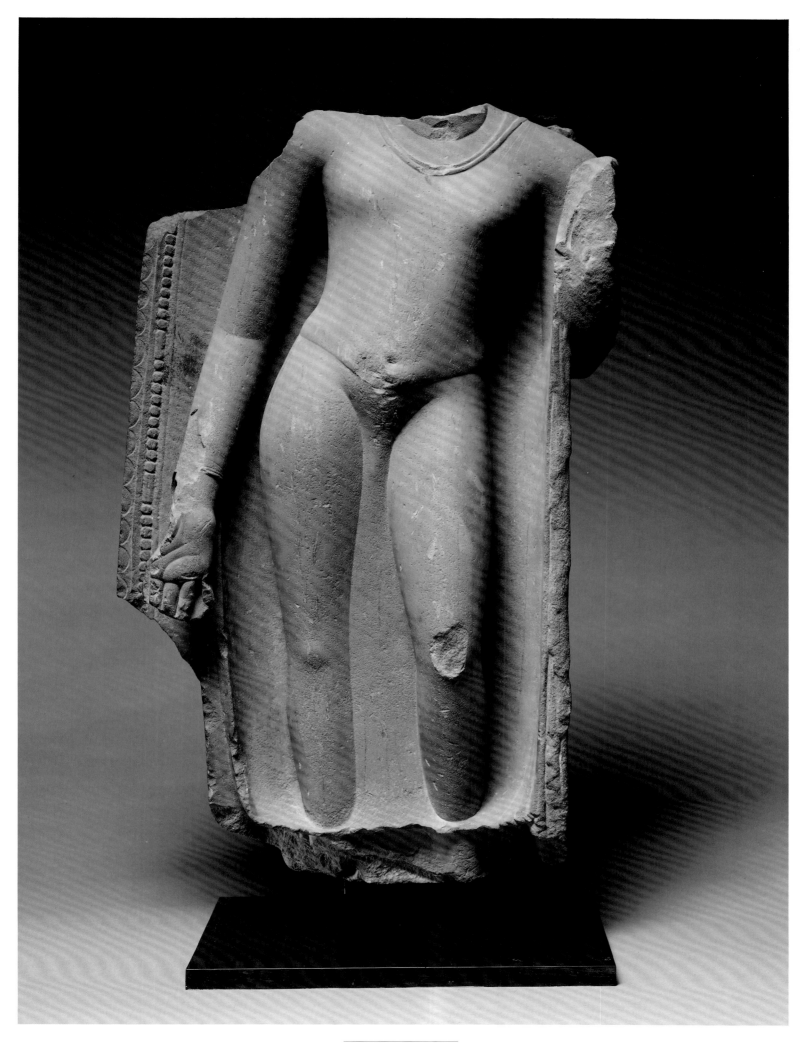

INDIA, MATHURA GUPTA PERIOD, 5TH CENTURY
RED MOTTLED SANDSTONE; H. 30.5, W. 16.5 CM
JOHN L. SEVERANCE FUND 1963.504

The spirituality of Gupta sculpture is most evident in this head of Buddha with its oval-shaped face and sensuous, well-defined features. The gently arching eyebrows, outlined by a double-line, almond shaped eyes with heavy eyelids, straight aquiline nose (now damaged), and broad sensuous lips all represent the usual Gupta idiom. Implying meditation, the semiclosed eyes convey a feeling of concentration. The subtle smile, which lights the face, creates the feelings of compassion and understanding expected of Buddha. The mood of tranquility and assurance is transmitted to the viewer at once, presenting a spiritual image of the master that bespeaks the sensitivity of the Gupta artist.

Buddha's hair is arranged in snail-shell curls, with an auxiliary brain *(uṣṇiṣa)* at the top of the head, usual for representations of Gupta buddhas. The ears once had long earlobes, which have been broken off. There are three "beauty lines" on the neck, yet another standard Gupta feature.

The red mottled sandstone quarried at Sikri near Mathura, implies that the atelier responsible for this head was Mathura. The spiritual content of the head and its facial features are universal for both Mathura and Sarnath schools—the two most active centers of production during the Gupta period. Only the material distinguished them, the buff-colored Chunar sandstone typical for Sarnath and the reddish, often-mottled Sikri sandstone characteristic of the Mathura style.

While the physical perfection of the facial features is by no means neglected here, the spiritual content has priority. Literature dealing with the Gupta period often defines it as the "conquest of mind over body," which sums up well the achievement of the Gupta artist who attained a perfect balance between spiritual and physical beauty. S.C.

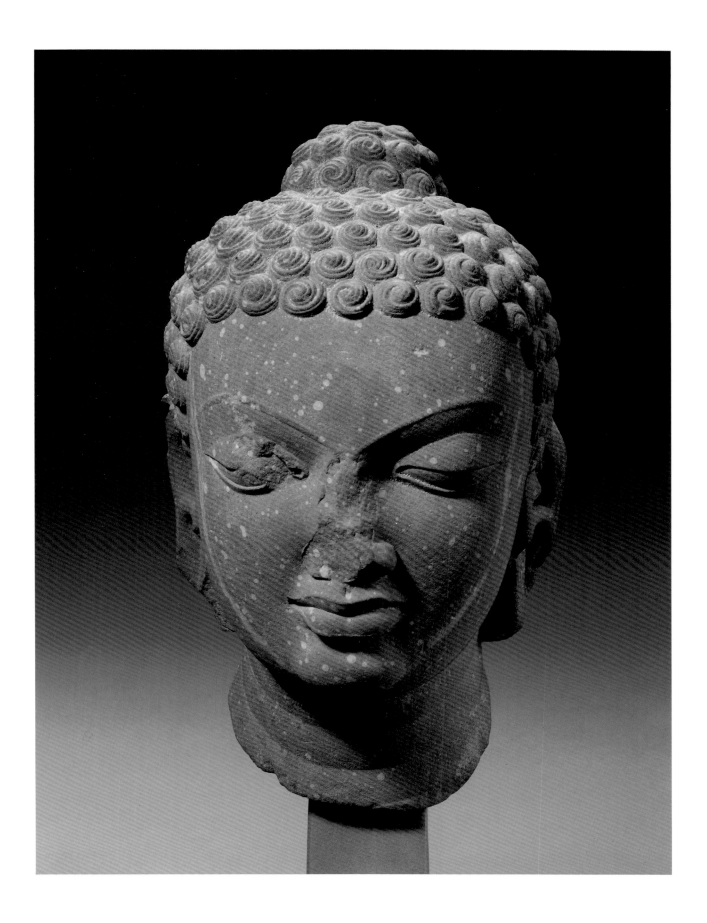

INDIA, GUPTA PERIOD, DATED AD 591

BRONZE; H. 46 CM

PURCHASE FROM THE J. H. WADE FUND 1968.40

While metal sculpture of the Gupta period is rare, what makes this bronze even more unusual is its dated inscription. Information provided by the lengthy inscription engraved on the base suggests that the sculpture was inscribed in ancient Patan (Kathmandu) in Nepal. Thus it was either produced in Nepal or, if made in India, carried to Nepal and inscribed there. If the former is the case, historians could conclude that the early Licchavi style in Nepal (examples of which barely survive) was practically identical to the Sarnath style of Gupta India.

The transparent garments of the Buddha, the modeling of his body, and his stance closely reflect the Sarnath style. The facial features, however, are more fleshy than classical Sarnath and may suggest that if indeed the piece was cast in India, Sarnath proper may not have been where it was made. The most likely solution is that it is a product of one of the local ateliers under strong Sarnath influence. s.c.

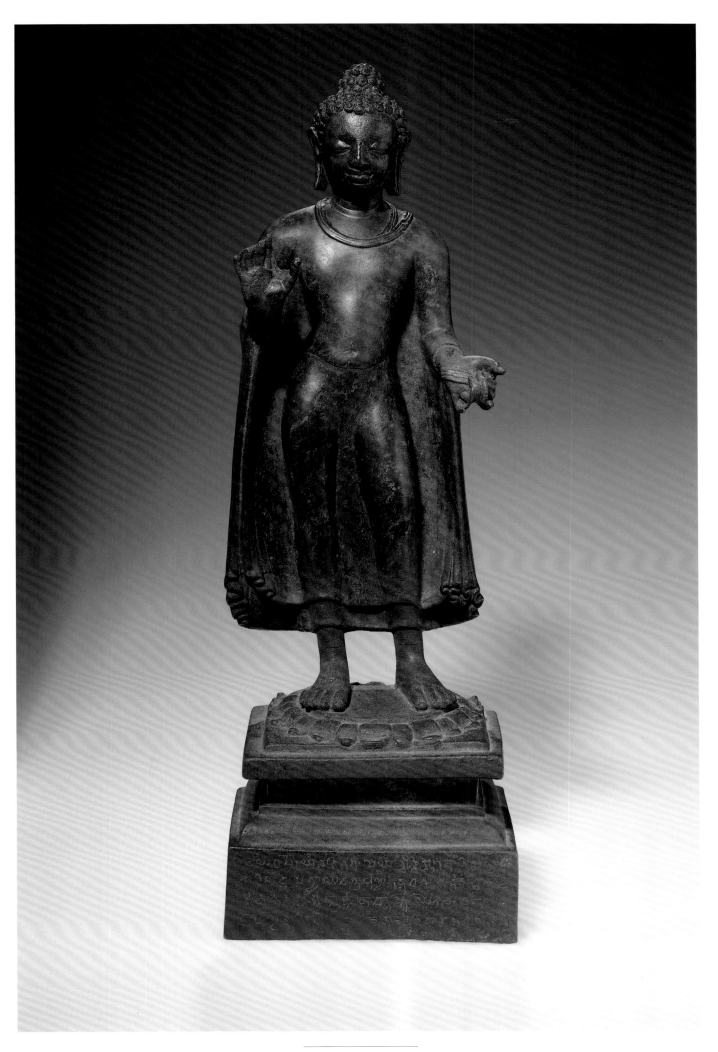

INDIA, MADHYA PRADESH, VIDISA DISTRICT, BESNAGAR, GUPTA PERIOD,

4TH CENTURY

SANDSTONE; H. 40.6, W. 38.1 CM

JOHN L. SEVERANCE FUND 1969.57

Vedic Hinduism, formulated in India in the second millennium BC, provided the foundations for the Buddhist faith that dominated the early centuries of Indian art. Hinduism regained its prominence again during the medieval period. The Gupta age marks the time of that transition when Buddhism was still at its height and Hinduism made its spectacular reappearance for the first time.

The monumental head seen here provides a magnificent example of the sculpture of this early Hindu revival. The heavy squarish crown *(karaṇḍamakuṭa)* with ribbons on the side and a lion's face *(siṁhamukha)* in the center of a lotus medallion is typical for the gods Vishnu or Surya. It is not possible to determine which is depicted as nothing from the body of the image survives to provide positive identification. These deities are closely related, however, with Surya being frequently considered an emanation of Vishnu. The hair is rolled up at the back and strings of pearls are twisted around it.

While the oval face with almond-shaped eyes, straight nose, and sensuous lips introduces a new Gupta idiom, the head still retains enough Kushana characteristics to allow dating it to the early Gupta period. Furthermore, the relief of Vishnu from cave 6 in Udayagiri in the Vidisa District of Madhya Pradesh, dated by the inscription to AD 401, displays close stylistic relations with this sculpture. The head reportedly came from the Triveni temple at Besnagar situated in the Vidisa District, not far from Udayagiri.

The inspiring spiritual expression of the face characterizes Gupta sculpture. It is achieved by the same means evident in the head of Buddha on page 129 where the subtle smile lightens the face, conveying a feeling of peace and compassion. S.C.

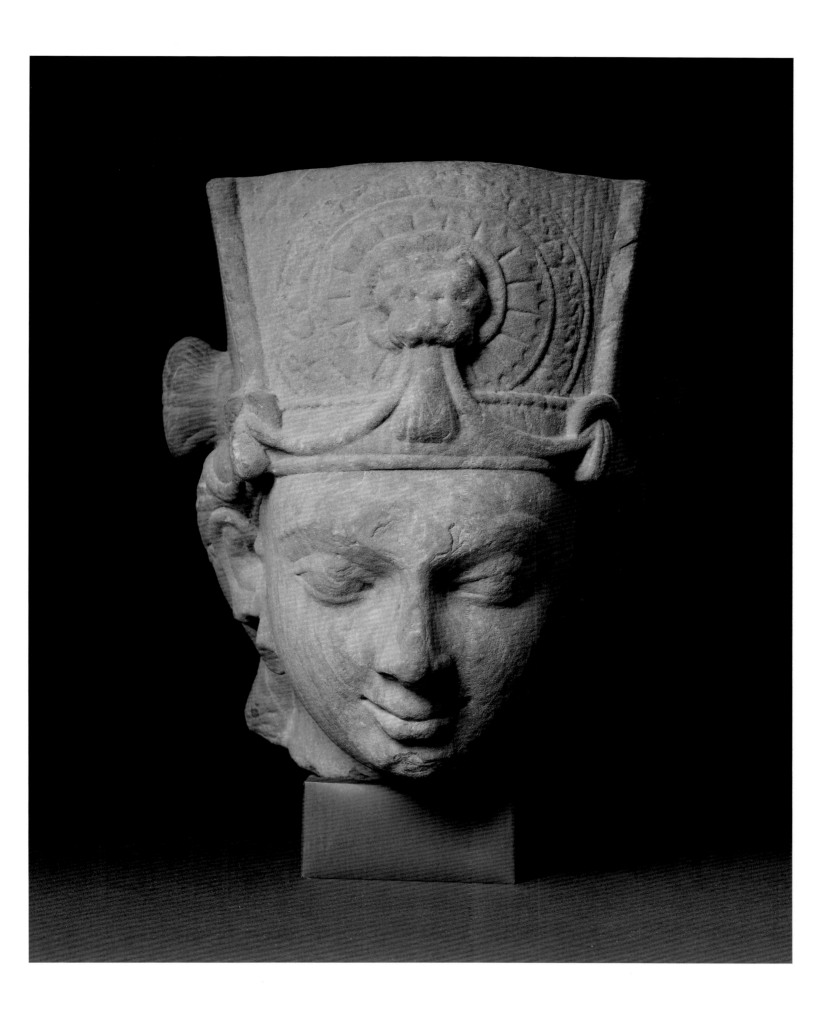

A Mother and Child *(Mātṛkā)*

INDIA, RAJASTHAN, TANESARA–MAHADEVA, GUPTA PERIOD, LATE 5TH–EARLY
6TH CENTURY
GRAYISH-GREEN SCHIST; H. 79.4 CM
PURCHASE FROM THE J. H. WADE FUND 1970.12

This lovely image of a mother-goddess with a child formed part of a popular Hindu iconography of the seven mothers *(Saptamātṛkā)*. It came originally from a group in the village of Tanesara-Mahadeva, in the vicinity of Udaipur. Two other well-known sculptures from the same set are in the Los Angeles County Museum of Art. The voluptuous goddess holds the child standing at her side by the hand, trying to restrain his playful mood. The semismiling expression on her face indicates her affection for the child. Her grace, easy relaxed posture, and the "psychological" connection between the figures classify it as one of the most compelling representations of mother and a child in Indian art. She could compete very successfully with the best representations of Christian Madonnas. In fact, this parallel seems particularly appropriate, considering the style of the sculpture, which was under strong Western influence. The village of Tanesara in Rajasthan is geographically not too far removed from the Gandhara region, nor is the time of the sculpture's execution. Thus, the intermingling of Gandharan and Gupta influences is responsible for this unusually naturalistic depiction of the subject matter.

While the mother goddess cult can be traced back as far as the Indus Valley civilization, in later periods the *Saptamātṛkā* are represented as the consorts *(śakti)* of various Hindu gods. In the instance of the Tanesara-Mahadeva set, however, there are no attributes or vehicles *(vāhana)* that would allow specific identification. Consequently, they are sometimes simply referred to as the mothers of the god Skanda *(Skandamātā)*. S.C.

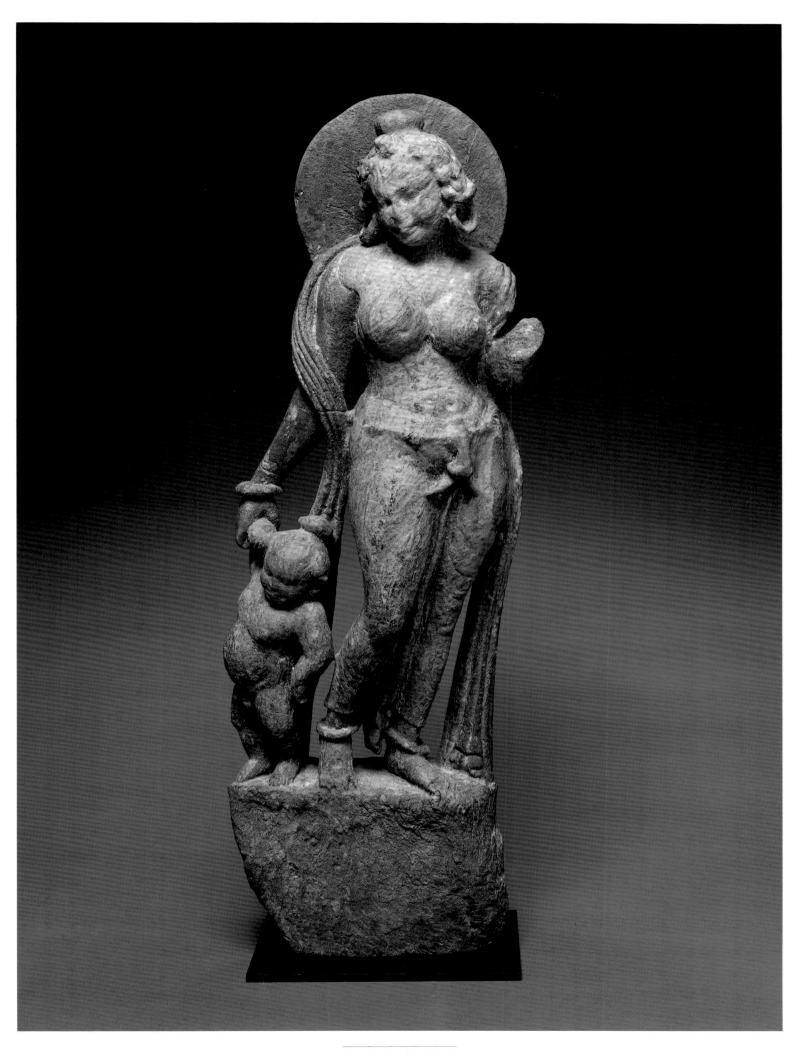

EAST INDIA, BIHAR, POSSIBLY NALANDA, MEDIEVAL PERIOD, PALA DYNASTY,

9TH–10TH CENTURY

BLACK CHLORITE; H. 94 CM

DUDLEY P. ALLEN FUND 1935.146

Although early Indian art is dominated by Buddhism, by the seventh century the religion survived only in its original home, Magadha, today the states of Bihar, Bengal, and Bangladesh. Hinduism, which replaced Buddhism at the time in the rest of India, to some degree left its mark on eastern India as well, but this part of the country remained the stronghold of the Buddhist faith.

Buddhist images produced under the auspices of the Pala dynasty represent a late form of Buddhism known in India as Vajrayana or Tantric, after *vajra* (scepter in the shape of a thunderbolt), or *tantra* (scripture). This form of Buddhism was strongly influenced by the newly revived Hinduism, and consequently one frequently finds deities with many arms as well as ferocious looking representations of protectors of the disappearing faith. The Pala style continued to a great extent the Gupta tradition of plasticity and three-dimensionality but became harsher in execution and, with time, richer in ornamentation. The typical images of Buddha, especially in the early Pala style, still owed a great deal to Gupta influence. In turn the Pala school provided inspiration for both early Himalayan and Southeast Asian art.

This beautiful high-relief stele depicts a subject favored by Pala Buddhist sculptors—the moment of Buddha's enlightenment. In Gupta art, seated images of Buddha from Sarnath (where Shakyamuni preached Buddhist doctrine for the first time) most frequently show him with his hands in a preaching gesture *(dharmachakra* mudra); in Pala art (where the most important place of pilgrimage was Bodh Gaya—where Shakyamuni achieved his enlightenment) he is shown with his hands in the earth-touching gesture *(bhūmisparśa)* and meditation *(dhyāna)*, signifying the stages leading to his enlightenment. While seated cross-legged in mediation under the bodhi tree (here shown above his head), the buddha-to-be was tempted by the evil forces of Mara, who tried to prevent his enlightenment. The earth-touching gesture refers to the temptation—when Buddha touched the ground calling the earth goddess, Bhumi Devi, to witness his temptation.

Buddha is seated on a double-lotus flanked by two standing buddhas clothed in transparent garments. The central image wears a monastic robe *(sanghāṭi)* with carefully marked folds that reveals the modeling of the body underneath. The great plasticity and sensitivity in the sculptural rendering of this image and the similarity of the side buddhas to Gupta-Sarnath images, indicate an early date for this stele, no later than the ninth to tenth centuries. Similarly the round top is characteristic of early Pala pieces. In later examples stelae become pointed at the top and more stylized and mannered. Buddha's throne is supported by an elephant flanked by two lions, symbols appropriate to the Shakya clan. Framing the lions on both extremes are ascetic figures: one bearing a garland, another worshiping with his hands clasped in the *namaskāra* gesture. Ornamental foliage decorates the back of the throne and a halo with flying celestials *(vidyādharas)* encircles Buddha's head.

The inscription in the lotus petals of the image quotes a Buddhist credo proclaiming: "States of being which arise from a cause—their cause the Tathagata has told; and also their cessation—thus the Great Monk speaks." The other inscription above the niche with the elephant, has thus far eluded translation. S.C.

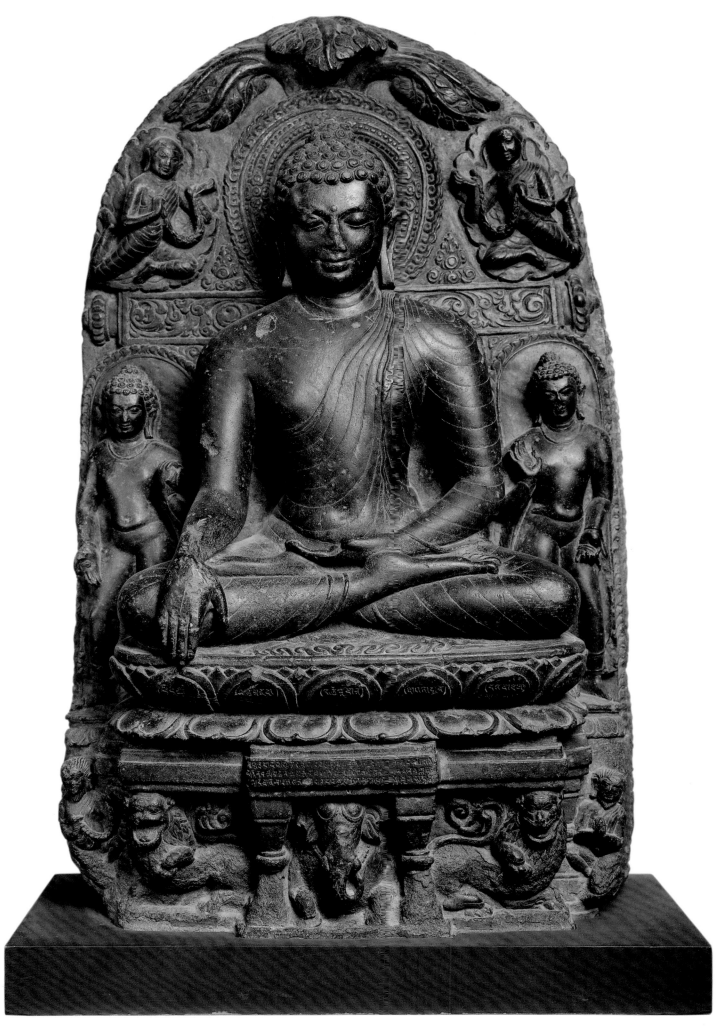

EAST INDIA, BIHAR, KURKIHAR, MEDIEVAL PERIOD, PALA DYNASTY, LATE
9TH CENTURY
BRONZE WITH SILVER AND COPPER INLAY; H. 39.4, W. 26.6 CM
PURCHASE FROM THE J. H. WADE FUND 1970.10

This image of a seated buddha could be considered a bronze equivalent of the stone stele of Shakyamuni triumphing over Mara (see page 137). It represents Akshobhya, who presides over the Eastern Paradise. He is one of the five Dhyani (Meditative Buddhas) identifiable by his *vajra* (a scepter in the form of a thunderbolt) in front of him. His position, hand gestures, and a double-lotus throne supported by lions are all closely related to the stone stele, except that the image here is cast in bronze.

Metal sculpture was very popular in Eastern India, which is known for its rich ore deposits. Because it is easily portable and because the technique allows great fluidity in execution, bronze sculpture is popular in Pala domains.

The lost wax technique—where an image is fashioned in wax over a core, encapsuled in a clay mold, the wax then melted and replaced by molten metal— allows great refinement in execution and richness of detail. Frequently metal inlay is used, as in this case, where the *ūrnā* (a whorl between the eyebrows) and eyes are made in silver while the lips are in copper. Pala bronzes consist of alloys of different metals, usually eight (according to ancient manuals), with copper dominating. The bronzes were usually gilded, though the gilding is now frequently gone. Except for small pieces they are hollow cast.

The two most important sites for production of metal images in the Pala kingdom were Nalanda and Kurkihar, represented by the present bronze. Nalanda images are earlier (early to mid-ninth century), and are usually smaller and closer to the Gupta style, while later Kurkihar bronzes (late ninth to tenth century) are larger in size and much more elaborate. The figures are usually placed on richly decorated thrones. The stylization of the image—long arms, broad shoulders, tapered torso, beak-like nose—are the features of developed Pala style, which left its mark on the Buddhist sculpture outside India. The Thai Sukhodaya style is a good example of this influence.

Aside from the highly accomplished formal appearance of Pala images, they successfully convey a spiritual message. Great compassion and serenity radiate from this image, features that are encountered only in the finest religious icons of any given culture. s.c.

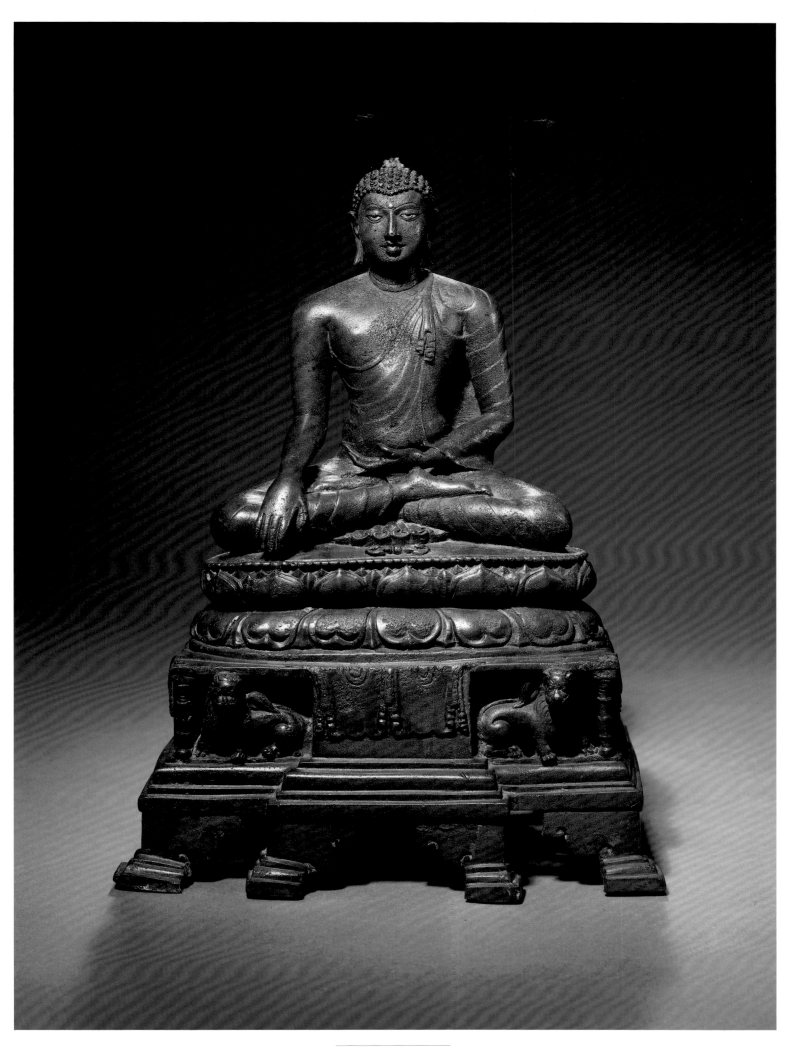

One-Faced Linga *(Ekamukhalinga)*

EAST INDIA, BIHAR, MEDIEVAL PERIOD, PALA DYNASTY, 7TH–8TH CENTURY

BLACK CHLORITE; H. 83.8 CM

JOHN L. SEVERANCE FUND 1973.73

Unlike the other Pala sculptures (see pages 137 and 139), which were Buddhist, this one is a Hindu image representing a phallic emblem of Shiva, a symbol of his procreative energy. During the medieval period in India, when Hinduism was a dominant religion, linga(s) were the most sacred and revered images placed in the innermost sanctums of temples. The version seen here is known as *mukhalinga*, where the linga is adorned with one or several heads of Shiva. In some instances it may be adorned with as many as five heads. In this case the front of the linga has only one head, so it is referred to as *ekamukhalinga*. The linga seen here is square at the base, octagonal in the middle of the shaft and round at the top. Originally probably only the topmost cylindrical part of the linga, and possibly its octagonal portion, was meant to be seen, while the base was buried or set into a yoni (a symbol of the female generative organ) that served as a pedestal for a linga. That is why the square base shows definite chisel marks and was left rough and unpolished. Today the octagonal portion also shows signs of burial in the form of earthy encrustation. Contrary to that, the topmost, visible part was highly polished and it still retains this finish today.

The god wears a high symmetrically arranged chignon *(jaṭāmakuṭa)* with his symbols: a crescent in his hair and a snake, both of them on the proper right side of the head. He has a large third eye in the center of his forehead.

The full, sensuous facial features still retain a great deal of Gupta feeling about them, at the same time revealing a certain degree of sharpness found in Pala and later Sarnath sculptures. Shiva wears heavy earrings of the *makara-kuṇḍala* type, in the form of an aquatic monster, and a single-string beaded necklace *(ekavali)* with a prismatic bead in the center. S.C.

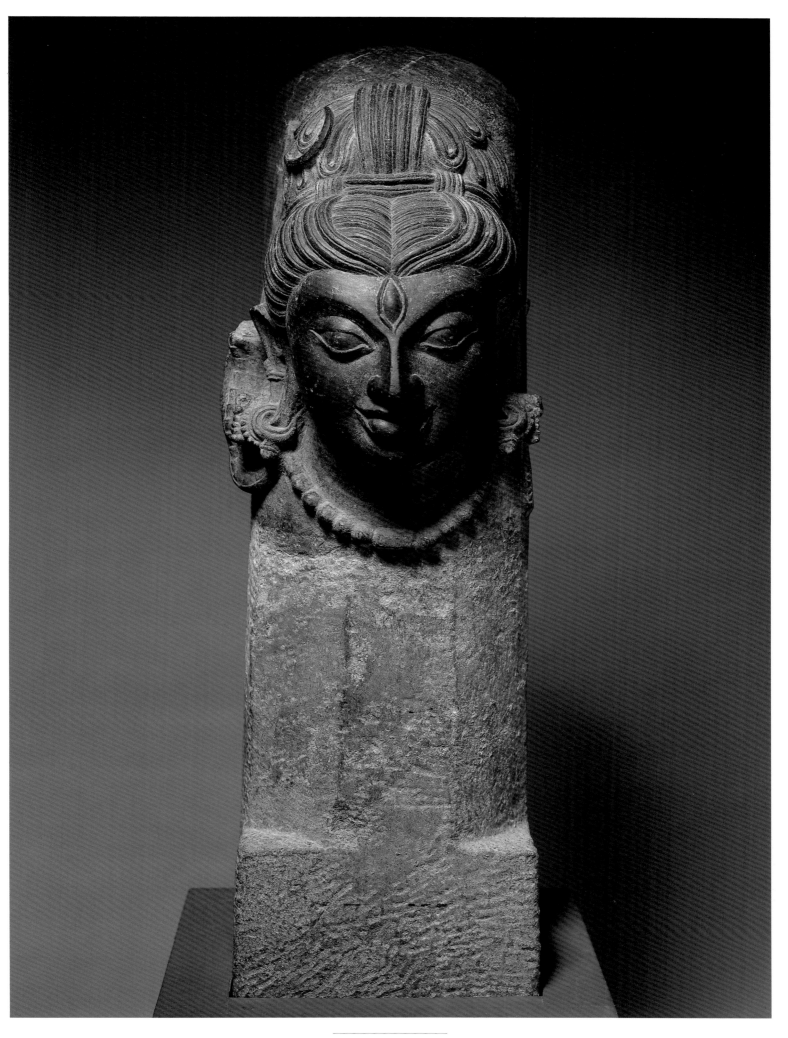

Lovers *(Mithuna)*

INDIA, MADHYA PRADESH, KHAJURAHO, MEDIEVAL PERIOD, CANDELLA DYNASTY,
11TH CENTURY
RUST COLORED SANDSTONE; H. 74 CM
LEONARD C. HANNA JR. FUND 1982.64

The function of many Hindu sculptures of the medieval, or Hindu dynasties, period (from the sixth century onward) was to decorate the exterior walls of temples. A great profusion and variety of sculptures gave those monuments an exuberance unequaled during any other period.

The Hindu temple was a favorite community meeting place and these sculptures inspired and instructed the populace and were admired by thousands of viewers. The monuments well known for this profusion of sculptural decoration are the temples of Khajuraho, which represent the "erotic genre" of sculpture, very popular in medieval India.

The amorous couple is a very ancient and popular theme in Indian art. During the period of the Hindu dynasties, however, this subject takes on an especially erotic connotation to which various factors contributed. Some see it as the symbolic union of the soul and the divine stimulated to a degree by Tantric rituals and practices, others speculate that it was the result, or product, of a contemporary society. Practices such as temple prostitution and the popularity of the love-manual, *Kamāsūtra*, must have greatly contributed to the interest in this subject matter.

The temples of Khajuraho in Madhya Pradesh, built under the auspices of the Candella dynasty (tenth to eleventh centuries), and the Sun Temple in Konarak, a product of the Ganga dynasty built in the fourteenth century, are the best known monuments of erotic sculpture. The present sculpture represents a typical Khajuraho style. The couple is shown in an embrace, kissing, while the male, whose masculinity is emphasized by a beard and mustache, is about to disrobe his partner. The female's clothing consists only of a transparent muslin skirt, hardly covering her thighs. Her passion is emphasized by the rapid twist of her body and the upward turn of her head. This rapid movement and the almost angular position of the limbs, which emphasizes the movement, are characteristic of the Khajuraho sculpture. The two figures are totally engrossed in each other—connoting gentle eroticism. s.c.

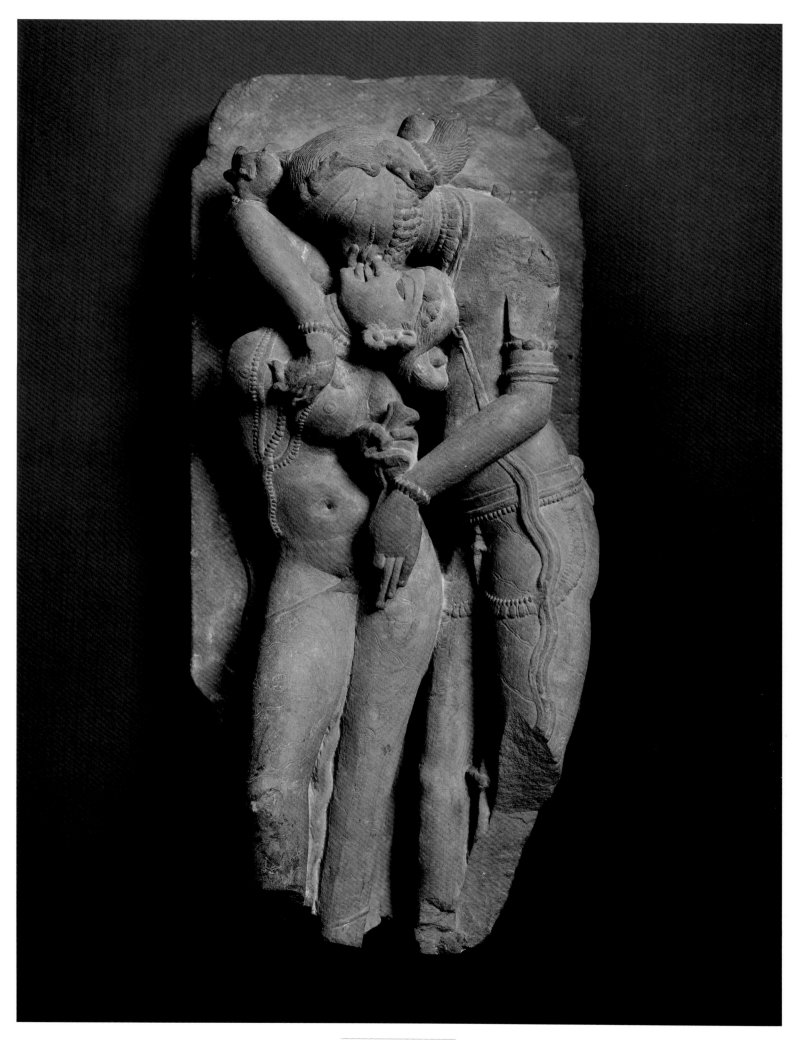

Vaishnava Trinity (Shri Devi, Vishnu, Bhumi Devi)

SOUTH INDIA, MEDIEVAL PERIOD, CHOLA DYNASTY, FIRST HALF OF THE
10TH CENTURY
GRANITE; H. 175.9 (CENTER FIGURE)
JOHN L. SEVERANCE FUND 1963.104–1963.106

This important large trinity of the Hindu god Vishnu (the preserver) with his two consorts, Shri (the goddess of beauty and wealth) and Bhumi (the earth goddess), is representative of the early phase of Chola art. The Chola empire in South India flourished from the tenth through the thirteenth centuries.

The sensitive sculptural rendering of the images—the slightly more hieratic central figure of Vishnu and his gracefully swaying companions—is typical of the early Chola period. The four-armed Vishnu stands erect on a double-lotus base (in *samabhanga* stance) with his front right arm in a gesture of assurance *(abhaya)* and his left resting on his hip *(katyavalambita hasta)*. His upper right arm carries a wheel *(chakra)* and the left a conch *(śanka)*. He wears a high crown *(kiritamakuta)* and elaborate jewelry: earrings, necklaces, sacred thread, armlets, bracelets, anklets, and a girdle with lion's mask *(simhamukha)*.

His companions' postures, however, are relaxed, their inner hands hold lotus buds, outer ones rest on their hips in the *katyavalambita* gesture. Bhumi Devi, in addition to regular ornaments, wears a jeweled breastband typical of this goddess.

While granite is one of the hardest stones to work, it did not seem to have restrained the Chola artist's creativity in this instance. The images at once display physical beauty (the richness of ornamentation contrasting very effectively with the "softness" of the flesh) and spiritual content. The elegant elongations of the figures, and the grace and ease that permeate these pieces, classify them as some of the most accomplished sculptural representations of the Chola style. S.C.

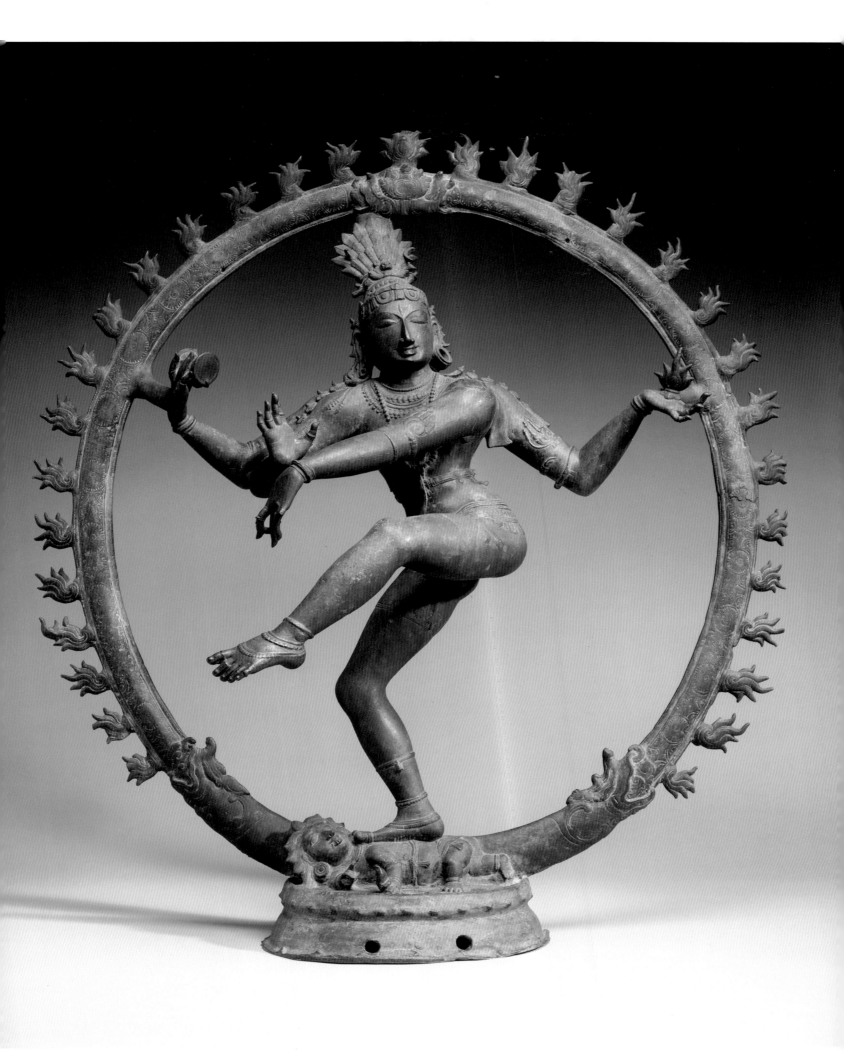

Shiva's Trident with Ardhanarishvara (Half Shiva/Half Parvati)

SOUTH INDIA, MEDIEVAL PERIOD. CHOLA DYNASTY, 11TH–12TH CENTURY

BRONZE; H. 39.6 CM

PURCHASE FROM THE J. H. WADE FUND 1969.117

The *triśūla* (trident) is one of the attributes of Shiva. In the context of this sculpture it was probably set on a wooden pole and used in a temple's ritual processions. Here it is enhanced with the figure of Ardhanarishvara (a combined form of Shiva and Parvati) wherein the proper right side of the body is that of Shiva and the left Parvati, representing masculine and feminine aspects of the god in union—which on a symbolic level equals the union of a worshiper with a god.

Shiva's part of the body has two arms (half of the usual four) one holding an axe *(paraśu)*, while Parvati has only one; the Shiva side of the body is clad in a dhoti (loin cloth), while Parvati wears a long skirt; Shiva's hair is pulled up in a high coiffure *(jaṭāmakuṭa)*, while Parvati has a conical crown and a round earring in her ear. The body of the image is dramatically flexed in the *tribhaṅga* (three-bent) posture, especially pronounced on Parvati's side. Her hip is thrust to the side with the weight of the body resting on her leg, while Shiva's leg is slightly bent and relaxed. Behind the androgyne figure is the bull, Nandi, which usually accompanies Shiva and Parvati.

Tridents of this type are extremely rare, especially when enhanced by sculptural representations. This is a particularly fine example in terms of its execution and style, representing the fully mature Chola style, when some of the best bronzes of that school were produced.

The additional enhancement of this bronze is a beautiful jade-green patina. The metal alloy used in Chola bronzes is often prone to this type of patina, which forms with the passage of time. S.C.

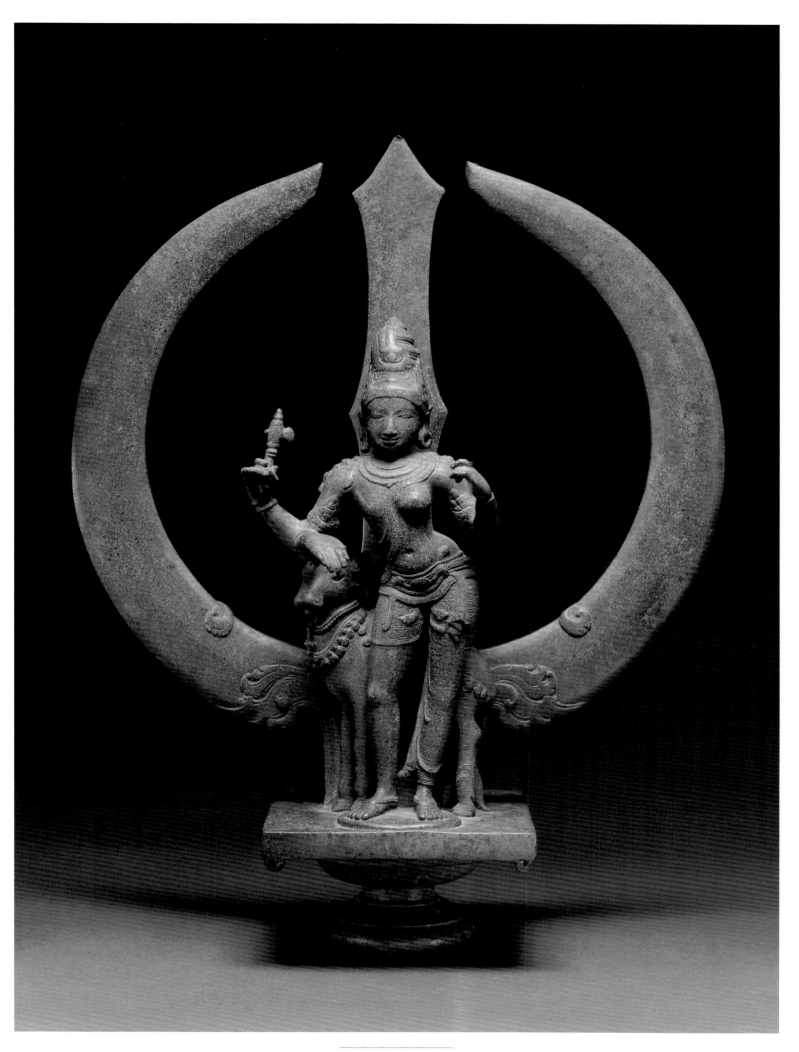

Ganesha

SOUTH INDIA, MEDIEVAL PERIOD, CHOLA DYNASTY, 12TH CENTURY

BRONZE; H. 50.2 CM

GIFT OF KATHARINE HOLDEN THAYER 1970.62

This bronze of the elephant-headed god Ganesha has the same type of jade-green patina as in the bronze of Shiva's trident (see page 149) and also represents the mature and very accomplished Chola style. One of the most auspicious and revered in the Hindu pantheon, this delightful deity represents the god of wealth and abundance. He removes obstacles and offers all kinds of protection to his worshipers; consequently his name is invoked on any given occasion, be it birth, wedding, housewarming, or commencement of any project. His rotund body and the dish of sweets he holds in his lower left arm symbolize his prosperity. Other hands hold a *pāśa* (noose), a *paraśu* (axe), and his broken tusk.

While many myths describe how he became the composite of an elephant and a man, the most common version relates the story of how he was decapitated by his father, Shiva, in a rage of fury and restored to life by the intervention of his mother, Parvati. Shiva agreed to revive him with the head of the first creature encountered, which happened to be an elephant.

With such colorful mythological fables behind this iconographical depiction, the concept of a god in animal form is utterly Hindu and not easy for Westerners to comprehend. If one bears in mind, however, that according to Eastern religions reincarnation can occur in either human or animal form and that the image is a purely symbolic representation of a deity—the concept of worshiping the god in any given form becomes more understandable.

Ganesha's vehicle is a rat or mouse, not present in this image. The idea of opposites such as an elephant (one of the largest living creatures) coexisting peacefully with a rat (one of the smallest animals), the profound spiritual knowledge for which Ganesha is known, his fondness for food, and his connoisseurship as a dancer and awkward roundness may teach even Westerners a lesson: extremes can coexist in this world in perfect harmony. S.C.

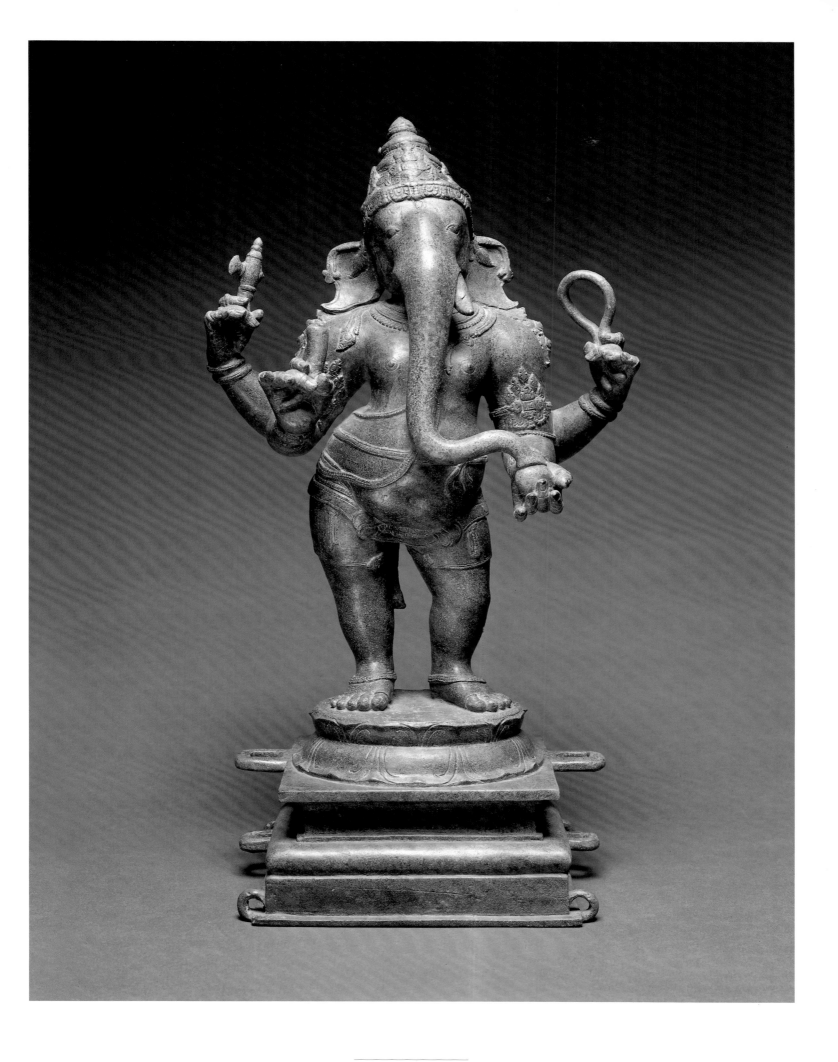

Fasting Buddha

KASHMIR, 8TH CENTURY

IVORY; 12.4 X 9.5 CM

LEONARD C. HANNA JR. FUND 1986.70

After the Begram ivories (see page 123), the second largest group of ancient ivories from the Indian world that survives is from Kashmir. Unlike the Begram ivories, which were secular, Kashmir ivories are exclusively Buddhist and most were produced in ateliers active in the eighth century. As suggested by a couple of surviving examples (one in the British Museum and another in private collection in India), they were conceived as small portable altars. A larger central plaque, such as the one seen here, was set in a painted wooden architectural shrine and flanked by two smaller ivory figures of attendants. Although only two complete shrines are known today, several ivory plaques and attendant figures still survive. The ivory here (one of two owned by the museum) is unusual in terms of its iconography since it shows Buddha as a fasting ascetic. This iconography, while popular in Gandharan art, was not commonly found outside this school. Buddha sits within the trefoil-arched cave in the *dhyānāsana* position, with his hands folded in his lap in the meditation gesture. His emaciated body with the conventional but effective skeletal-vein structure, sunken stomach, and haggard face are the most successful means used by the artist to portray the haunting image of an ascetic who overcomes the limitations imposed on him by his human form in order to attain higher spiritual values.

In accordance with the rules of continuous narration, the master is shown three times (two figures of Buddha flank the central image). On the left, he is in his emaciated form with his head resting on his right hand supported by his left raised knee, as if exhausted. The female figure immediately below him seems to offer him a rice-filled bowl (like those used by Buddhist monks to beg for food). It may well represent Sujata, who provided Buddha's first meal at the conclusion of his austerities. Here, however, he seems oblivious to her offer. On the right, he is seated in the "European pose" *(pralambapādāsana)* with his legs extending down from the throne, supported by the lotus. Once again well nourished, he is attired in monastic garb, indicating that he has achieved enlightenment. He now holds his begging bowl in the palm of his left hand, while his right, partially broken, is raised to his open mouth in the gesture of eating. Next to him is another female, probably again Sujata. The three Buddhas sit on a cushioned rocky podium. The rock formations among the figures that hover above the central images suggest a cave setting. Also present are celestial attendants on the top, the usual heads of ascetics *(siddhas)* framing the arch, and many yaksha and dwarf-like figures, probably representing the temptation of Buddha by the evil forces of Mara. Although partially damaged in the center, the scene below looks like an ordinary genre scene with multiple figures involved in a lively discussion. Because cows are present and some figures seem to be churning butter *(ghi)*, the scene could depict the household of Sujata's father (who was a cowherd), where the story of Buddha's enlightenment is discussed in vivid terms. It may, however, simply depict villagers and their flock paying homage to Buddha.

The panel is a superb example of refined workmanship, more intricate and delicate than most. This ivory employs a rich *ajouré* (pierced) technique where the perforated areas create a lace-like effect. The plaque curves slightly, following the tusk's natural contour. No traces of paint remain, which may indicate that the piece was cleaned at one point. The ivory has a rich brown patination. s.c.

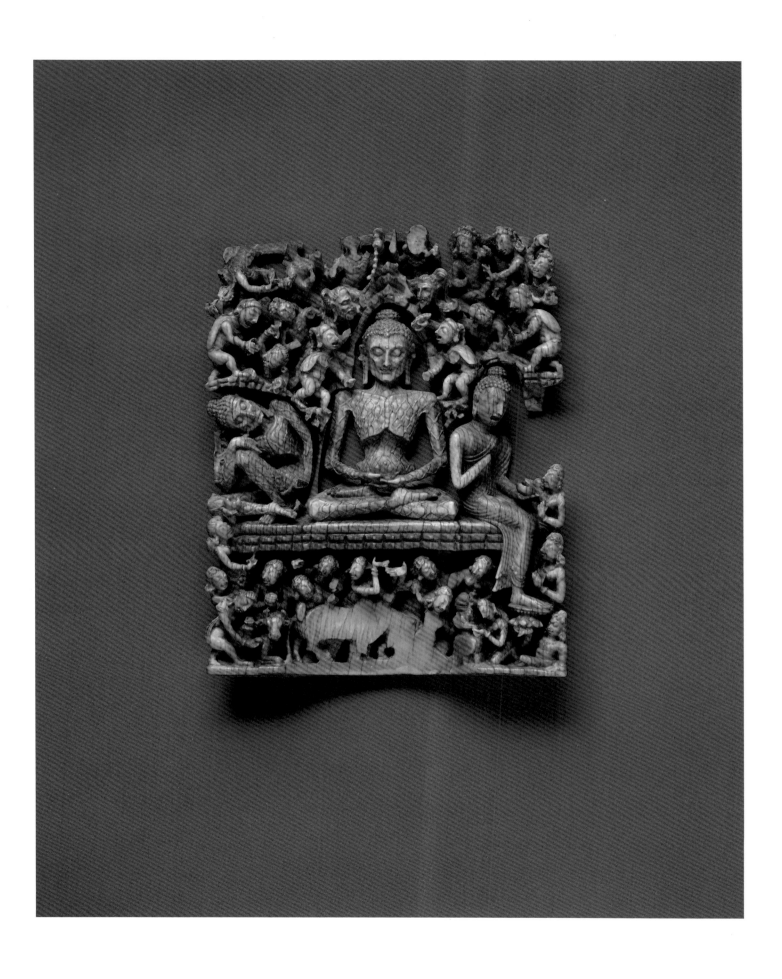

Standing Buddha

KASHMIR, LATE 10TH–EARLY 11TH CENTURY

BRASS; H. 98.1, W. 28.2 CM (AT BASE)

JOHN L. SEVERANCE FUND 1966.30

The northwestern frontiers of India were a melting pot of various cultural influences, and it was also the area responsible for the dissemination of Indian culture to the outside world. During the early centuries of the Christian era, the territory of Gandhara primarily held this distinction, while from the eighth century onward, Kashmir took over the role. The invasion of the White Huns in the fifth century and the Muslim raids in the early eighth century devastated the area and the focal point moved farther northeast, to the then politically more stable Kashmir, ruled by the Karakota dynasty. Some of the most spectacular bronzes produced in the Indian world belong to this school. This style is distinguished by great elegance and sophistication. Its slightly elongated figures combine the naturalistic modeling of Gandhara and the sensuality of Gupta art. This bronze, one of the largest and most important Kashmiri bronzes to survive to this day, provides a spectacular example of this style.

While originally thought to be somewhat earlier, today we are inclined to date it to the late tenth to early eleventh centuries, on the grounds of similarities with some wooden sculptures from the monastery of Tabo, as well as the Tibetan inscription that appears on its base. It refers to "Lha-tsun ['god-monk,' a title used for some monks of the royal linage] Nāgarāja." There is a good chance that he may be identifiable with a personage of that name in West Tibet who dates to the beginning of the eleventh century. This identification, as well as the fact that the inscription is in Tibetan, poses an interesting problem as to whether the image was commissioned by a Tibetan, made in Kashmir and only inscribed in Tibet, or made in West Tibet itself. As time goes by, our knowledge of West Tibetan (Ladakhi) art has expanded and we know today that its early phase is virtually undistinguishable from what used to be considered a "classical Kashmir style." The best examples of that are sculptures such as the Maitreya in Mulbek (dating to about the ninth century) or the murals of Alchi (dating to about the eleventh century). Thus one could argue effectively both points that the image was cast in Kashmir for the Tibetan market or possibly was made in West Tibet, especially since we know that many Kashmiri artists were active there. Considering the proximity of Kashmir and Ladakh it is not surprising to find cultural traditions so closely overlapping. S.C.

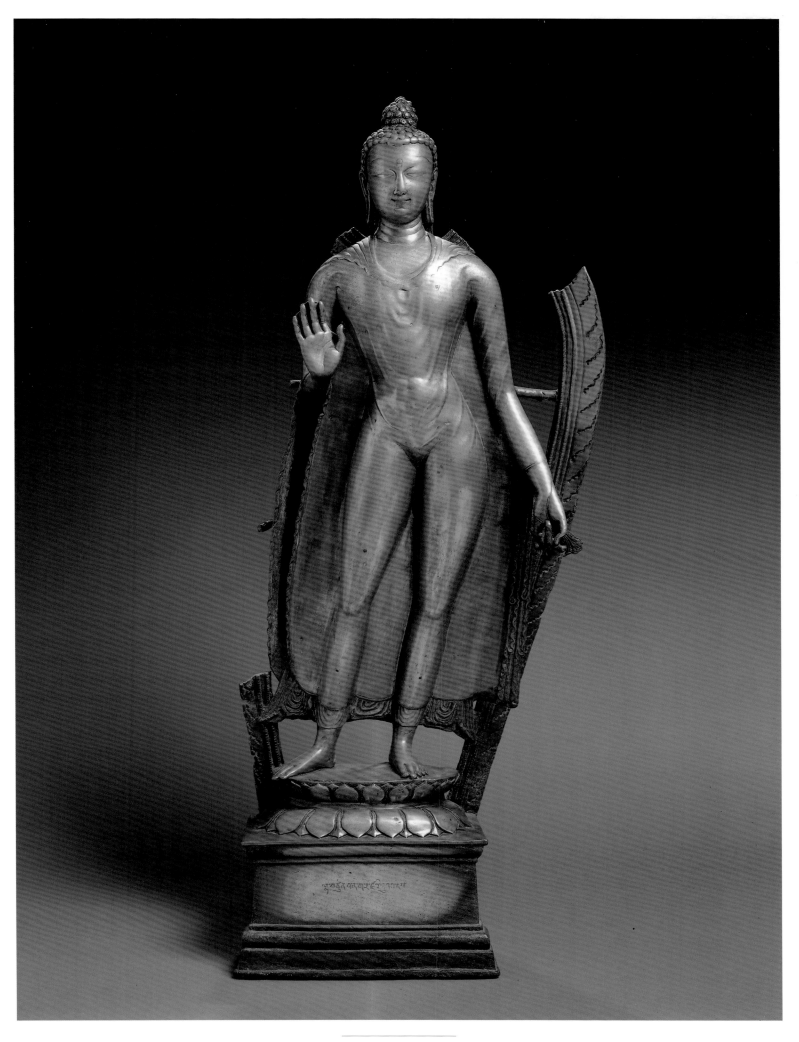

NEPAL, ABOUT 12TH CENTURY

BRONZE; E. 62 CM

JOHN L. SEVERANCE FUND 1976.3

The Nepalese bronze seen here represents one of the most revered Buddhist deities, the Bodhisattva of Mercy, Avalokiteshvara. This iconography is attested by the seated figure of Buddha Amitabha in his crown, always present with this deity.

The image sometimes is referred to as Padmapani (lotus bearer) since the lotus stalk held in his hand is another identifying mark of this bodhisattva. Here it is held in his proper left hand, shown in the flower-holding gesture *(kataka* mudra) although now the stem is broken off. The right hand expresses a boon-conferring gesture *(varada* mudra).

The bodhisattva is clad in a dhoti and adorned with the rich ornaments and the long sacred-thread *(yajnōpavīta)*. The subtle sway of the body gives it a special rhythm and grace, which is further emphasized by the beautiful and spiritualized face, lighted by a compassionate smile. The unusually sensitive rendering of the body, with its smooth and highly polished skin surfaces, contrasts successfully with the sharp definition of the ornaments and clothing, making this image particularly appealing.

The twelfth century was one of the most prolific and accomplished periods in metal casting in Nepal, of which this image is eloquent evidence. Not only is it large (by bronze standards) but technically and aesthetically it is a masterpiece. It is one of the most important and beautiful Nepalese bronzes in existence today.

The technique, as customary, was *cire perdue*, the lost wax method. Finishing touches were then added by hand; here they include an additional inlay of semi-precious stones enhancing the ornaments. As a rule images were gilt, of which only slight evidence remains on this bronze. Yet the high copper content, typical of Nepalese bronzes, gives it an unusually deep brownish coloring that is particularly attractive. S.C.

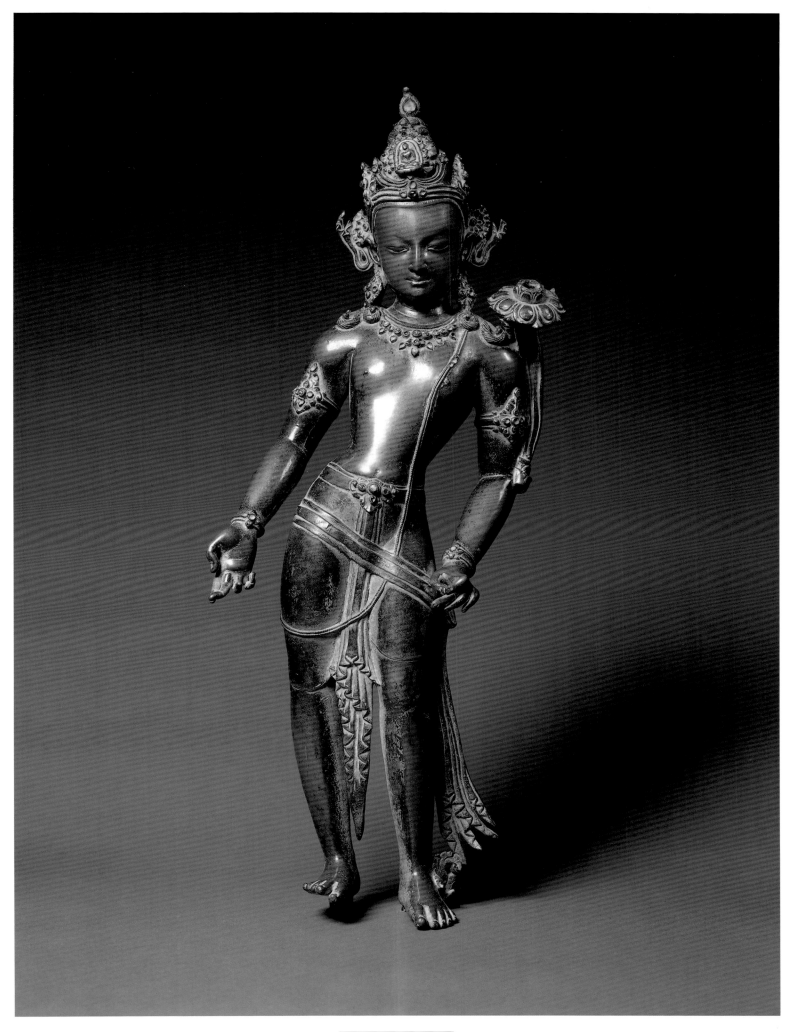

157

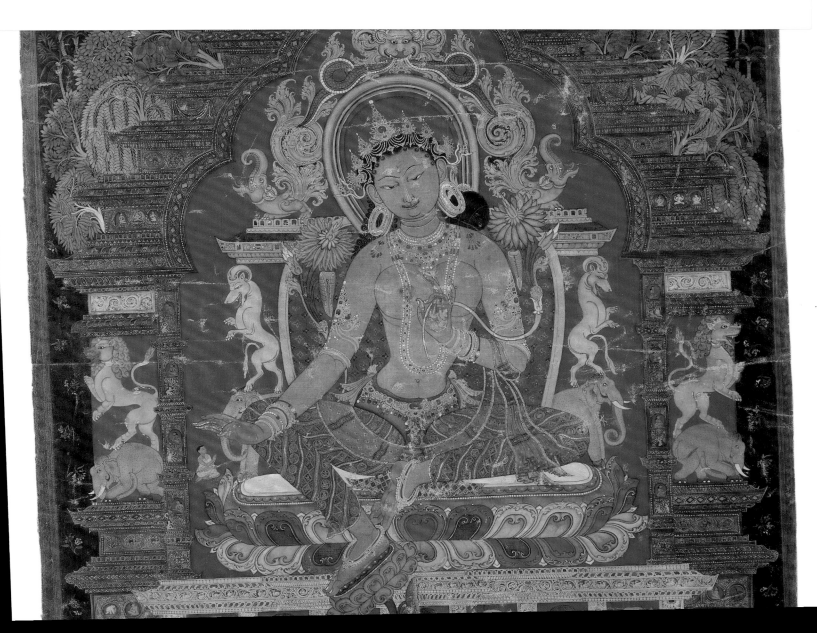

Thangka with Green Tara

TIBET, 13TH CENTURY

COLOR ON CLOTH; 52.1 X 43.2 CM

PURCHASE FROM THE J. H. WADE FUND, BY EXCHANGE 1970.156

Green Tara, or Syama Tara, is one of the most popular deities in Tibet. She is a personification of transcendent wisdom *(prajñā)* who offers protection and salvation to her devotees. While she can take on infinite iconographic variants, here she is shown as Astamahabhaya Tara (Protectress from the Eight Great Perils). The perils are painted on both sides of the doorjambs of the architectural shrine in which she is placed. Behind the shrine are seventeen species of the bodhi tree, each characteristic of a different buddha, which symbolize their enlightenment and emphasize the Green Tara's role as the mother of all buddhas. The largest of the trees, at the top, with gems instead of fruits, can be identified as the wish-fulfilling tree *(kalpa-latā* or *kalpa-vṛkṣa)* (see also page 109, where it was depicted in the form of a creeper rather than a tree). The Green Tara is seated on a double-lotus placed on a base decorated with lions and elephants. Above the image is an arch *(makara-toraṇa)* with the face of glory *(kīrttimukha)* at the top. The arch is supported by rearing rams standing on elephants. Corresponding to it, on the outer wall of the shrine, are upright lions also standing on elephants.

The style of painting shows a strong eastern Indian and, at the same time, Nepalese influence, which not only indicates an early date for the painting when the influence of the Pala style was dominant, but also suggests that the painting belongs to the period when Newari influence in Tibet was particularly strong. Indeed the thirteenth century was such a period, especially when Aniko's studio was active in Tibet and China and when he became much in demand after receiving Kublai Khan's patronage. In fact, the Newari influence is so pronounced in this painting that for the longest time it was attributed to Nepal rather than Tibet.

At the bottom of goddess's right hand is an image of the monk who commissioned the painting, whose identity unfortunately remains unknown. On the reverse is an inscription in Tibetan (another indication of the Tibetan origin of this painting), quoting a Buddhist mantra and a poem. No names of patrons or reference to the date or locality of the painting are contained within the inscription. S.C.

Krishna Govardhana

CAMBODIA, PRE-ANGKOREAN PERIOD, PHNOM DA STYLE, FIRST HALF OF
6TH CENTURY

LIMESTONE; H. 200.8 CM

JOHN L. SEVERANCE FUND 1973.106

This sculpture of Krishna lifting Mount Govardhana represents the god in his aspect as the savior of mankind: by lifting the mountain, he provided his followers with shelter from torrential rains and flooding.

The Phnom Da style that this sculpture illustrates is the earliest phase of Cambodian art and a prototype for later Cambodian sculpture. The sophistication of this precursory style can be attributed to Cambodian artists' knowledge of Indian sculpture, since Southeast Asia was colonized by Indians at that time.

Aside from the great art-historical significance of this image and its rarity (there are only a handful of images of the early Phnom Da style known, most of them in the Phnom Penh Museum in Cambodia), in purely aesthetic terms it is one of the sculptural masterpieces of the world. The plasticity of the body, the physical beauty, and the spiritual content reflect the great influence of classical Indian Gupta style sculpture, which inspired Phnom Da sculpture.

When this image of Krishna Govardhana was acquired by the museum in 1973 from the well-known private collection of Adolphe Stoclet in Brussels, the lower portion of the stele with the legs was missing. Many fragmentary pieces of early Pre-Angkorean sculptures discovered in the hamlet of Phnom Da by the French Archaeological Mission of the École Française d'Extrême-Orient in 1935 had been sent to Stoclet who intended to have them restored. The fragments were so badly broken and in such a poor state of preservation that the task, in the circumstances available to a private collector, proved too onerous. Shortly after Stoclet's attempt, the fragments were abandoned in his garden in Brussels where they lay buried for the next forty-odd years. Subsequently, in 1977 this author "excavated" them, making the restoration of sculpture to its present form possible. S.C.

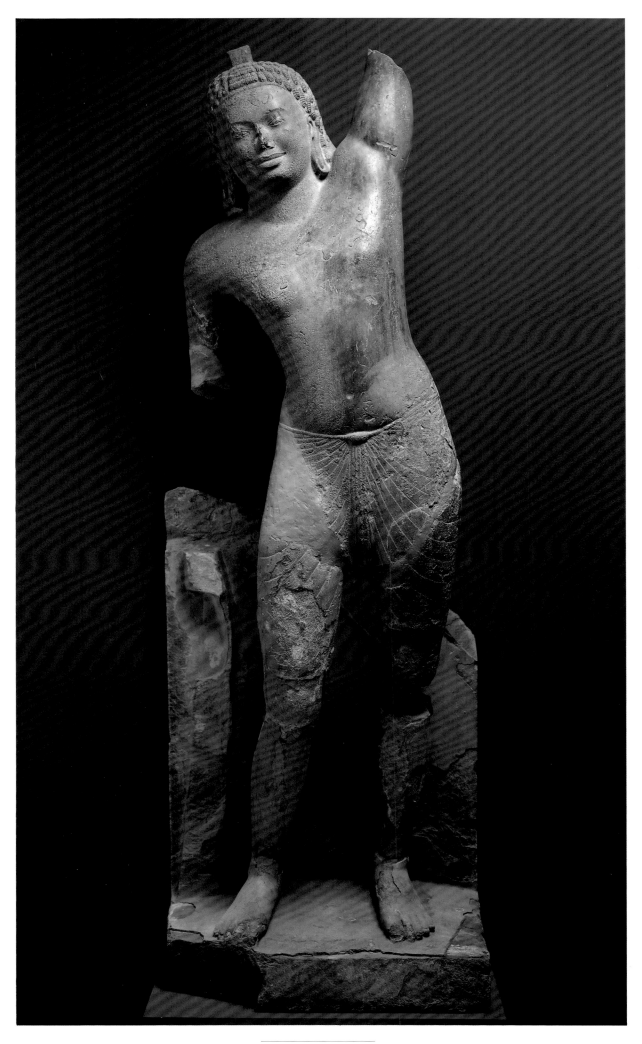

Buddha Sheltered by Mucalinda, the Serpent King

CAMBODIA, ANGKOREAN PERIOD, ANGKOR WAT STYLE, EARLY 12TH CENTURY

BRONZE; H. 58.4 CM

JOHN L. SEVERANCE FUND 1963.263

The Cambodian school of sculpture produced numerous stone images but was equally prolific in the production of bronzes, which became particularly popular during the Angkorean period (ninth to thirteenth centuries). This image represents the height of the Angkorean period and corresponds in date to the erection of the most famous of all Cambodian temples, Angkor Wat.

Buddha is represented in the pose of meditation seated on the coils of the multiheaded serpent Mucalinda. In Cambodia, buddhas are frequently adorned with princely ornaments such as those seen here, including a crown, earrings, necklace, armlets, bracelets, and anklets. He wears a monastic robe drawn over the left shoulder with a rectangular lappet hanging from it.

The figure represents the Buddha of Healing, Bhaishajyaguru, who was the only Buddhist deity popular during the reign of Jayavarman VII (ruled 1181–1219), a Hindu. The medicine jar in the upturned palm of Buddha's right hand verifies this identification. The presence of the *nāga* (snake) symbolizes the protective power associated with serpents. It also refers to a popular story of how Buddha was protected during a torrential rainstorm by a cobra that spread its hood over Buddha's head to provide shelter and prevent the interruption of his meditation shortly before he reached enlightenment.

The figure is a portable image *(chala chitra)* that can be viewed from all sides. It is cast in three parts—the figure, the hollow coils, and the solid hood. There are still traces of gilding on the incisions of the serpent's scales. S.C.

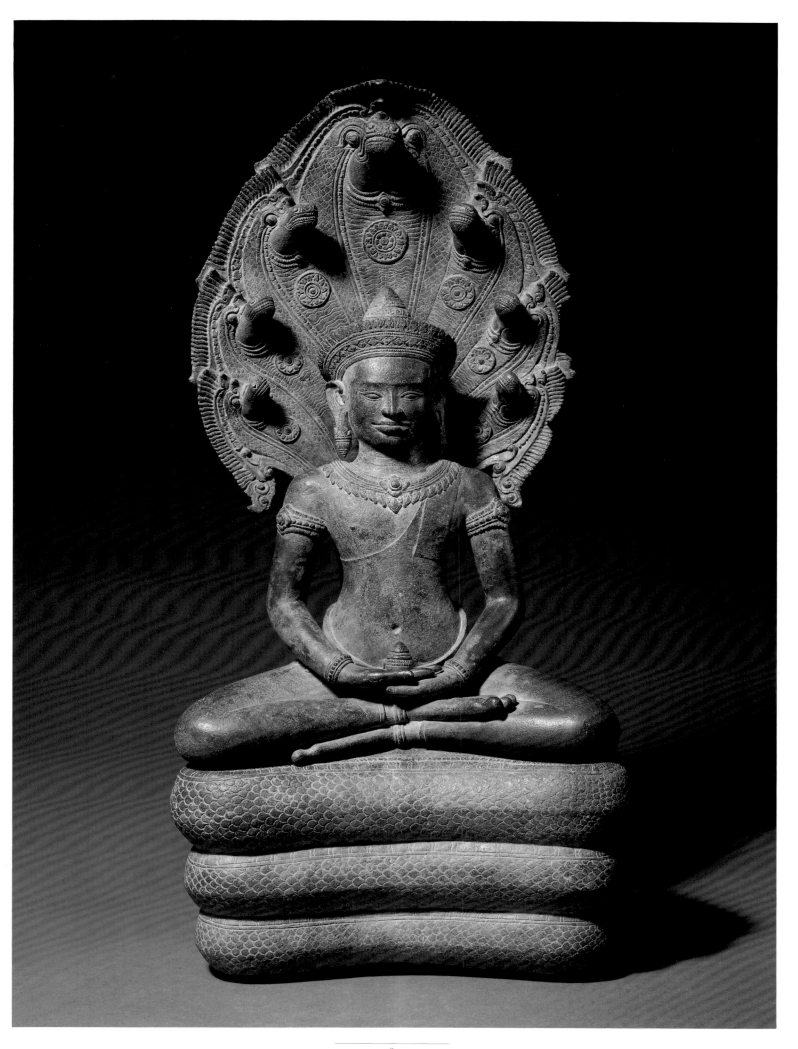

Buddha

THAILAND, PROBABLY SHRI THEP, MON-DVARAVATI STYLE, ABOUT 7TH CENTURY

SANDSTONE; H. 132.7 CM

LEONARD C. HANNA JR. FUND 1973.15

This exceptionally beautiful and monumental sculpture depicts a standing Buddha with his body gracefully flexed in the *tribhanga* posture. Although his hands are now broken off, the arm positions indicate that the right one was once in the *abhaya* mudra while the left one supported the hem of his monastic garment. These hand positions, like the stance, are typical for the Sarnath school of sculpture in India, which was the source of inspiration for this image.

The connection with Sarnath indicates an early date, before the "national" characteristics of the Dvaravati style were formulated. The standard later images of Dvaravati Buddhas show a rigid frontal position, with both arms bent at the elbows, on a parallel level, displaying the *varada* mudra (blessing gesture). In fact, if it were not for the head of this image, which displays broad Mon facial characteristics, a purely Siamese feature, the image could almost have passed as a product of the Sarnath school.

Another unusual feature of this Buddha is the refined treatment of the details such as the collar and shoulder bones, the cleavage in the center of the rib cage, and the rendering of the kneecaps. Entirely unique is the full modeling of the back with its subtly curved spine. This author, aware of only one other Dvaravati image of Buddha with a modeled back, believes this feature is a landmark of sculptures produced in the Shri Thep atelier in Petchabun province in north-central Thailand. Shri Thep was an important center on the trade routes between the Menam and Mekong valleys, an area adjacent to the ancient Dvaravati and Funan empires. This local principality was exposed to both influences, which it then transformed into an idiosyncratic style of its own. It is likely that Shri Thep started as an Indian settlement because all the sculptures have in common a strong dependence on Indian prototypes (as does the Cambodian image of Krishna, see page 161).

Following the historical assumption that Dvaravati broke from the Funanese empire and gained its independence in the seventh century, as attested by Chinese chronicles, one can speculate that would have been the most appropriate time for Shri Thep to have received the Dvaravati Buddhist influence as well as the time this image was conceived.

When the sculpture entered the museum, the base with the feet was missing. It was later found and joined with the body. S.C.

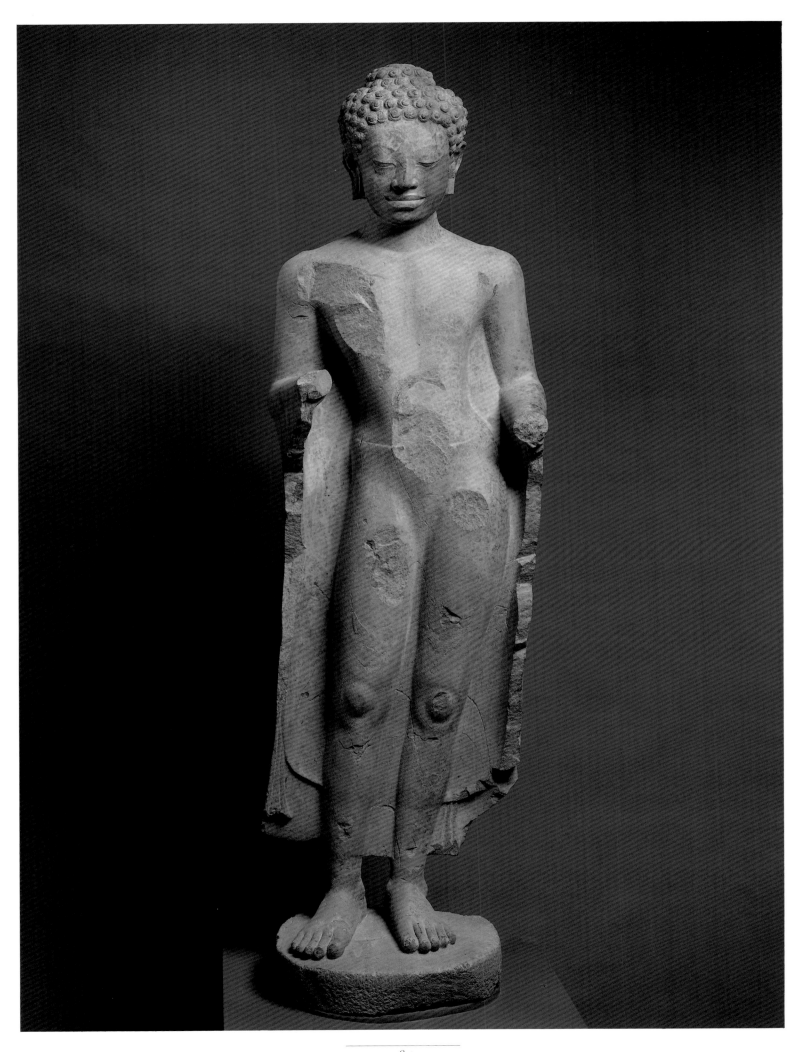

Seated Shiva

VIETNAM (CHAMPA), DONG-DUONG MONASTERY AT INDRAPURA, 9TH CENTURY

SANDSTONE; H. 86 3, W. 37.5 CM

EDWARD L. WHITTEMORE FUND 1935.147

This impressive image of Shiva, seated in a posture of royal ease, represents a specific, rare type of Cham (early Vietnamese) sculpture known as the Dong-duong style. Dong-duong was a famous Buddhist monastery, no longer extant. Some of its sculptures survived, however, to give us an idea of this unique and powerful style.

The sculpture is Hindu, although it was produced within the context of Buddhist art, as was the case with some Hindu sculptures made in Cambodia. Chams, who were originally vassals to Khmers but eventually defeated them, had many points in common with the Cambodians, with the syncretism between Buddhist and Hindu sculptures being one of them.

The most imposing group of sculptures from Dong-duong that survives today is in the Danang Museum in Vietnam. Among the several Buddhist images and guardian figures (three life-size *dvārapālas*) is an altar with a seated image of Shiva, comparable to this sculpture. The Shiva in the Cleveland Museum of Art represents probably the most important sculpture of this style in the United States today. It was also one of the earliest Asian sculptures acquired by the museum, entering the collection in 1935.

The Dong-duong style is represented predominantly by large-scale sculptures of great dynamism and strength, distinguished by a certain awkwardness but possessing nonetheless a refreshing and charming quality. The broad facial features, uniquely Vietnamese, consist of double-outlined thick eyebrows forming a continuous line, flat nose with large nostrils, and a wide mouth with fleshy lips. The upper lip, with a bushy moustache, is usually more prominent and dominates the lower one, below which is a short receding chin. The facial expressions are more often than not forbidding and almost grotesque. A great emphasis is usually put on heavy and deeply cut jewelry and ornaments, richly decorated with floral motifs, in this instance the headgear of the figure and its large floral earrings.

The base of the figure is decorated on the front and two sides with vertical rectangular panels depicting a mask of glory *(kīrttimukha),* another landmark of this style. S.C.

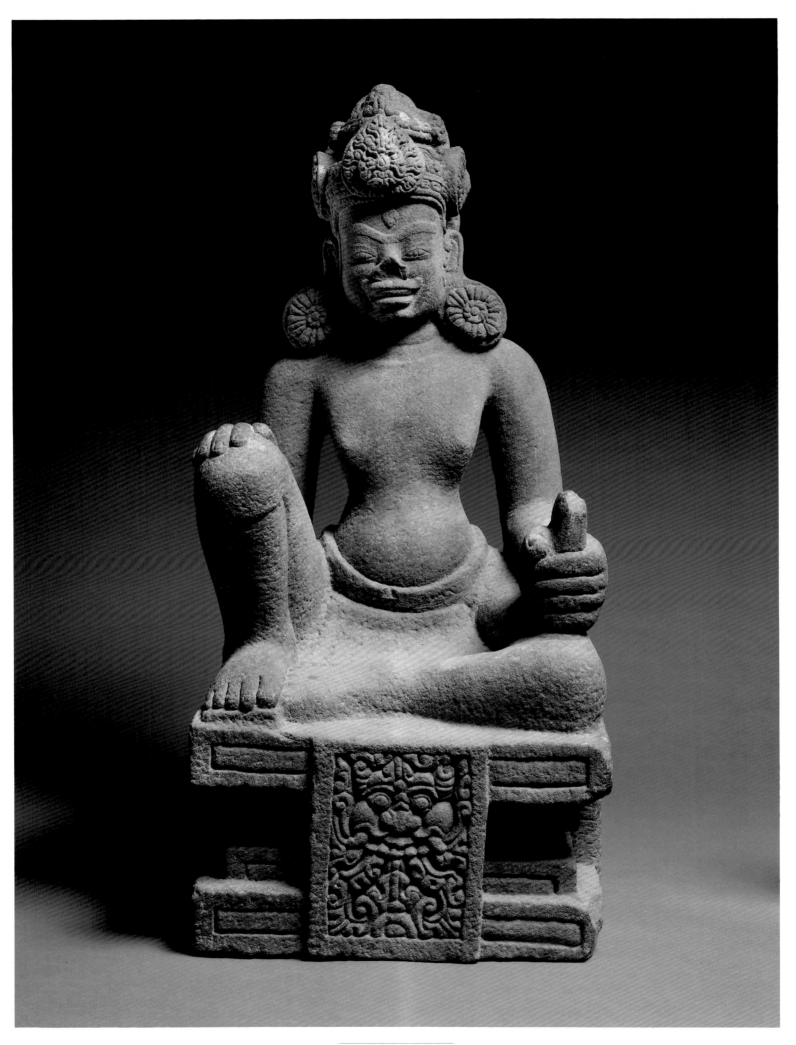

Tent Hanging

WESTERN INDIA, ABOUT 1560–1610

LAMPAS WEAVE: SILK; WARP 93.8 CM, WEFT 172.5 CM

GIFT OF GEORGE P. BICKFORD 1953.474, 1953.474A

Rows of Rajput horsemen led by armed warriors cover the principal section of this three-part hanging, while a floral pattern arranged in stripes ornaments the two identical end panels. The central design, figures in rows separated by borders or rosettes, is a typical Hindu pattern and occurs in several other known hangings. In one of them, each row depicts a Rajput horseman, a warrior, a tree flanked by animals, and then three more warriors. In another, the warriors and horsemen are replaced by archers riding elephants. Elsewhere, the tree motif is combined with elephants and riders. Differences in structure verify that these textiles are separate fabrics woven from a stock repertory of motifs. Attached to some of the related examples are similar end panels with floral designs arranged in stripes.

Stylistic elements and details of the horsemen's costumes indicate that the central panel was woven in the late sixteenth or the beginning of the seventeenth century. This dates the textile at the end of the reign of the Mughal emperor Akbar (ruled 1556–1605). Not only did he reorganize and rejuvenate crafts of all kinds, including weaving, but he was interested in Hinduism and tolerant of it. The high technical quality of the weaving of this hanging suggests that it may have been produced in the royal workshops of Ahmedabad, a city known at the time for its exceptional textiles. It is believed to have been one of many decorative panels that ornamented the interior of a splendid Mughal tent. A.V.

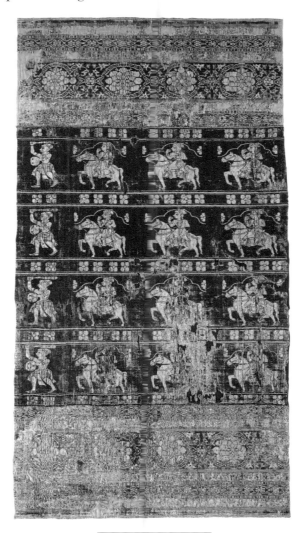

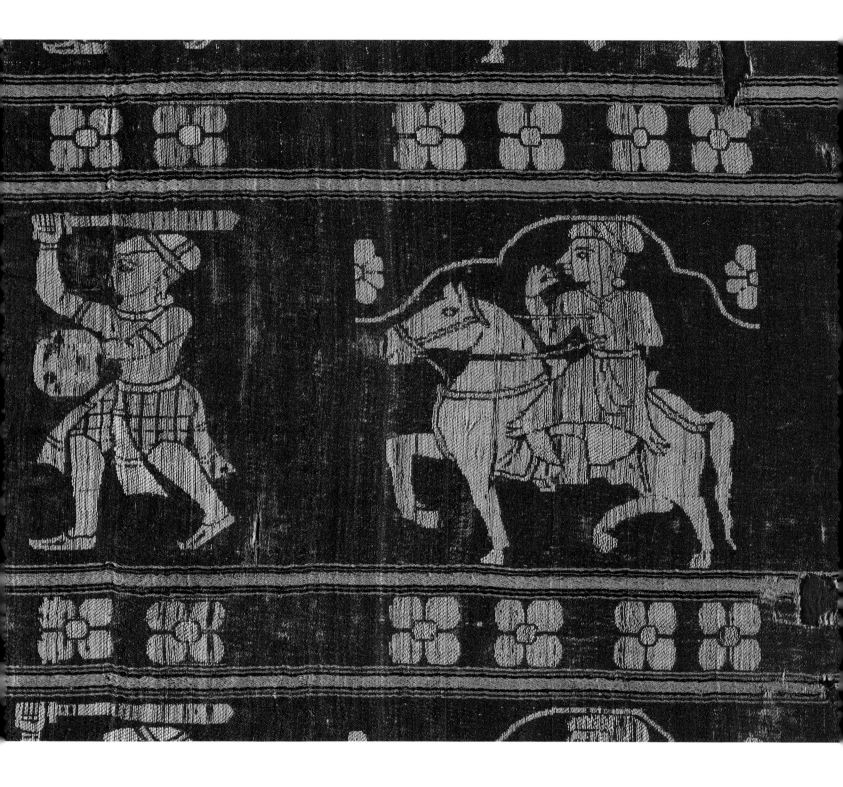

"Alam Shah Closing the Dam at Shishan Pass," from Dastan-i-Amir Hamza

INDIA, MUGHAL SCHOOL, AKBAR PERIOD, ABOUT 1570
COLOR AND GOLD ON COTTON; 69 X 52.2, 83.7 X 67 CM (WITH BORDER)
GIFT OF GEORGE P. BICKFORD 1976.74

The *Dastan-i-Amir Hamza* (Romance of Amir Hamza), popularly known as the *Hamza Nāma*, is a text that deals in colorful terms with the many heroic adventures of Amir Hamza, a legendary uncle of the prophet Muhammad. Illustrating *Hamza Nāma*, a favorite Islamic tale, was one of the main undertakings of the imperial studio set up by the greatest Mughal ruler, Akbar (ruled 1556–1605). Several Persian artists, along with artists working more in the native Indian tradition, contributed to this project. The text consisted of twelve volumes, each one numbering a hundred folios, and every folio was illustrated, as we learn from Akbar's biographer, Abul Fazl. The largest collections of pages from the *Hamza Nāma* survive today in the Osterreichisches Museum für Angewandten Kunst in Vienna (about sixty pages) and in the Victoria and Albert Museum in London (twenty-five pages).

The general style of painting in these pages is in the Persian miniature tradition, although the color, details of costume, and architecture are often Indian. The tendency toward realism and the interest in the visual aspect of things, in which an attempt is made to place objects spatially, are Mughal inventions. They reflect the same characteristics expressed in the Mughal royal diaries, particularly the immense interest in firsthand observation of the surrounding world. S.C.

Sita in the Garden of Lanka

INDIA, PAHARI HILLS, GULER SCHOOL, ABOUT 1725

GOLD AND COLOR ON PAPER; 55.5 X 79, 56.3 X 81 CM (WITH BORDER)

GIFT OF GEORGE P. BICKFORD 1966.143

This page comes from a well-known set of Pahari illustrations of the *Rāmāyana* epic. It relates in colorful terms the story of the abduction of the beautiful Sita, Rama's wife, by the demon Ravana, the ruler of Lanka. He kept her captive until she was rescued by Rama, with great assistance from the monkey-god, Hanuman, with his army. Sita, who represents feminine virtue, is shown here on the right in the garden of a fortified castle of Ravana, surrounded by a moat and a high wall. She faces her many-armed and -headed abductor, accompanied by his wives, guarded by several demons. In agreement with the method of continuous narration, popular in Indian paintings, Ravana is shown again on the left seated inside his castle, in conference with his demons.

This famous set of unusually large paintings, many unfinished, is known through several surviving pages and many more partially colored or uncolored drawings. Most are in the collection of the Museum of Fine Art, Boston, while individual paintings are in the Metropolitan Museum of Art in New York and the British Museum in London, a private collection, and this page in Cleveland. The Prince of Wales Museum in Bombay has nineteen uncolored drawings from this set.

The Cleveland page has a dull-red border with some damage to its left side and lower border that partially extends into the water of the moat. There is also some loss of pigment in front of the Sita figure. s.c.

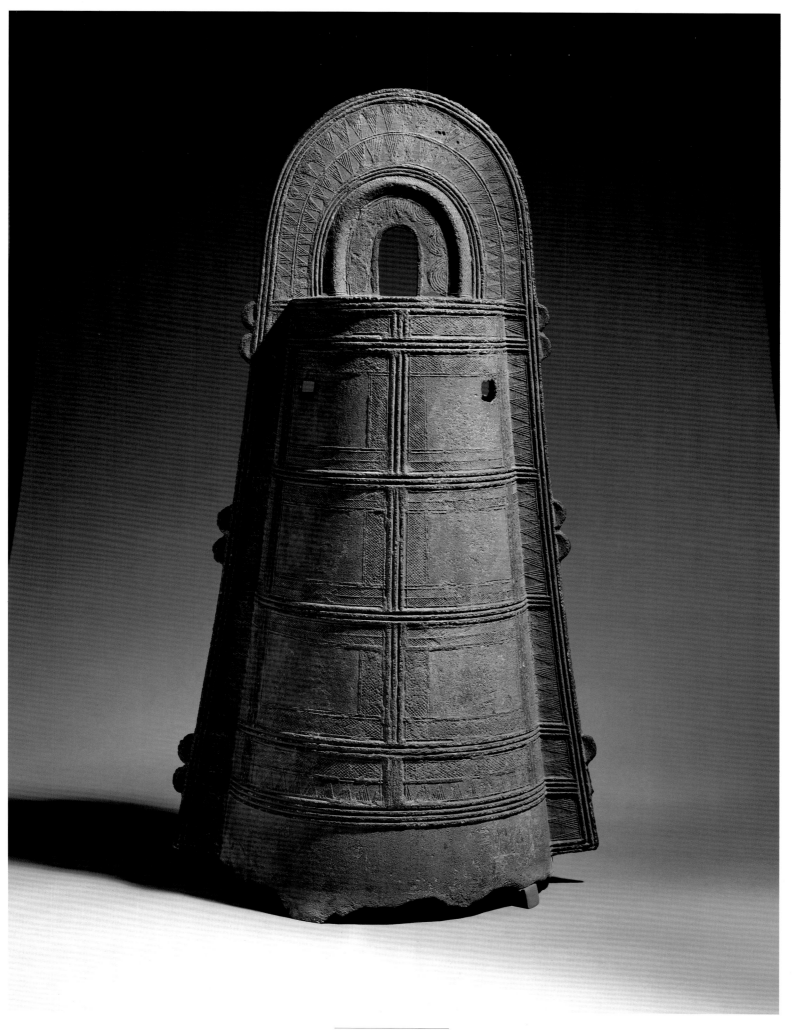

Buddha of the Future (Maitreya)

JAPAN, ASUKA PERIOD, LATE 7TH CENTURY

CAST BRONZE, INCISED, WITH TRACES OF GILDING; H. 39.4 CM

JOHN L. SEVERANCE FUND 1950.86

Among the most popular devotional images of early Buddhist Japan are those portraying a seated figure, right leg crossed on top of the knee of the suspended left leg and right hand elevated to touch the chin. The left hand rests quietly on top of the ankle of the crossed right leg, adding balance to the whole statue.

Represented is the Future Buddha, Maitreya (Miroku in Japanese), the deity thought by devout believers to appear at the end of the world to offer salvation. This idea predicting the fiery death of the planet was in fact preached widely in early Japan, and an actual date in the mid-eleventh century was identified with the event. One response to this ominous forecast was the production of Miroku statues, both as large central icons and as small devotional images. Many of the latter were buried along with sacred religious texts and other ritual objects in anticipation of future generations' use of them with Miroku's arrival. The cult of worship to Miroku was vigorous among the Buddhist clergy and the close-knit aristocratic families who were the new religion's staunchest supporters.

Buddhism in Japan was still in its infancy, although under the reign of Empress Suiko (593–628) and her regent, Prince Shotoku (574–622), its practice flourished. Prince Shotoku supported the new religion as he strove to consolidate the power of an imperial lineage within his family lineage, in the face of challenges from competing clans. By maintaining active relations with China, and especially with Korea, Empress Suiko and Prince Shotoku were able to develop, and then initiate, sweeping changes in government organization and society. Shotoku is reverentially acknowledged in Japanese history as the principal protector and promoter of Buddhism, elevating it to the status of a state religion and personally directing the founding of the country's oldest Buddhist temples south of present-day Nara.

The building of these structures and the adornment of their interiors required the skills of immigrant Koreans adept at woodworking, tile making, and metalwork—particularly bronze casting. Bronze images of the Buddha of the Future in meditation are numerous in sixth- and seventh-century Korean art when the deity's following was especially strong. Serving as models for the gilt-bronze icons subsequently made in Japan, oftentimes by Korean artisans, these sculptures gradually took on more decidedly Japanese features. That is the case with this large seated figure. In comparison to Korean prototypes, its torso is more stocky, the face and facial features broader, and the details of robing and jewelry less pronounced. M.R.C.

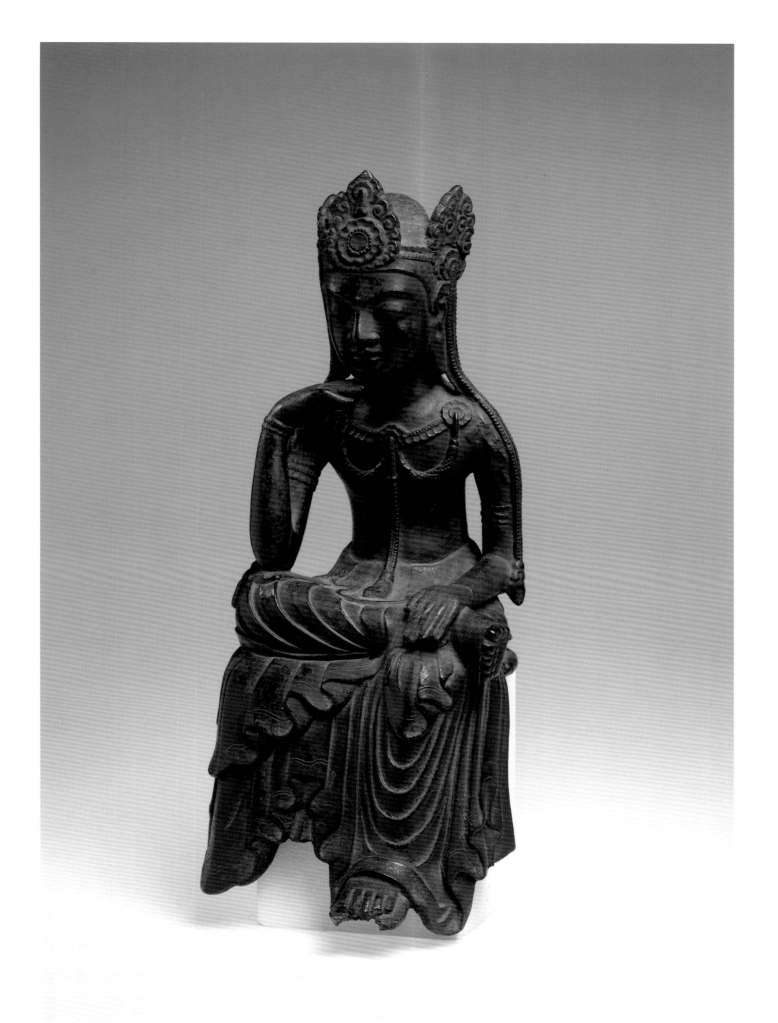

Shinto Deities

JAPAN, HEIAN PERIOD, 12TH CENTURY

WOOD, WITH TRACES OF POLYCHROMY; H. 53.3, W. 47 (LEFT), H. 50.3,

W. 28.1 CM (RIGHT)

LEONARD C. HANNA JR. BEQUEST 1978.4, 1978.3

The introduction in the sixth century of the religious ideas, images, and customs that defined Buddhism for the Japanese had a powerful, startling effect upon the people. They already possessed a complex system of beliefs, known as Shinto, which identified natural phenomena with the power of the gods *(kami)*. Special trees, boulders, mountains, waterfalls, or similar physical expressions of nature's awesome powers were viewed as the abodes of kami. Extraordinary objects in the natural world were considered manifestations of the forces of nature and particularly of the higher powers causing them to be in the world. Humans were viewed as but part of this vast landscape of nature, and life but part of a cycle that included awareness of the realm of the dead as well as of the gods. In fact, the early Japanese did not distinguish between these realms as much as they embraced a natural, active recognition of their commonality and sought through ritual to obtain the benefit of the powers of all kami. Japan's earliest written accounts of its history contain dramatic passages describing the crucial role of the gods in the nation's affairs.

Because no images of these kami existed in early Shinto, the sudden appearance of bronze representations of Buddhist gods incurred a strong reaction in Japan. Such icons were considered essential educational tools for conveying the teachings of the new religion. While the idea of using a man-made object to convey the identity and potency of a higher power was foreign to Shinto practice, over a period of two to three hundred years that position gradually shifted. By the ninth century the Shinto clergy had joined closely with the court and ruling aristocratic clans to identify the authority of the emperor with three specific sacred objects, erect shrines for their worship as emblems of their ancestry to the gods, and allow the production of sculptural images of kami for placement in shrines.

Naturally these kami were usually crafted to resemble male and female aristocrats, as in this seated pair. The larger male figure holds an upright wooden tablet *(shaku)*, a courtly symbol of authority. The projecting head cap with epaulets falling gracefully over each shoulder is recognizable, too, as one worn by high-ranking members of the court in early Japan. The female kami wears a multi-layer robe tied at the waist in fashionable Heian court style.

Both Shinto images were carved from wood taken from a specially selected tree, itself perhaps regarded as a kami. The sculptor carefully followed the core and grain of the wood to help illuminate the natural power of the material. Each image consists of a central upright torso with an added horizontal element for the knees. The surfaces of the kami were initially painted. Even though these images were secreted in the dark recesses of a provincial Shinto shrine, away from view of the public, over the centuries the elements and insects have been at work. M.R.C.

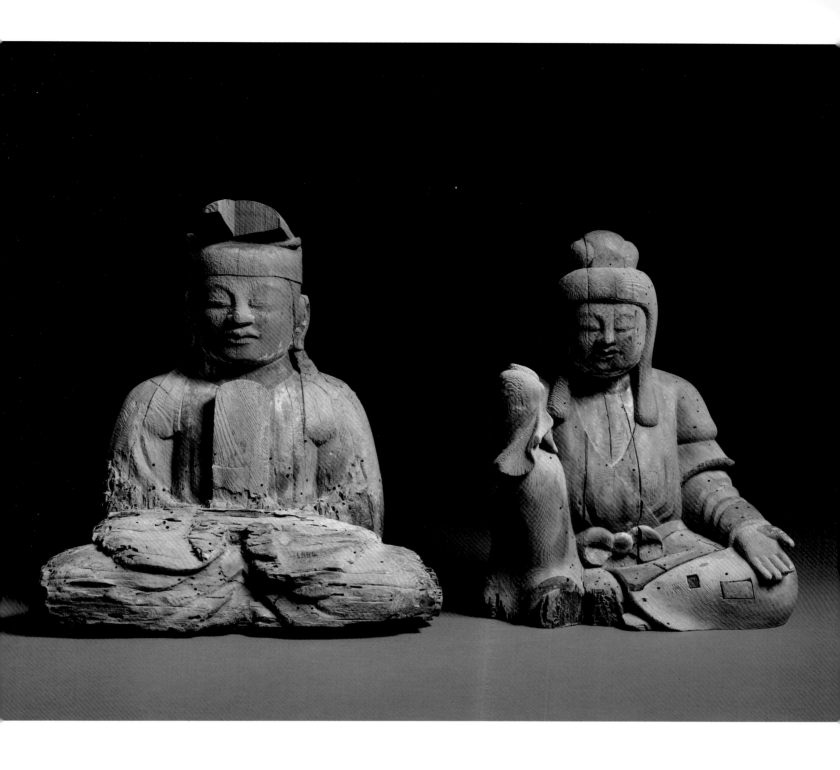

Votive Plaque *(Kakebotoke)* with Kannon Image

JAPAN, HEIAN PERIOD, 12TH CENTURY

BRONZE, WITH APPLIED MOLDED IMAGE WITH ETCHED DESIGNS; DIAM. 52.5 CM

LEONARD C. HANNA JR. BEQUEST 1985.16

The interiors of Japanese Buddhist temples focus on the religious statuary linked to the institution's principal deity or historical founder. These sculptures, usually constructed of wood and only modestly adorned, are placed in the central bay of the building within the temple compound set aside for their worship. Raised altar tables stand in front of the primary images, set with offerings of rice and fruit to the deity along with candle holders, oil lamps, and water and incense containers.

In front of this furniture are low tables, set on the tatami mat floor, for the ritual objects used at each day's services: sutras, bells, candle holder, incense container, and metal gong. Because the bay is often deep and the sculptural image set well back into it, away from sources of natural light, the unpainted wooden columns and beams of the interior architecture reinforce an ambience of solemn dimness amid open interrelated spaces.

Over the centuries various types of interior "decorations" were either adopted from Korean and Chinese prototypes or created wholly in Japan to help enliven these spaces where the faithful viewed the devotional statuary. In fact, the open structural system of beams and supports in Buddhist architecture provided ideal locations for attaching or suspending heavenly canopies, colorful textile banners, and an assortment of decorative metalwork. This paraphernalia helped illuminate the hall's interior as well as provide focus for worship.

This kakebotoke was originally suspended by brightly colored cords from a wooden beam in a Buddhist worship hall of the late Heian period. It was likely placed on a beam flanking the central icon and was joined by other kakebotoke in identifying the worship bay in front of the main sculptural altar. Originally its polished bronze surface reflected the flickering light of oil and candle flames. But through the centuries of exposure to the elements and wax and oil smoke, the metal surface has acquired the rich blue-and-green patination of age and usage so admired by the Japanese.

The seated figure of the universally benevolent deity, Kannon, sits on a lotus base surrounded by a double halo with flame patterns. These elements have all been cut from a sheet of bronze and delicately hammered into shape using a wood mold. The surface of the deity's figure and the individual lotus petals have been incised and carefully tooled to provide detailing of form and three-dimensional modeling. Small pins indicate how the image was attached to the disc of the plaque. Molded lion-head attachments provide suspension supports. In construction and style it resembles the splendid metalwork artistry of the Chuson-ji temple in northern Japan, a twelfth-century religious and artistic outpost of distinguished aristocratic patronage. M.R.C.

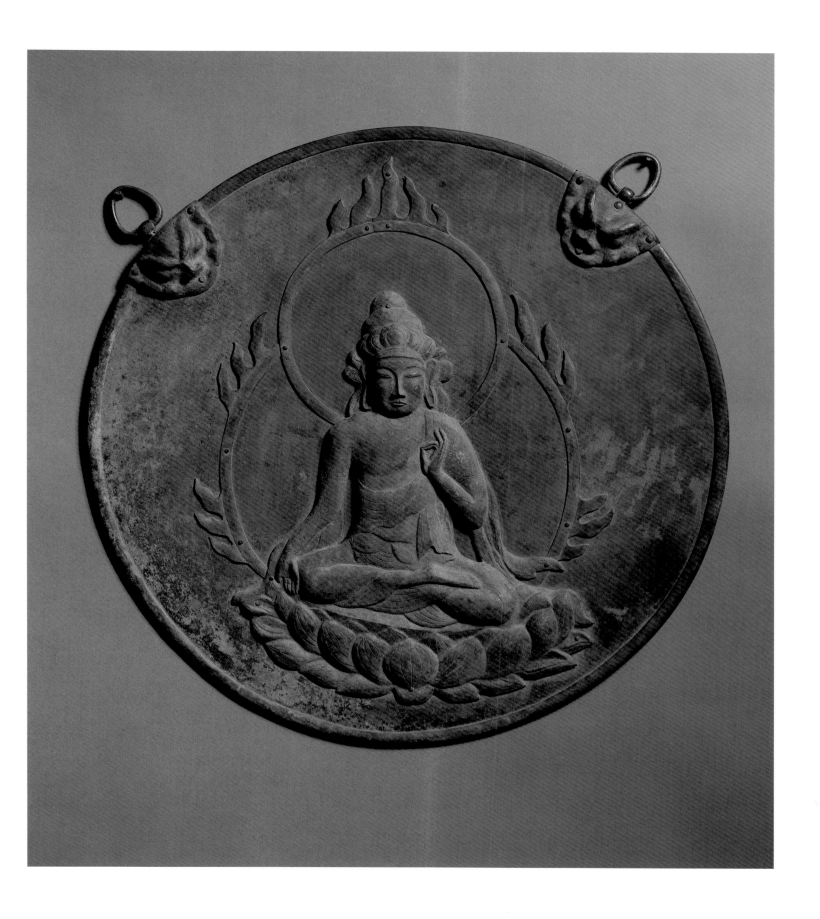

Buddhist Tabernacle

JAPAN, HEIAN PERIOD, LATE 12TH CENTURY

BLACK LACQUER OVER A WOOD CORE WITH HEMP CLOTH COVERING, GOLD PAINT,

CUT GOLD LEAF, INK, MINERAL PIGMENTS, AND ATTACHED METALWORK;

H. 160 CM

JOHN L. SEVERANCE FUND 1969.130

With the arrival of Buddhism in Japan in the sixth century came a variety of icons, ritual implements, and other related objects traditionally accepted for conveying religious ideas in Buddhist communities on the continent. Sculptural images depicting deities, for instance, did not exist in the native Shinto faith, nor did the elaborate buildings constructed especially for the worship of the Shinto gods. Thus the arrival of Buddhist images and then the artisans from Korea skilled in their manufacture represented a revolutionary change in Japanese society at that time.

At first, images were made of clay, then of thinly molded copper plates, and then of cast bronze. By the eighth century Japanese artisans fabricated hollow dry-lacquer icons based on a technique learned from examining imported Chinese examples. Lacquer, known and used in Japan since 4000 BC, had previously been applied to utilitarian objects such as serving bowls, mirrors, and combs. On architectural surfaces it protected wood from excessive dampness or heat or insect damage and also provided an appealing surface for decoration. For these reasons, carved images of wood as well as domestic and Buddhist furniture for everyday use were covered with colored lacquer beginning at least in the Nara period.

Numerous lacquered objects preserved in the eighth-century official imperial repository known as the Shoso- n illustrate the variety of forms and surfaces to which lacquer of varying hues was applied. If anything, the use of this attractive medium expanded in the ensuing Heian period as the Japanese population grew, as Buddhism flourished under the active patronage of the aristocracy, and as the impulse to decorate elaborately both religious and secular utilitarian objects expanded dramatically.

This tabernacle is a rare product of the late Heian Buddhist world, one still much linked to the upper classes and to the rites and practices of Esoteric Buddhism. It was a world of great splendor and religious mystery, but one also fearful of an imminent world cataclysm, resulting in extraordinary acts of private donations in the hope of assuring salvation. Such is no doubt the case with this shrine, one of a pair that are the only examples known in Japanese art. The entire structure is composed of carefully fitted and carved wood sections that have been covered with a layer of hemp cloth and then coated with multiple layers of clear lacquer. Then brown- and black-pigmented layers were added followed by gold paint, *kirikane* (cut gold leaf), black ink, and mineral pigments for the pictorial assemblage of guardian figures displayed on the two door panels and interior walls. Metal hinges in the form of esoteric ritual implements and the front embossed panel were attached last. This panel identifies the contents of the shrine as hundreds of handwritten sutras in handscroll format, arranged on two shelves built into the interior. Thus instead of a religious deity sculpted in recognizable human form, the Buddhist devotee viewed something more spiritually pure: handwritten holy texts offering the promise of redemption. M.R.C.

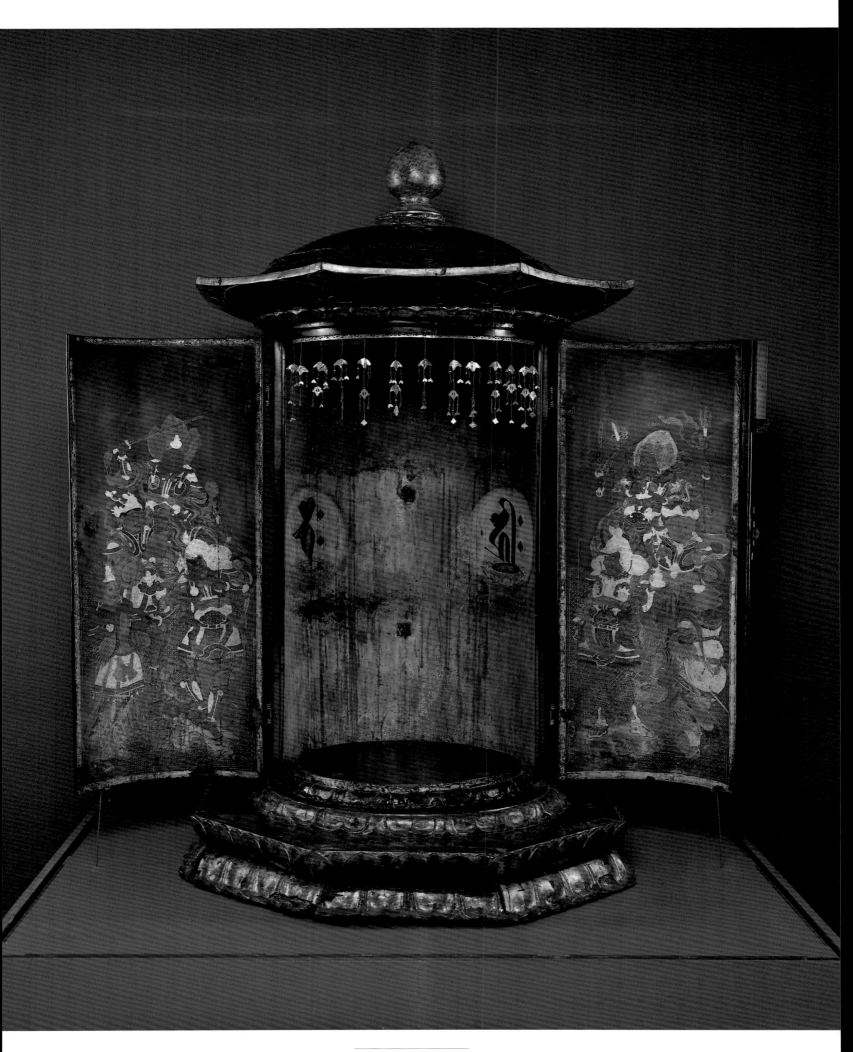

JAPAN, KAMAKURA PERIOD, ABOUT 1286

WOOD WITH HEMP CLOTH, BLACK LACQUER, AND IRON CLAMPS; H. 91.4 CM

LEONARD C. HANNA JR. FUND 1970.67

In Japan, portraits of revered spiritual leaders have been produced since the eighth century. First in life-size sculptures of clay, wood, or dry lacquer and, later, in painted versions, these austere images of Buddhist priests demonstrate the early Japanese mastery of realistic portraiture.

Hotto Kokushi (1203–1295), known as Kakushin, journeyed to China twice to study Zen, a sect of Buddhism. He became renowned in Japan for his lectures and as a masterful interpreter and teacher of Zen doctrine. Away from the more doctrinaire centers in Kyoto and Kamakura, he founded a small number of temples in western Japan where his reputation attracted serious students of Zen as well as common parishioners. Three *chinsō* (sculpture portraits) of Kakushin exist today at these monasteries, which continue to serve as icons of faith in the search for spiritual enlightenment. Such sculptural images were traditionally displayed only for special occasions, usually in a space such as a founder's hall specifically designated for that purpose. Memorial services marking the anniversary of the priest's death are still the most important observances each year. Each of the four extant *chinsō* of Kakushin depict him slightly differently, corresponding either to his age or perhaps to how his physiognomy was transmitted posthumously to the sculptor. Traditionally this was done by sketch or finished painted image.

Here the master is presented toward the end of his life, with prominent cheekbones and hollowed cheeks as well as the large ears and clean shaven pate that characterize his appearance in all four *chinsō*. The weathered condition of the image's surface reveals the iron clamps holding the thinly carved pieces of wood together and the sculpting grooves normally hidden by layers of hemp cloth and black lacquer. The determined, meditative expression of Kakushin's aged face and his monk's robe seem particularly sympathetic to these materials.

The sculpture separates where the torso meets the lower robes, at the elbows. The hands are carved as one piece but are not secured into the arm sleeves. They, like the monk's slippers and bench, are independent elements that allow for ease of transport and installation. These were matters of some concern to medieval temples and their patrons since damage from insects and fire was well known to them. In addition, fabrication by the joined wood system allowed for greater flexibility and detailing. M.R.C.

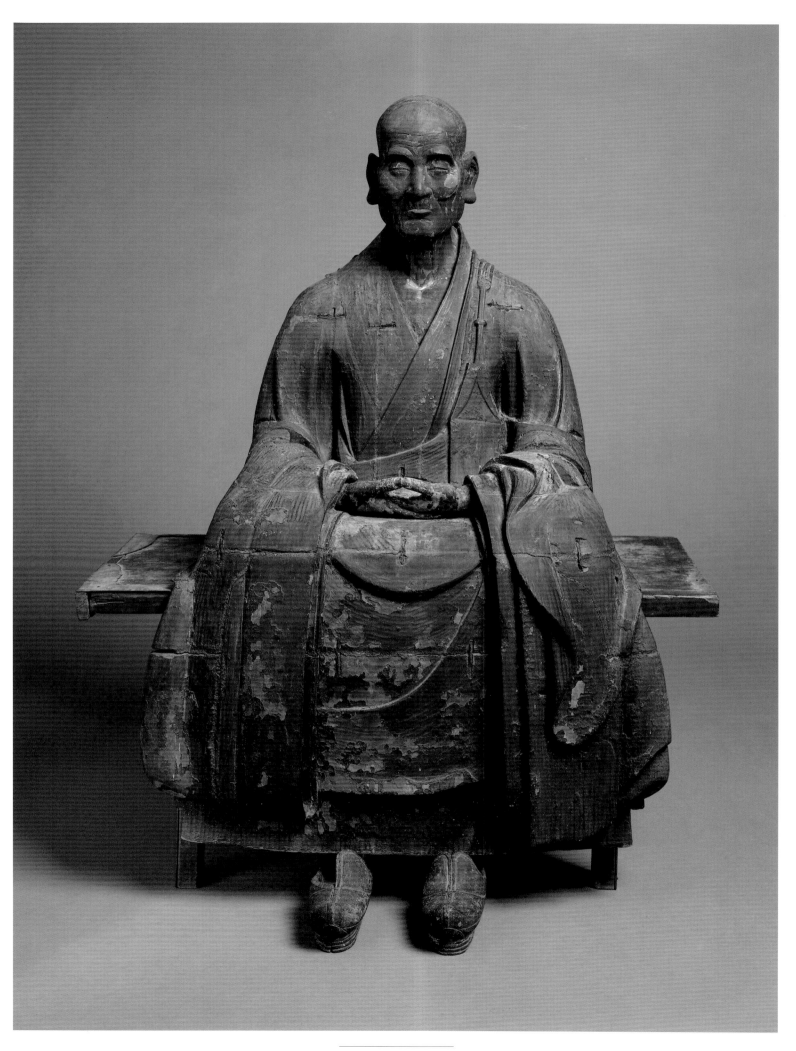

Kumano Mandala

JAPAN, KAMAKURA PERIOD, ABOUT 1300

HANGING SCROLL: INK AND COLOR ON SILK; 134 X 62 CM

JOHN L. SEVERANCE FUND 1953.16

Well before Buddhism arrived in Japan from Korea in the sixth century, the people of these islands already possessed a religious belief system. They envisioned everything in the natural world, including themselves, as beholding to higher powers or *kami* who resided in the local landscape. These animistic spirits dwelled in particularly beautiful, rugged areas often difficult of access but uncommonly powerful in their display of the forces of nature that shaped the land. The meeting of ocean and land, deep valley recesses, or tall peaks in remote mountain ranges where pure cold water flowed—such sites were recognized by the Japanese as extraordinary. They signaled the presence of a kami, and the recognition of that spirit through ritual, pilgrimage, and the building of monuments or imagery ensued.

After the ninth century, increasingly elaborate visual aids were made to identify and explain the local deities, a response to Buddhist practices that were then gaining popularity quickly in Japan. Indeed the rapid acceptance and dynamic spread of Buddhism in Japan fostered Shinto's development, and the two faiths joined forces so that by the time this painting was done the two religions had reached an easy accommodation. Shinto kami were given counterparts in the Buddhist pantheon of deities, and both Shinto shrines and Buddhist temple compounds invariably included a building dedicated to the worship of the other faith.

This painting provides a bird's-eye view of the Kumano shrine complex set deep in the mountains of the Kii peninsula south of Nara in Wakayama Prefecture. Nestled in these lush spring mountains near the sacred Nachi waterfall (upper right) are the three principal shrine compounds (actually several miles apart), to which pilgrims travel on foot or by boat on the nearby rivers. Groups of worshipers appear within these walled compounds, facing the individual shrines in which a hidden Shinto deity resides. Above the shrines, the anonymous painter has provided an image of that kami's Buddhist counterpart. Thus the entire painting becomes a map of this special landscape as well as a diagram (mandala) illustrating the religious significance of the shrine's various deities. In conception and in execution it stands as one of the finest surviving examples of traditional Japanese-style painting in Shinto art. Known as *yamato-e*, this style featured colorful pigments, dramatic compositions, and indigenous rather than foreign (Chinese or Korean) subjects. M.R.C.

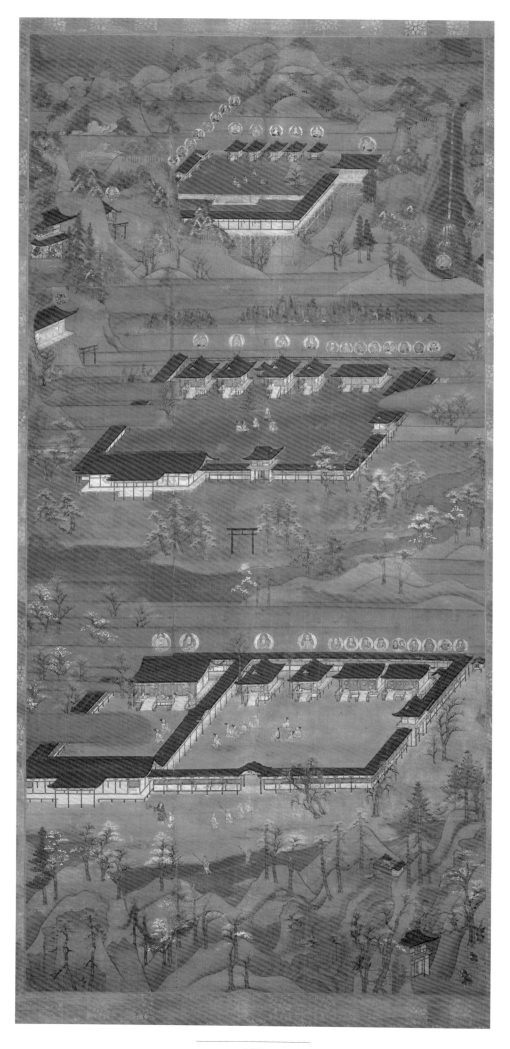

JAPAN, KAMAKURA PERIOD, ABOUT 1300

HANGING SCROLL: INK AND SLIGHT COLOR ON PAPER; 27.3 X 32 CM

JOHN L. SEVERANCE FUND 1952.286

In late Heian and Kamakura Japan the Buddhist arts flourished as never before, or after. The court, aristocratic families, and religious communities acted as the principal sponsors for buildings as well as a range of smaller precious objects in every medium and format imaginable. Aristocratic society embraced the daily rites of Buddhism, which focused on otherworldly concerns, while they cultivated a highly refined sensitivity toward the affairs of everyday life. Education in the Chinese classics was combined with, and then superseded by, Japanese models of learning and experience. Literary forms, especially poetry, were closely linked to visual imagery, and both became increasingly realistic in their attention to the world around them.

Beginning at least by the twelfth century, artists and patrons favored an extended handscroll format for depicting events of the day. Called *emakimono* (illustrated handscroll), these paintings could be comfortably unrolled in one's hands on a small table or rolled across the tatami mat of a room for viewing by several guests. Written passages alternated with illustrations, or the entire scroll might be an extended visual narrative composition devoid of text. Frequently these emakimono were composed as sets, but they were always intended to be viewed privately or in small intimate gatherings rather than in the public arena. They are exceedingly rare and rank among the most important contributions of Japanese art to world art.

This painting is a section of what was once a continuous handscroll portraying the most famous oxen of Japan's agricultural provinces. The scroll became so valuable to tea devotees in the Edo period that it was divided up and the fragments individually mounted as hanging scrolls. The massive body of the bull is painted in numerous carefully graduated layers of ink. Contours and surface body features are noted by thin undulating spaces that are devoid of color, or tonally reserved. This technique is demanding yet produces very subtle visual effects that combine to portray three-dimensional form, individuality, and dignity in an otherwise common farm animal. M.R.C.

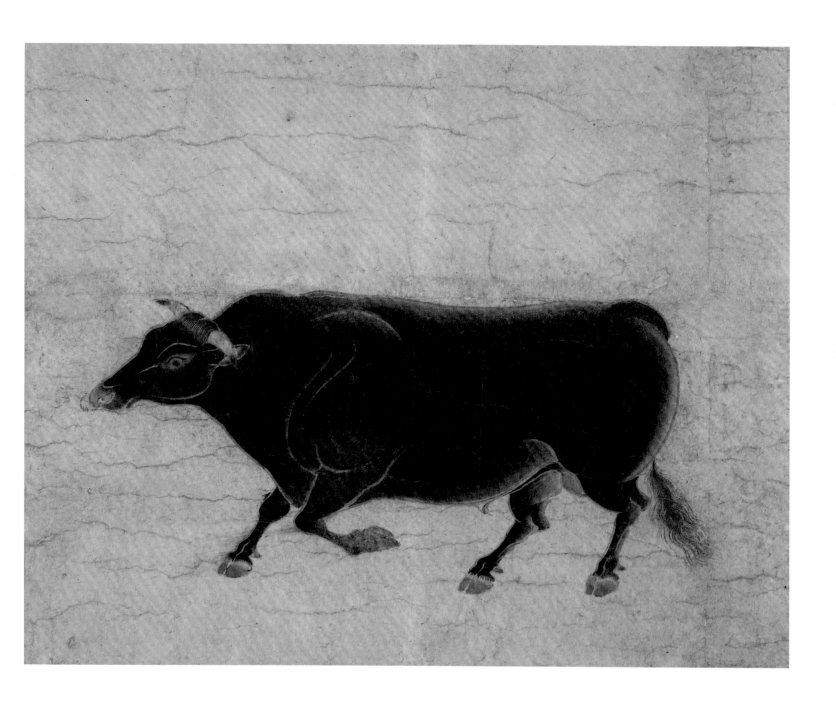

JAPAN, KAMAKURA PERIOD, DATED 1302

WOOD, COVERED WITH HEMP CLOTH AND COLORED LACQUER; H. 49.4,

DIAM. 47.2 CM

LEONARD C. HANNA JR. BEQUEST 1984.8

Lacquer has been in use in Japan since at least 4000 BC when the Jomon people used it to harden and decorate weapons (arrows) and utilitarian objects (wooden serving bowls). It was extracted from the sap of the *Rhus vernicifera* tree, refined through evaporation and skimming, and then embellished with red and black pigments. Since this earliest period of Japanese history, the practice of producing and using lacquer objects has remained constant although developments in its manufacture and refinement, usage, and patronage have naturally fluctuated.

No doubt the most profound change in the history of Japanese lacquerware occurred in the seventh and eighth centuries, when the new religion, Buddhism, had finally secured official court support for its existence. As its influence and power spread from the capital in Nara to the outlying provinces, lacquer objects and furnishings became increasingly in demand for use in temple communities. Lacquer was used to decorate room interiors, architectural fittings, furniture, musical instruments, shrines and statuary, clothes and object chests, and serving utensils. Perhaps the most desirable wares were the monochrome black, brown, or red objects used every day in Buddhist temples in the Kamakura period.

Carved wood bases were coated with many successive layers of colorless lacquer, and the final applications were tinted black, and then red. Through usage, wear produced a natural surface of red and black random patterns. This large jar was formed from two pieces of wood that were turned on a lathe and then joined. The neck and base were then added and the entire vessel covered with hemp cloth to produce a smooth surface except where three bands of parallel convex lines were carved. Black and then selected areas of red lacquer were added last. Foremost among these are three linked scenes at the bottom of the jar depicting a narrative of a monkey family crossing a stream. No other example of pictorial lacquer art of a similar age and genre subject has survived in Japan. M.R.C.

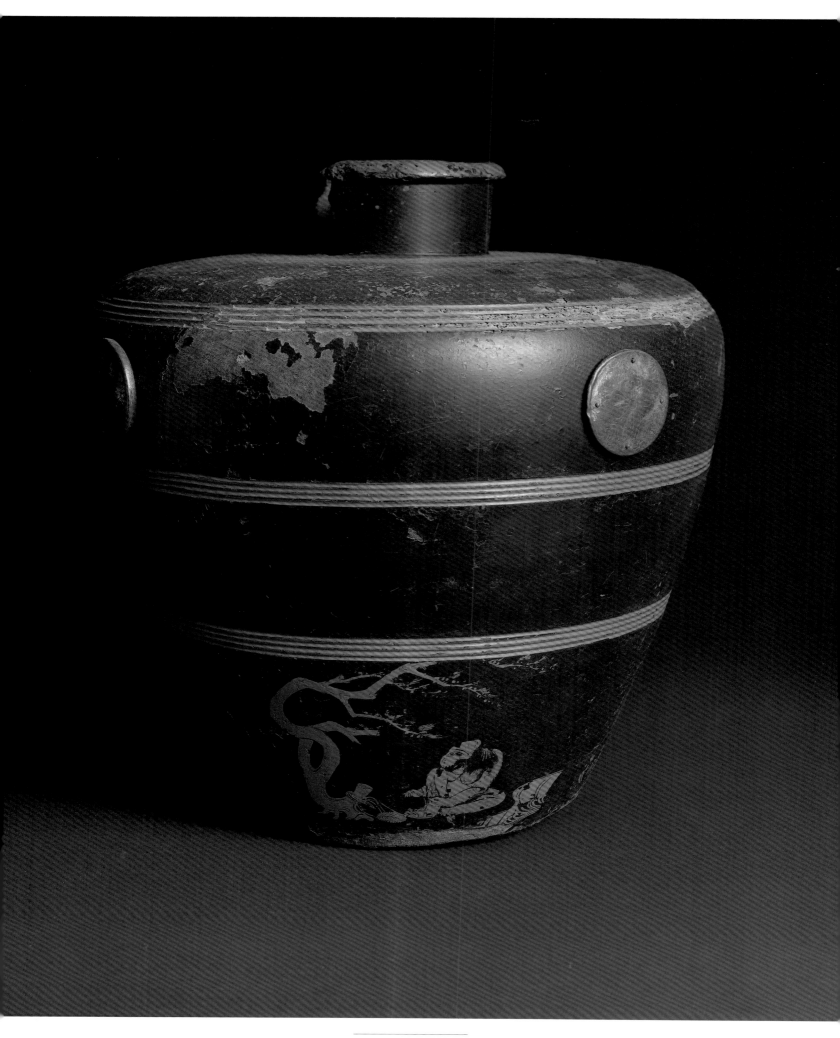

Aizen Myoo (Ragaraja)

JAPAN, KAMAKURA PERIOD, 14TH CENTURY

WOOD, WITH BLACK LACQUER AND RED PIGMENTS; 75 X 59 X 35 CM

BEQUEST OF ELIZABETH M. SKALA 1987.185

This fierce, seated figure of Aizen Myoo (Ragaraja in Sanskrit) possesses six arms, each of which once held an attribute signifying the religious power of the icon: thunderbolt, bell, bow, arrow, lotus flower, and clenched fist. A third eye appears between the furrowed eyebrows. Also visually prominent is the lion's head emerging amid Aizen's flaming hair strands. Its similar bulging eyes and ferocious mouth echo the expression of its iconographical vehicle: Aizen.

This deity of Esoteric Buddhism was introduced into Japan during the ninth century, a period of intense religious fervor. Myoo (King of Light) often signify a ferocious or angry aspect of the Buddha of Wisdom, whose other aspects include spirit and graciousness. Indeed the wrathful appearance of Aizen conceals an equally intense search for spiritual enlightenment through love of the Buddha, a trait it seeks to instill in mankind. Aizen is especially associated with the quelling of worldly passions and became an increasingly popular, and potent, religious icon from the late ninth century onward.

The sculpting technique of this figure is noteworthy because it is carved from a single block of dense wood, except the four posterior arms. Most Buddhist sculpture of the thirteenth century and later is composed of numerous thinly carved pieces of wood carefully joined together and elaborately embellished with surface decor. The result is a light, detailed image often imbued with "realistic" (in a Western sense) attributes, an appearance at odds with the rugged, forceful clarity of this powerful deity. In this way, therefore, this seated figure shares technical and material characteristics normally found in Shinto sculpture, which are formed from a single wood block and emphasize the bulk, grain, and natural strength of the material. M.R.C.

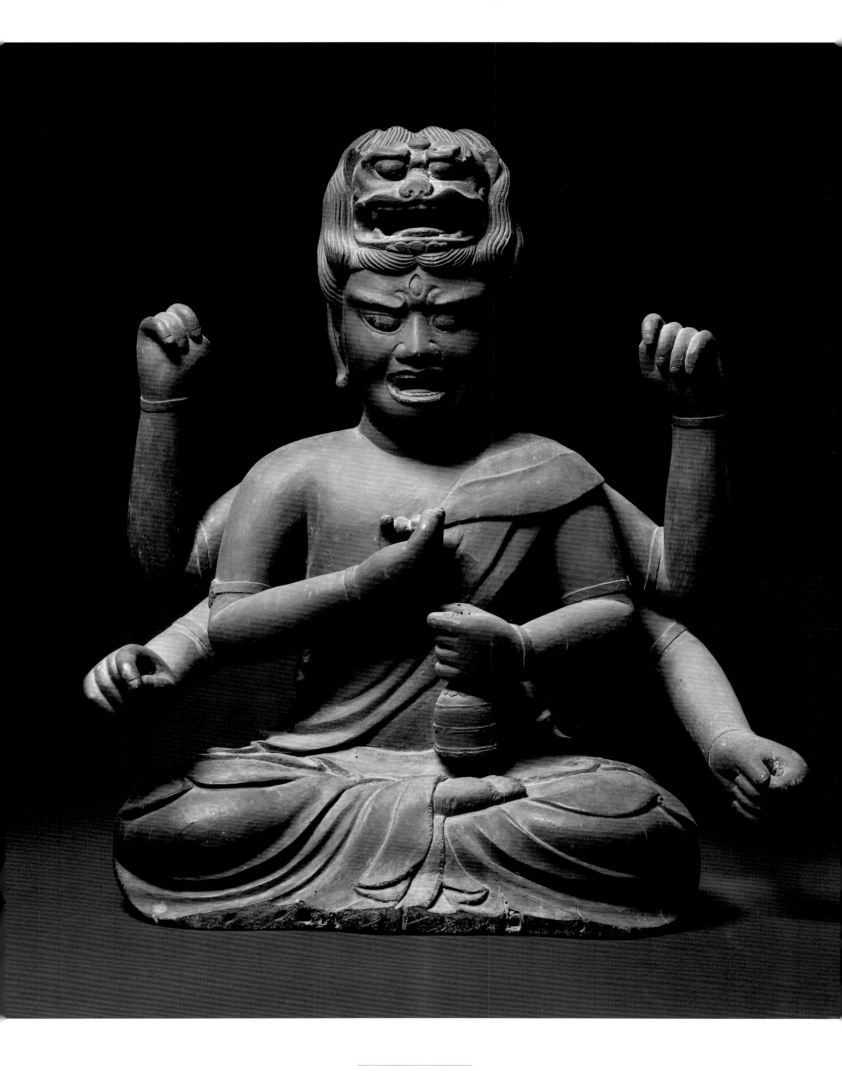

Taima Mandala

JAPAN, KAMAKURA PERIOD, 14TH CENTURY

HANGING SCROLL: INK, COLOR, AND GOLD ON SILK; 140 X 134.8 CM

THE SEVERANCE AND GRETA MILLIKIN PURCHASE FUND 1990.82

Popular Buddhism spread throughout Kamakura Japan aided by the efforts of traveling monks who, having become disenchanted with the stodgy conservative Buddhist center of learning in Kyoto's monasteries, sought to reinvigorate the religion's teaching through independent study and communication with the common man. Illustrated handscrolls of the period graphically record the lives of famous priests traveling through the countryside, giving sermons, treating the infirm and the elderly, and holding open town meetings to spread the faith to commonfolk. New, more appealing interpretations of religious texts were espoused, and, at the same time, simpler rituals made practice of the faith more understandable for the populace.

One traditional concept that captured peoples' attention in the twelfth and thirteenth centuries noted the existence of the Western Paradise, a place of salvation and rebirth to the faithful. Derived from an old sutra, its teachings and principal deity of worship, Amida, were championed by priests of the popular Jodo (Pure Land) sect. The continuous recitation of a short prayer or chant was said to ensure a believer's entrance into the Western Paradise where Amida resided.

This painting is a pictorial map (mandala) illustrating this heavenly vision with Amida at its center, flanked by his compassionate attendants and bodhisattvas in a glorious palatial setting. Overhead celestial angels and musicians provide accompaniment. All is described in a golden palette augmented by mineral blues, reds, oranges, and greens. The borders of this mandala contain sequential narrative scenes from a legendary religious text whose message extols the efficacy of meditations that lead one to rebirth in the Pure Land.

The oldest version of this subject is an eighth-century textile once owned by the Taimadera temple located just south of Nara, hence the derivation of the painting's title. Such mandalas were important didactic tools and visual aids in spreading belief in Pure Land sect Buddhism in medieval Japan. Few examples dating before 1400 have found their way to the West. M.R.C.

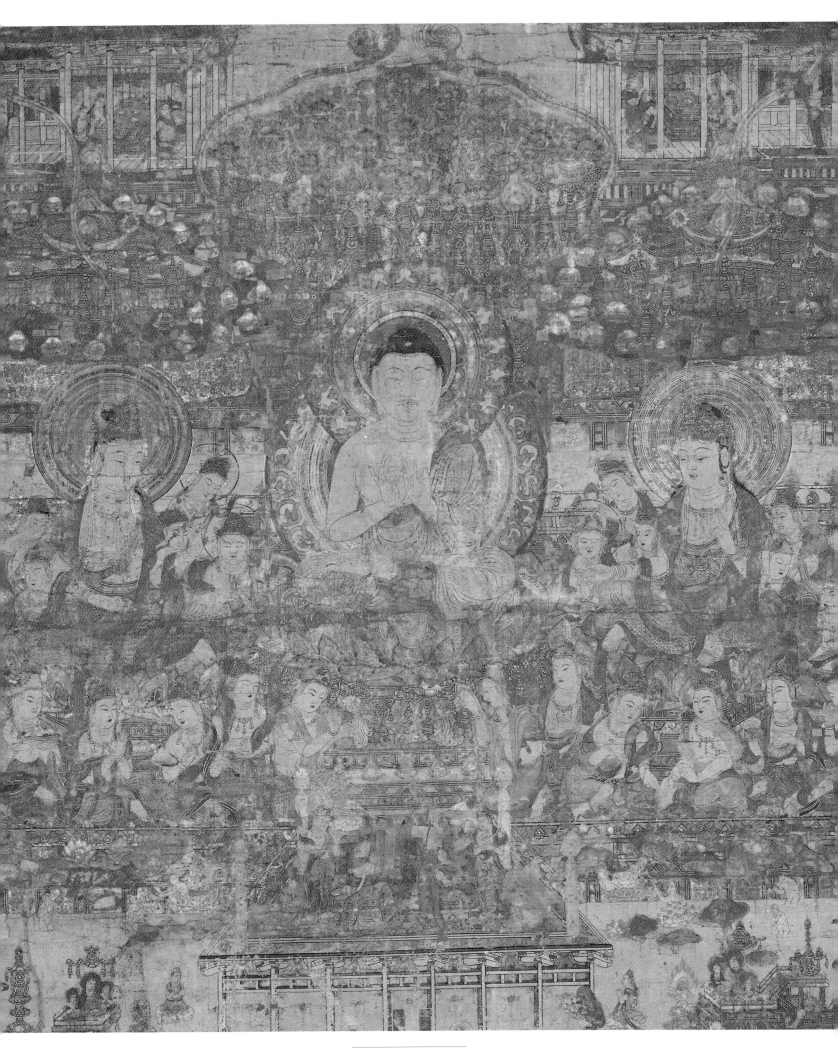

Storage Jar, Echizen Ware

JAPAN, MUROMACHI PERIOD, 15TH CENTURY

STONEWARE WITH NATURAL ASH GLAZE AND INCISED ARTISAN'S MARK;

H. 49.8 CM

JOHN L. SEVERANCE FUND 1989.70

Since the 1960s Japanese archaeologists and ceramic scholars have excavated an impressive number of production sites throughout Japan. Among these, more than a hundred of varying size and complexity have been identified as from medieval times (twelfth to sixteenth centuries), revealing the presence of an active ceramic production and distribution network throughout the provinces. Japan's economy was primarily focused on agriculture, especially rice and other grains, and clay storage jars played an integral role in that production system with its numerous regional centers.

Echizen, a fertile area along the Sea of Japan coast, emerged as a major pottery center in the fourteenth century. Utilitarian vessels for residential as well as agricultural needs were increasingly in demand, and distant ceramic production sources could not always keep pace with local demand reliably and economically. Individual artisan-farmers thus became the first producers of Echizen's earliest ceramics, succeeded by true, full-time village or regional potters in due course. By the fourteenth century ceramic production became centered in a village to the west of modern Fukui, where substantial deposits of high-quality clay material and an abundant wood supply existed.

This large jar is constructed from piling successive bands of clay on top of one another. Each section was built from clay coils pinched together by hand to form a wall, paddled with a wooden spatula, and allowed to dry before the next section was then added on top. The interior wall was paddled as well, then smoothed to help compact the clay fabric and seal it before the neck and mouth were added using a potter's wheel. The vitality of the jar's robust shape is, no doubt, due in large part to this vigorous construction technique.

The rich lustrous surface of the vessel is the result of its long (perhaps two weeks) firing in a kiln: wood ash present in the combustive atmosphere of the kiln settled on the jar's surface, accumulated, and then became molten, covering the entire vessel. In this way it became "sealed," the ideal container for protecting fragile grains and grain seeds from moisture and rotting. The abundance of natural glaze and the richness of its palette is extraordinary here and, as in most medieval wares, is fortuitous. While the Echizen farmer and potter no doubt held its durability as an object of everyday use in highest esteem, later generations have come to admire its natural, rugged beauty. M.R.C.

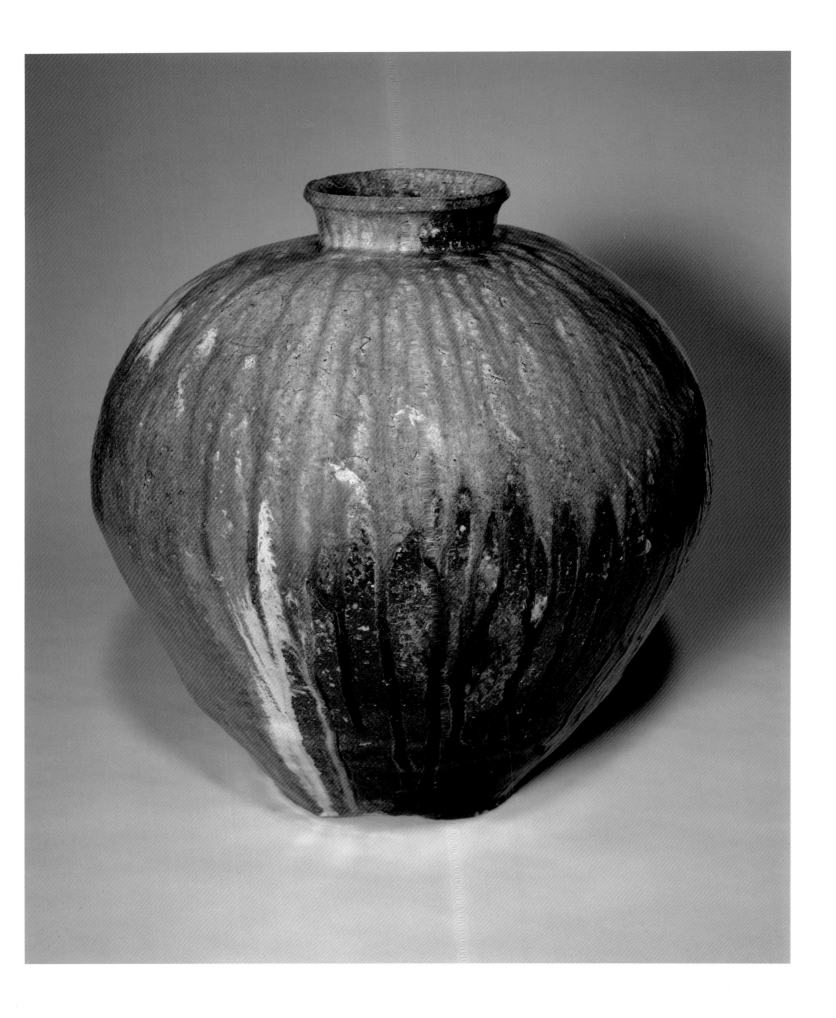

Windy Landscape with Sailboat

JAPAN, MUROMACHI PERIOD, MID-15TH CENTURY

HANGING SCROLL: INK ON PAPER; 84.6 X 30.6 CM

JOHN L. SEVERANCE FUND 1982.131

Japanese travelers to the continent in the fourteenth and fifteenth centuries were intent not only on commercial success but intellectual stimulation as well. Trade missions frequently included learned members of a Zen monastic community whose aspirations included audiences with renowned Chinese clerics at their rural monasteries, maintaining direct communications with religious colleagues of their Zen sect, and gathering new Buddhist religious texts, commentaries, and ritual implements.

Among the visual aids keenly sought after by the Japanese monks were portraits of revered Chinese Zen priests, iconographical drawings describing and interpreting Buddhist deities, and images in ink of imaginary mountain vistas, birds and flowers, or figural compositions. These ink paintings were invariably done in the rich "colors of ink" in an array of brush styles then novel to the Japanese. Executed on paper in the handscroll or hanging scroll format, these pictures were displayed in Chinese Zen (Chan) temples, often serving as subjects of contemplation or lively conversation. The Zen community in Japan and its supporters in the military government quickly became intrigued by these new pictorial images and their usage and set about obtaining them for export. The fifteenth-century shogunal collection in Kyoto contained several hundred Chinese paintings, according to historical documents. Korean monk-painters also came to Japan, where their work was esteemed and collected. The Japanese tried emulating their Korean and Chinese colleagues, for most of these ostensibly "simple" paintings were in fact not done by professionally trained artists but by amateur monk-painters themselves. Indeed as the demand in fifteenth-century Japan for Chinese and Korean paintings increased dramatically beyond the available supply, Japanese monk-painters were called upon to provide substitutes for the growing native audience. Eventually each of the major Zen monasteries housed a small group of residents proficient in ink painting, poetry, and calligraphy, all of which coalesced in the ink painting and inscriptions that frequently appear above the image.

Gradually ink painting came to embody not just the technically difficult ink-and-brush techniques, or even the novel and varied subject matter portrayed in these scrolls, but also an understanding of a comprehensive aesthetic sensibility permeating all aspects of life and material culture in medieval Japan and later. *Windy Landscape* depicts the humble waterside retreat of an official retired from government service. He gazes out over the wind-swept water expanse toward a scurrying merchant sailboat and distant, mist-enveloped mountain ranges. All the forms in this dynamic composition reveal a masterly control of the subtleties of ink washes and brush movement in the service of expressing a cultural ideal of the time. Actually, the landscape vision is as imaginary as the social reality of fifteenth-century Japan: few government officials, or even eminent clerics, were able to retire into the countryside away from the call of politics. M.E.C.

ATTRIBUTED TO GAKUO (JAPANESE, LATE 15TH EARLY–16TH CENTURY),

MUROMACHI PERIOD

HANGING SCROLL: INK ON PAPER; 104.5 X 44 CM

JOHN L. SEVERANCE FUND 1985.110

The Bodhisattva Avalokiteshvara (Kannon in Japanese) is among the most popular Buddhist deities in Japan. By at least the twelfth century, painted images of this merciful figure surrounded by water, lush vegetation, and bamboo were being imported from the continent and also painted within the compounds of Japan's own monastic institutions. While initially such imagery emerged from literary descriptions in important religious texts extolling the virtues of Kannon, by the fourteenth and fifteenth centuries in Japan the deity depicted became more physically attractive and its presentation more varied. Shedding the guise of "foreignness" (Chinese or Korean), the white-robed manifestation of Kannon became the primary figural subject of medieval Zen painting.

The relaxed swaying posture of Kannon lends an air of informality to this picture, enhancing the deity's appeal. The casual brushwork describing rocks, streambank, and water ripples accentuates this mood. Binding the composition together is a carefully orchestrated painting of subtly toned ink washes suffusing the atmosphere and illuminating the face and upper torso of the figure with the arc of the large halo. The composition and its constituent elements—especially the bamboo grove and the artist's clear delight in executing quick, almost rough, brushstrokes—mark a highly individualistic departure from normal representations of the time. Still, the fundamental Zen enigma remains accessible for pondering: which is more "real," the moon or its reflection?

In the quest for spiritual awakening, Japan's medieval Zen monasteries embraced the use of paintings such as this white-robed Kannon as ceremonial objects and aids in instruction. Fresh interpretations of traditional Zen subjects were encouraged and they varied as widely as individual paths to enlightenment. M.R.C.

Phoenix and Paulownia, Peacock and Bamboo

ATTRIBUTED TO TOSA MITSUYOSHI (JAPANESE, 1539–1613), MOMOYAMA PERIOD
PAIR OF SIX-FOLD SCREENS: INK AND COLOR ON GOLD GROUND;
160.5 X 362 CM (EACH)
LEONARD C. HANNA JR. FUND 1986.2, 1986.3

The flowering paulownia trees on the right screen signal summer, which gives way across the golden expanse of the painting's surface to the arrival of winter, indicated by the red lantern flowers. Traditional *yamato-e* (a colorful indigenous style of painting) embraces seasonal references through displays of specific flora and fauna, or human activity, painted in vivid mineral pigments rather than the ink tones associated with Chinese and Korean painting. The viewer is invited to acknowledge the passage of the seasons as part of the larger cycle of life, and time, in the world of things. The placement of concentrated "islands" of trees, bamboo, and flowers against the gold background enhances these references and highlights the dramatic pairing of peacocks and phoenixes.

These colorful birds have been taken from classical Chinese lore to symbolize rebirth as well as imperial authority. The peacocks also lend themselves to this theme in colorful stylization. Proud, and rare, such imagery appealed to the taste of wealthy merchants or powerful military leaders in the sixteenth century whose large residences were adorned with wall and sliding door paintings and portable screens like these. The gold background was also practical, providing a reflective surface for the candles and oil lamps used at the time for interior illumination.

Although expensive, such paintings were in demand, and studios of artists labored to provide them. Craftsmen trained in such decorative arts as lacquering joined with carpenters and painters on these commissions, some of which called for entire castles to be outfitted. The Tosa school of yamato-e painters produced many fine bird and flower compositions in the Momoyama period, among which this pair of screens represents a particularly dramatic example to have entered a Western collection. The painting style is reminiscent of the artist Tosa Mitsuyoshi, whose compositions include not only large screens but also small, delicate fan and album paintings. These, too, were staples of the Tosa studio, which championed subjects and themes native to Japanese history and culture in their commissions. M.R.C.

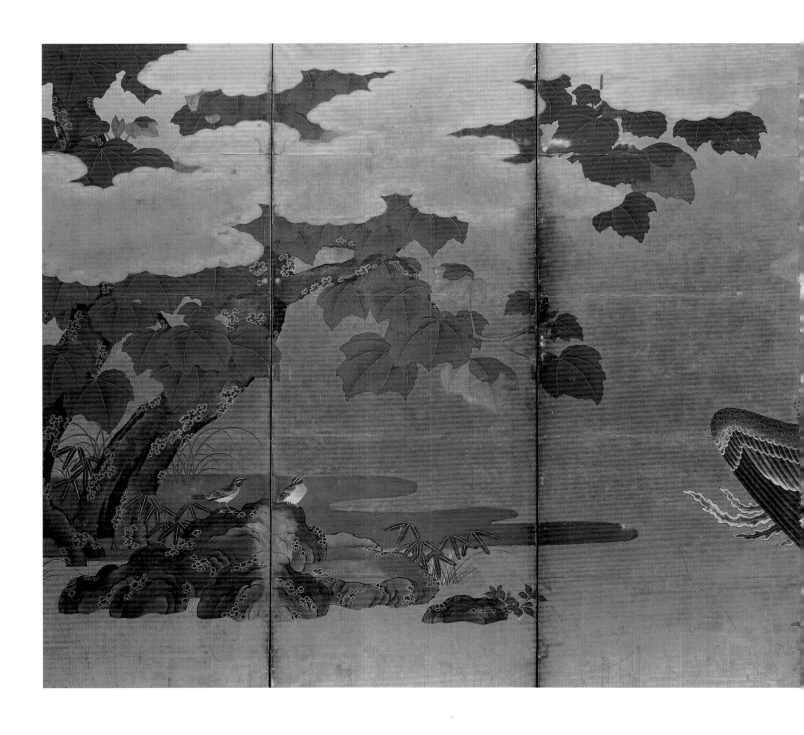

Horse Race at Kamo Shrine

JAPAN, EDO PERIOD, FIRST HALF OF 17TH CENTURY
PAIR OF SIX-FOLD SCREENS: INK AND COLOR ON PAPER WITH GOLD;
161 X 362 CM (EACH)
PURCHASE FROM THE J. H. WADE FUND 1976.95, 1976.96

Among the major Shinto shrines of ancient Kyoto few occupy a more prominent role in the life of the city's residents than the Kamo shrines. Dedicated by the seventh century to the worship of native *kami* (deities), both the upper and lower shrines have become impressive compounds with numerous outbuildings. Shown here is a panoramic view of the lower shrine, which sits on the promontory in central Kyoto formed by the joining of the two branches of the Kamo river. Set in deep woods, the shrine's principal buildings are arranged along an axis that proceeds from the tall red *tori* (entrance gate) toward the walled compound in which the hidden deities reside (left screen). But, as these screens reveal, an assortment of activities associated with daily life as well as special holiday events occur within shrine grounds.

Taking up nearly the entire right screen is a depiction of the annual 15 May horse race held in conjunction with the Hollyhock Festival. This event, which dates to the Heian period, enjoyed the participation of the court and drew many thousands of spectators. Each wears a distinctively patterned garment and assumes a particular gesture or pose that sets him or her apart from those nearby. Children also appear in the crowds; the special viewing building, set back slightly, is for privileged court members. The animation and density of the figural groupings is extraordinary, even for genre paintings of the Edo period. These lively compositions draw upon the venerated Heian period illustrated handscroll tradition of scenes from daily life or religious narrative for inspiration. The tradition of depicting ordinary people in scenes of everyday life occurs in Japanese art earlier and more continuously than in the artistic traditions of either of its East Asian neighbors.

The unknown painter of these screens was equally adept at rendering the landscape scenery, plant life, and architectural features of the various shrine buildings. These screens are in fact an abbreviated version of a much larger "mural" painting: originally the Kamo festival scenery filled several *fusuma* (sliding door panels) of an entire room based on the Kamo horse race subject. Two other fragments of the original painting panels are known, in Japan and Germany, providing a larger glimpse of the work's breadth of vision. Regrettably the identity of the painter is unknown, but his training in the colorful and animated tradition of yamato-e is readily apparent. M.R.C.

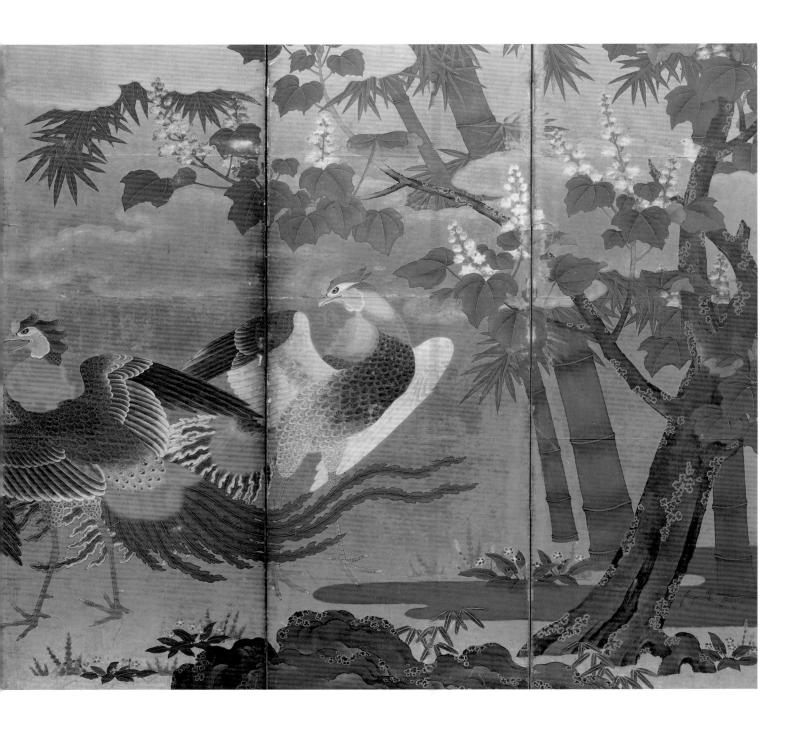

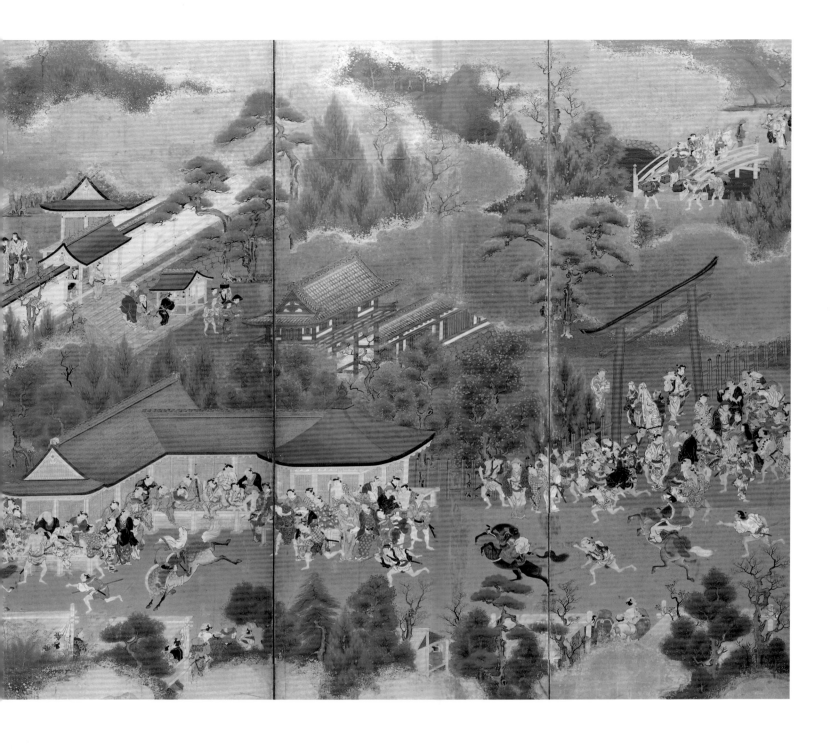

Flask in the Shape of a Fan, Kakiemon Ware

JAPAN, EDO PERIOD, LATE 17TH CENTURY

PORCELAIN, MOLDED, CARVED, AND GLAZED WITH OVERGLAZE ENAMEL DESIGNS;

H. 33.3, DIAM. 19.4 CM

SEVERANCE AND GRETA MILLIKIN PURCHASE FUND 1993.2

Japan's earliest Jomon vessels and medieval utilitarian jars reflect the culture's fundamental preference for natural earthen colors and gritty robust forms. So it is not surprising that the materials and technology necessary to produce white porcelain became available well after similar developments in Korea and China. Indeed, neither the technical discovery nor the urgency to produce porcelain were indigenous. Instead, the Korean potters in Kyushu, the large southern island of Japan, first identified a source for porcelain clay there, and Dutch tradesmen, who were searching for a source to match the demand for porcelain in their Southeast Asian and European markets, encouraged its production. Chinese porcelain with blue-and-white designs had been exported directly by the Portuguese to Europe by the mid-sixteenth century, thereby establishing a taste there for these colorful ceramics. In the early seventeenth century the Dutch began to rival and then surpass the Portuguese as exporters of Chinese, and then Japanese, porcelain wares. Further, when China's civil wars inhibited the flow of high-quality porcelains, the Japanese industry in the area around Arita in Kyushu stepped in to fill the void.

By the mid-seventeenth century the porcelain industry in Arita was producing an improved underglaze blue ware as well as early enameled wares. Toward the last decades of the century, when the rare shape depicted here was produced, various innovative styles of high-quality overglaze decoration had become established at kilns in the Arita region. Among these, Kakiemon was particularly appreciated by both Dutch and Chinese traders, whose primary markets included France and England for this type of ware. It is precisely this Kakiemon style that the porcelain factories at Chantilly, Meissen, and Chelsea emulated in the eighteenth century.

Indeed this unusual sake flask came from a collection in England where documented inventories of Japanese porcelains from the late seventeenth century filled the public rooms of aristocratic country houses. Its shape is that of a rigid, rather then folding, bamboo fan with painted panels. The white clay body is of very high quality, and the flower and phoenix design delicately executed. Most notable however are the felicitous compositions, done with the inimitable Japanese sensibility for the economy of space and the acute precision of placement. M.R.C.

Plate with Persimmon Branch Design, Kutani Ware

JAPAN, EDO PERIOD, LATE 17TH CENTURY

GLAZED STONEWARE WITH OVERGLAZE ENAMEL DECORATION; H. 6.2,

DIAM. 33.4 CM

GIFT OF SEVERANCE A. MILLIKIN 1964.245

The seventeenth and eighteenth centuries in Japan offer an especially rich and varied group of ceramic wares. Their individual histories of development and patronage, technical advance, and visual creativity is relatively well recorded. The strong domestic market for tea utensils favored the traditional earthenware and stoneware kilns. But high-fired painted porcelains from China and Korea were known and sought after by the well-to-do in Edo society. The market for underglaze blue ware or plates decorated with classical Chinese legends appealed to the Japanese, and the Chinese produced and exported sufficient numbers to meet the demand. Domestic kilns also sprang up in the Arita region in Kyushu, eventually producing good quality porcelains decorated in underglaze cobalt blue for a Southeast Asian market.

But it was the fall of the Ming dynasty and the subsequent disruption of the flow of export ware from China to Europe that promoted the meteoric rise of Japan's porcelain industry. Through the offices of the Dutch East India Company, which had an office on an island near Nagasaki, Japanese potters were given huge orders to fill with requirements for higher quality ware. Between mid-century and the early decades of the eighteenth century the Japanese porcelain industry responded with various, brilliantly colored ware in a style that Europeans favored over Chinese examples. Imari ware and especially Kakiemon were in great demand, as was the more standard blue-and-white Arita ware.

But other porcelain types, Kutani and Nabeshima ware, also appeared at this time and found favor primarily with the burgeoning domestic market. Kutani ware features large plates decorated in bold designs that embrace the entire surface of the form. The rich enamel palette comprises blue, green, red, yellow, and aubergine applied in bold contrasting patterns. While most of these designs feature compositions with imaginary Chinese scenery, another important group presents imagery done in a classical Japanese-style painting vocabulary.

This plate, with its background of mustard yellow ferns acting as a foil for the truncated branch of a persimmon tree, is a splendid example of Kutani's exuberance. It is an innovate motif not unlike those in the highly decorative and imaginatively designed compositions of the Rimpa School of artists in the seventeenth and eighteenth centuries. And while those artists were justly famous in their day, very little can be factually stated about the Kutani kilns and their potters. Thus far the potters, decorators, and patrons of the ware remain anonymous. Yet along with Nabeshima, Kutani is among the most sought after of all Japanese porcelains. M.R.C.

TAMURA SUIO (JAPANESE, ACTIVE ABOUT 1680–1730), EDO PERIOD

HANGING SCROLL: INK AND COLOR ON SILK; 50.5 X 82.3 CM

THE KELVIN SMITH COLLECTION, GIVEN BY MRS. KELVIN SMITH 1985.275

Toward the end of the sixteenth century Japanese artists and their patrons became increasingly interested in depicting scenes of life in their own country rather than imagined vignettes of traditional China and Korea. With the consolidation of political authority in the land and the resultant expectation of peace came economic prosperity. The arts also began a period of sustained growth and enrichment, supported not by the court or feudal lords so much as by the emerging merchant class.

Although they occupied a low position in Japan's rigid social order, merchants enjoyed the new prestige of affluence and naturally found ways to indulge their interests at their leisure. They actively participated in and were oftentimes the principal benefactors of literary groups, tea ceremony parties, and the celebrated entertainment districts of Osaka, Kyoto, and Tokyo. In these precincts men from all classes were granted admission provided they had the financial means to pay or some creative talent that could be supported by a wealthy benefactor. The women of these pleasure quarters were the most beautiful and among the most educated in all society, and their company cost dearly in seventeenth- and eighteenth-century Japan.

Artists flocked to the Yoshiwara district in Tokyo (then called Edo) too. They participated in its diversions and creative gatherings, recording many of its activities, personalities, and sights. Popular culture, in particular the entertainment worlds of the theater and the Yoshiwara, became a legitimate, vibrant subject in the established vocabulary of Japanese painting and literature.

This charming portrayal of four young women enjoying an autumn afternoon together shows the camaraderie of the Yoshiwara beauties. Their conversations and reading has been interrupted by the arrival of a young man, the suitor of one of the women. The elegant robes and fine furnishings indicate the sophisticated taste of contemporary urban society in eighteenth-century Japan. And the idyllic, breezy outdoor setting depicted in the painting lends to the air of youth and optimism so characteristic of the time. M.R.C.

ATTRIBUTED TO FUKAE ROSHU (JAPANESE, 1699–1755), EDO PERIOD
SIX-FOLD SCREEN: INK AND COLOR ON GOLD GROUND; 150.6 X 271.8 CM
JOHN L. SEVERANCE FUND 1954.127

The Edo period in Japan was a vibrant era, characterized by political stability, economic expansion, and an unprecedented range of expression in the arts. Patronage expanded dramatically in this environment, and individual artists and craftsmen, as well as studios of artisans, responded to orders and requests for objects to adorn residences, temples, and castles.

Among the more innovative schools of painting that emerged in the seventeenth century was the Rimpa (Decorative School)—painters, lacquerers, book designers, and calligraphers from Kyoto, Japan's cultural center since the ninth century. Inspired by the literary themes and visual impact of traditional Heian period art, these artists sought to revive and then transform these ideas and motifs for a modern audience. In this way the classics, which had once been the sole province of the small aristocratic class, entered the public domain. The newly wealthy merchant class became particularly strong, even lavish, patrons of the arts.

This single screen reflects the eighteenth century's abiding taste for one tenth-century poetic classic, the *Tales of Ise* (Ise Monogatari). Composed as an episodic narrative, it recounts the legendary journey from Kyoto toward the distant northern provinces by the courtier Ariwara no Narihira (about 824–880), known for his talents as a poet and as one who had numerous affairs of the heart while in attendance at court. Narihira's life gathered mythical dimensions over the centuries thanks to the popularity of the poems collected in the *Tales of Ise*. Depicted here is a scene in the anthology, "Ivy Lane," also known as "The Pass through Mt. Utsu," in which Narihira asks an itinerant monk on his way to Kyoto to carry a poem back to a lover.

The mountain shapes are truncated and devoid of Western "realistic" features. Similarly the stream and nearby rocks and plant life are schematized to compose and focus the figures. Likewise, the mineral pigments are rich yet subdued in tonalities, allowing the gold leaf background to provide visual accents. Although Roshu's oeuvre is small, this subject is the one he is most closely identified with, and one that has come to epitomize Rimpa painting. Elegant, filled with classical allusions to poetry, literature, and history in a remarkable combination of curvilinear shapes never fully revealed, Rimpa art represents an important contribution to East Asian painting traditions. M.R.C.

JAPAN, EDO PERIOD, FIRST HALF 18TH CENTURY

EMBROIDERY: SILK AND APPLIED GOLD LEAF ON SILK GROUND;

158.5 X 138 CM

PURCHASE FROM THE J. H. WADE FUND 1974.36

This magnificent robe was a costume specifically designed for performances of Noh theater in Japan. Originating during the fourteenth century from simple folk plays, Noh drama evolved into formal presentations of ritual, drama, dance, and music performed in the courts and shrines of the nobility. Stories were derived from a variety of sources—myths, legends, poetry, prose—many dating back to the medieval period. Because great importance was placed on subtlety and elegance, plots tended to be minimal. All roles, whether male or female, were played by men.

Central to these performances were the masks and costumes worn by the actors. The brilliance and elegance of this robe are characteristic of costumes made solely for Noh theater. Its date in the first half of the eighteenth century is indicated by the proportions of the robe, the choice of embroidery stitches (satin, couching, and outline), and the absence of decoration at the hips, a fashion also reflected in kimonos at that time.

The design of weeping cherry trees and irises in the snow was very likely inspired by a medieval Japanese poem. Robes decorated with embroidery against a gold ground were reserved for female roles. These robes were worn under an external garment and were, therefore, only partially visible. A.W.

225

Tiered Food Box with Stand

JAPAN, RYUKYU ISLANDS, EDO PERIOD, LATE 18TH CENTURY
RED LACQUER OVER A WOOD CORE, WITH LITHARGE PAINTING AND ENGRAVED
GOLD DESIGNS; H. 53, W. 68 CM
PURCHASE FROM THE J. H. WADE FUND 1989.5

Extending south from the islands between Kyushu and Taiwan, the Ryukyu Islands form an important historical, ethnic, and cultural link between the continent and Japan. These islands had been united as an independent kingdom since at least the fourteenth century, when written documents note contact with the Chinese as well as internal political conflicts. The Ryukyus were geographically well situated to participate in maritime commerce between Southeast Asia and East Asia, especially for traders from China and Japan. But the islands also had a distinct cultural identity, as can be seen in their textiles, ceramics, architecture, basketry, and lacquerwares. While contacts with China and Japan were frequent, the Ryukyus maintained their independence, with a capital on Okinawa, until being annexed in 1872 by the Japanese. Thus, while the early lacquers of the fourteenth and fifteenth centuries reflect strong influences from Chinese monochrome or inlay lacquer types, by the sixteenth century a Ryukyuan lacquer style as well as special techniques of fabrication were in place.

Such pieces were eagerly sought after by knowledgeable Japanese collectors, for their special "flavor," shapes, and combination of materials. Tea patrons sought them out as accessories that brought a special nuance to the tea ceremony. And, unlike comparable Chinese types, they were less costly. Tokugawa Ieyasu, the first shogun of modern Japan, assembled hundreds of Ryukyu lacquerwares in his lifetime and enjoyed using them.

This large pentagonal food box was also meant to be used as a kind of portable dinner set. Three fitted trays and a lid are stacked together and rest on a carved stand with five feet. The distinctively Ryukyuan red lacquer surface has two principal designs: a lid with intertwined imperial dragons and lateral surfaces with assorted floral patterns. All these designs are executed in two techniques: incised lines cut through the lacquer and into the wooden core that are then painted with gold; and oil-base pigments in a variety of tones (litharge painting). The result is an imposing architectural structure, inventively decorated with emblems combining references to the imperial lineage (dragons) and the Buddhist world of transience (lotus flowers). This food box was no doubt intended to be used for only very special occasions. M.R.C.

WATANABE KAZAN (JAPANESE, 1793–1841), EDO PERIOD, DATED 1827

HANGING SCROLL: INK AND COLOR ON PAPER; 221.3 X 117.6 CM

LEONARD C. HANNA JR. FUND 1980.177

Watanabe Kazan enjoyed the exalted social status of being born into the samurai class, yet he suffered from poverty during his entire lifetime. Indeed, nineteenth-century Japan was a period of social and economic turbulence, and government officials frequently found it impossible to support themselves on an annual stipend. Kazan's predicament was exacerbated by his talent and his intellect. As a young man he excelled in his studies of the Chinese and Japanese classics, and this traditional course propelled him into an examination of Western ideas, which were popular at the time but officially censored by the seclusionist military government. Stifled economically and intellectually by the status quo, Kazan pursued a career as a painter to support himself but also followed his interests in the outside world. Realizing Japan's weakened position in a rapidly modernizing world order, he openly proclaimed the country's need to secure its own interests while it entered the international arena of world affairs. Not embraced by the government, his views instead led to his arrest, exile, and eventual suicide.

Kazan met Ozorabuzaemon in Edo where the young man from the distant provinces had traveled with his feudal lord in hope of becoming a sumo wrestler. His gigantic size and shy country manners attracted great curiosity in urban Edo. These features are recorded in Kazan's sketch portrait, done when he met Ozorabuzaemon in the summer of 1827 at a friend's house. In addition to the various statistics recorded in the inscription is an actual impression of the giant's handprint, testimony to the era's keen interest in the documentation of natural phenomena à la Western scientific methods currently in vogue in Japan. Kazan's portrayal, beginning with the preliminary drawing lines, which are still visible, is poignantly sympathetic and intense. It uses the informality of the assembled paper sheets, sketchily brushed lines, and then transparent ink washes to convey the psychological fragility of the subject and, in a way, the artist's own condition. M.R.C.

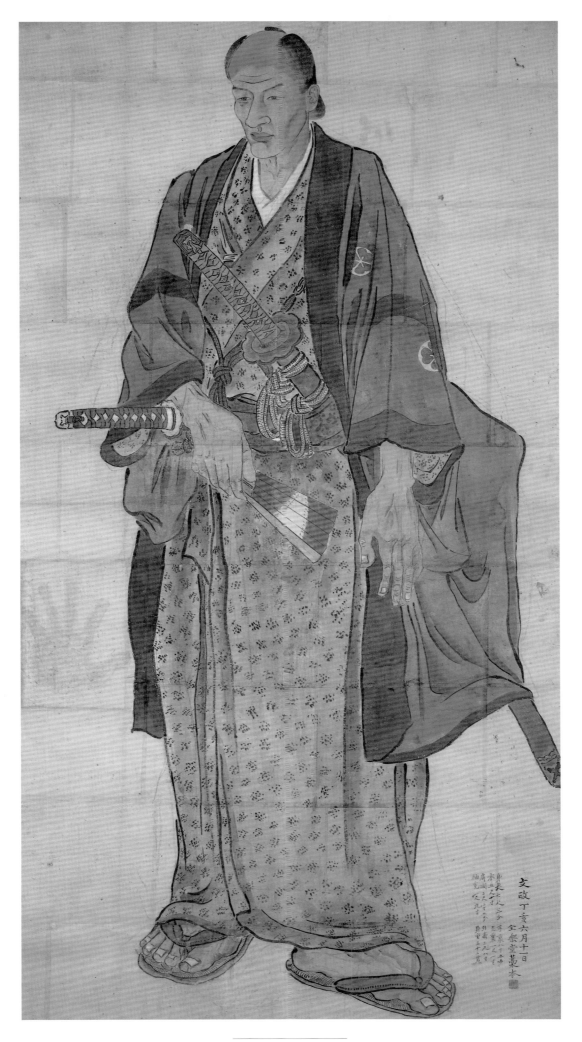

文政丁亥六月十一日
金樂堂葛木

Standing Buddha Amitabha (Amit'a)

KOREA, UNIFIED SILLA PERIOD, 9TH CENTURY

GILT BRONZE; H. 25.4 WITH TANGS 26 CM

LEONARD C. HANNA JR. FUND 1988.34

The Kingdom of Silla in southeastern Korea coexisted with its neighbors Kaya (to the south), Paekche (to the west), and Koguryo (to the north) for several centuries before political tensions erupted into serious conflict in the seventh century. Competing alliances among the kingdoms and between foreign neighbors to the north (China) and east (Japan) resulted finally in Silla's campaign to overcome its peninsular neighbors. Koguryo felt Tang China's power in the early seventh century, gradually succumbing to allied Tang-Silla armies in 668. Paekche had already fallen to Silla six years earlier. As a result, a unified state of Silla began governing the various peoples of the Korean peninsula under the watchful eyes of its neighbor to the north, which had absorbed much of Koguryo's former territory. Contact with Japan diminished although Paekche allies who had fled in defeat to the island nation proved a valuable source of information about systems of government, technology, and current Buddhist thought on the continent.

As the new Unified Silla state actually expanded its governance into the former territories of Paekche and Koguryo it also discovered their rich, diverse cultural environments: Paekche had the flavor of southern Chinese influence, and Koguryo the northern Chinese provinces. The great expansion of Silla then consolidated and increased the development of native cultural forms and styles. While politically and culturally aware of Tang China, the late seventh and the eighth centuries mark the time during which Buddhism and the arts in Korea began to take on an independent, native cast once more.

The synthesis of truly international styles with native traditions represents a major theme in East Asian art at this time and appears in this robust gilt bronze Amitabha (Amit'a in Korean). The Tang attention to attractive bodily proportions and arrangements of jewelry has become simplified. This Amit'a is stout, its drapery less busy and more revealing of the bodily forms underneath. The facial expression reflects the gentle compassion of Amit'a, whose worship became very popular during the Unified Silla period, primarily because of the belief that the simple recitation of a short phrase honoring the deity's name would assure rebirth in his abode in a heavenly Western Paradise. Such comparatively easy paths to spiritual salvation fostered the spread of popular Buddhism throughout Korea, a message also conveyed by portable icons to which the devout could pray in private, wherever they might be. M.R.C.

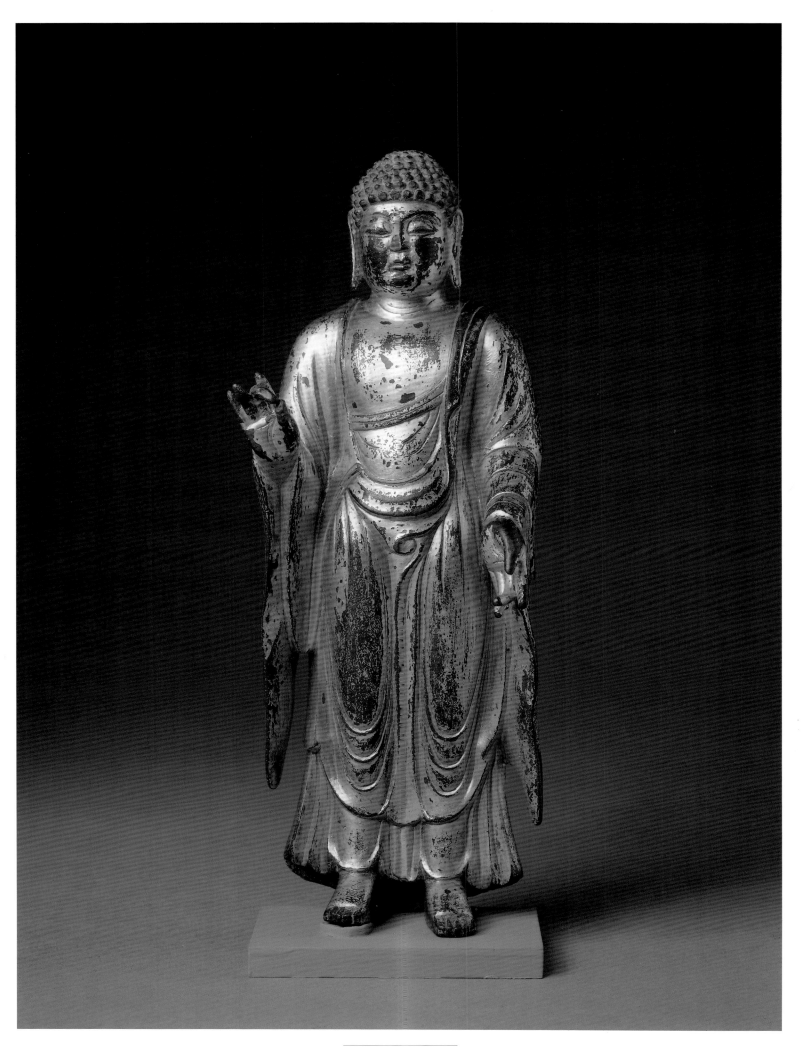

Basin

KOREA, KORYO PERIOD, 13TH CENTURY

CAST BRONZE WITH INLAID SILVER INSCRIPTIONS, FLORAL DECOR, AND FIGURAL

DESIGNS; H. 17, W. (AT MOUTH RIM) 28.3 CM

LEONARD C. HANNA JR. FUND 1985.112

The designs encircling the surface of this vessel are inlaid in silver. This technique of cutting designs into a form and then filling it with a contrasting material to create a lively surface pattern was popular during the Koryo period and attained a high level of sophistication not only in metalwork but also in the ceramic art of Koryo celadons. After this vessel, probably an incense burner, was cast, it was turned on a lathe to finish the surface and make subtle adjustments in the shape. Then the roundels with poems, arabesques with central figures of children, and upper and lower border designs were chiseled into the hard metal surface. Next, strands of thin silver wire were carefully hammered into these recesses, providing the overall linear decor. The result is a surface design combining the decorative with the instructive: the four-line poems in the three roundels carry a Buddhist message.

The form of this vessel is rare. Most Korean incense burners have wide flaring rims and sit on high pedestals. The plain foot of this basin contains an important inscription incised into its surface that names a monk-priest and the temple to which this vessel was donated. The two loop handles are Japanese additions applied when the vessel was later adapted for use in the tea ceremony. The military ruler Toyotomi Hideyoshi (1536–1598) ordered a Japanese invasion of the Korean peninsula in 1592 that wrought destruction throughout the country for a half-dozen years. Virtually all the country's Buddhist monasteries were looted and destroyed. Large numbers of cultural artifacts were also brought back to Japan, especially ceramics and Buddhist objects that were genuinely esteemed by the Japanese. In time these Korean treasures became part of Japan's cultural fabric, both as individual art objects and as catalysts for aesthetic appreciation in Japanese society. M.R.C.

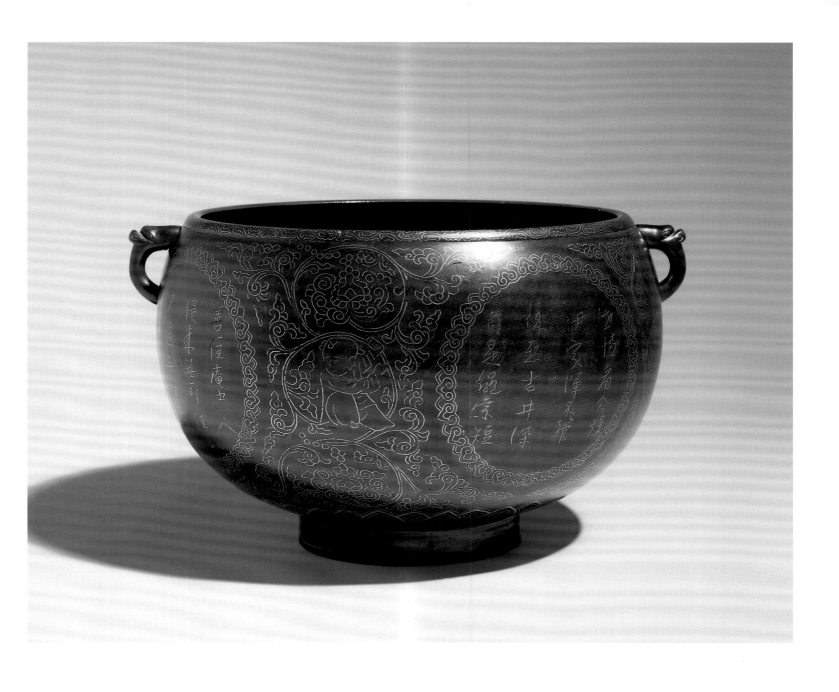

233

Bell

KOREA, KORYO PERIOD, 13TH CENTURY

CAST BRONZE WITH INCISED INSCRIPTION; H. 23, DIAM. 14 CM

JOHN L. SEVERANCE FUND 1992.118

Casting metal to produce objects used in Buddhist rituals enjoys a long tradition in Korea. By at least the early sixth century, artisans were producing finely detailed, gilt-bronze images for private devotion. By the next century these icons had proliferated dramatically and attained impressive scale and a distinctively Korean appearance. Like the Chinese icons brought to Korea, these Korean statues were carried to Japan to help spread the new faith since religious sculpture did not exist in that land before the arrival of Buddhism.

As more and more Buddhist temples were established throughout the Korean peninsula during the Unified Silla and Koryo periods, the demand for statuary and ritual objects used in daily services expanded. Among these objects, one of the most important is the bell, which calls the faithful to services in the temple precinct, announces the beginning of each day, and highlights special ceremonies held throughout the year. The ancient Silla capital, Kyongju, had several grand temple complexes, one of whose bronze bells survives. It stands 3.3 meters high, weighs more than two tons, and has exquisitely cast surface designs of heavenly angels amid clouds. Like most large temple bells it was suspended in a separate building within the temple compound.

Most bronze bells of the Koryo period, however, are more modest in scale, such as this example. It was proudly kept inside the main hall of the temple, in front of the principal devotional icon along with other ritual objects used in daily services. It could have been hand-held or suspended from a simple wooden support frame. The bell produces a tone when struck on the exterior surface with a wooden mallet.

Korean bells have a vertical tube on the top surface adjoining the dragon "hook" from which they are suspended. This sound tube, thought to have evolved as a structural feature for amplifying the sound of the bell, is a feature uniquely Korean. The surface decor includes raised diaper patterns, floral arabesques, and seated deities on lotus bases. Following the successful casting of these elements a dedicatory inscription was incised into the surface, a custom often found in the Buddhist arts. In this way, the patron who commissioned the bell gained religious merit. Although the identity of both the donor and the temple recipient of this bell are not stated, the text represents an important document of Koryo Buddhist metalwork. M.R.C.

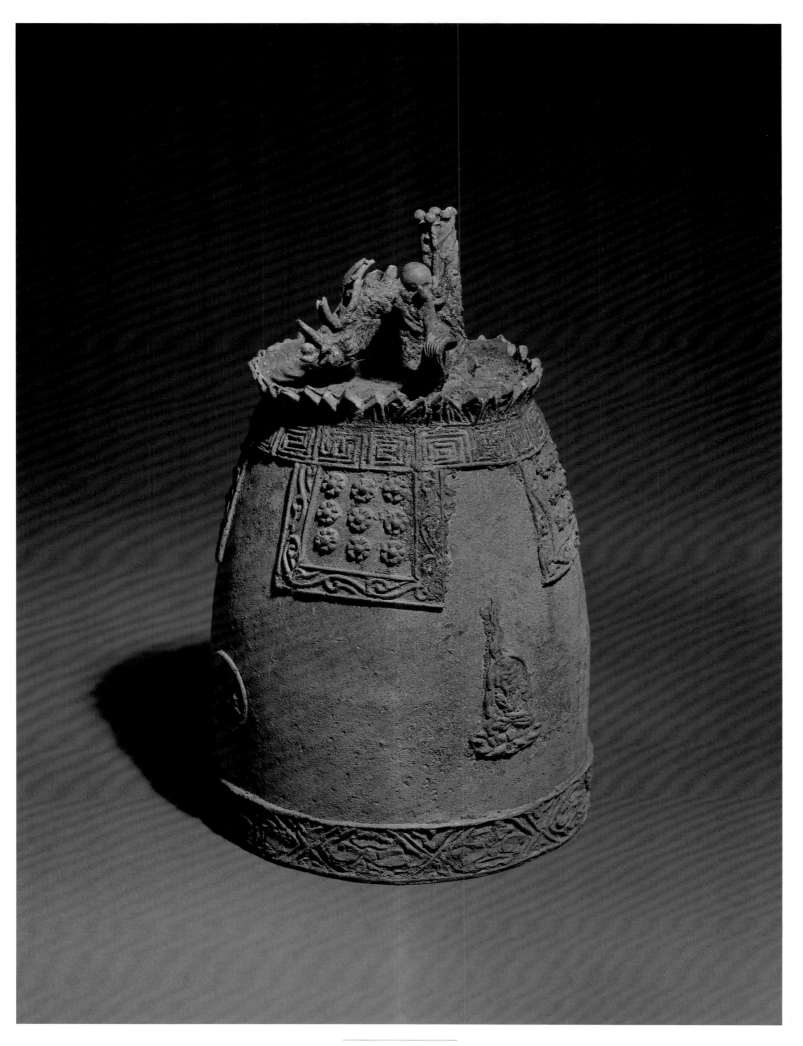

Avalokiteshvara (Kuanum Bosal)

KOREA, KORYO PERIOD, 14TH CENTURY

HANGING SCROLL: INK AND COLOR ON SILK WITH INSCRIPTION IN GOLD INK ON

SILK; 155 = 51.4 CM

THE SEVERANCE AND GRETA MILLIKIN PURCHASE FUND 1986.8

During the Koryo dynasty, Buddhism flourished as it had never before in Korea. Introduced into the culture during the Unified Silla period from China, a distinctly Korean Buddhist faith that had virtual state support was thriving by the tenth century. Throughout the country hundreds, if not thousands, of temples served as the focal point for Buddhist rituals and culture.

Central to worship were painted images of the Buddhist deities, among whom Amitabha (Amit'a in Korean) and that deity's two attendants Avalokiteshvara (Kuanum Bosal in Korean) and Mahasthamprapta (Taeseji Bosal in Korean) are pre-eminent. This triad is closely linked to sutras (sacred religious texts) explaining the virtues of salvation in the Pure Land, or the Western Paradise, the home of Amit'a. Visual representations of the Amit'a triad fostered the acceptance and understanding of this concept and were produced in considerable numbers as Pure Land sect Buddhism became even more popular. Gradually Kuanum gained attention in its own right as a potent deity, recognizable by the small seated buddha image in the crown.

In this painting Kuanum Bosal stands frontally on two lotus bases, left hand holding the wrist of the right hand, which clasps a string of prayer beads. A diaphanous white overgarment does not hide the elaborate robe and sumptuous jewelry beneath. Additionally, a halo behind the icon frames the quiet, introspective face. Above, attached to the silk painting, is an excerpt from a sutra written in gold ink on brown paper, providing a concrete example of how the written word and visual image propel one another in the Buddhist art of Korea. M.R.C.

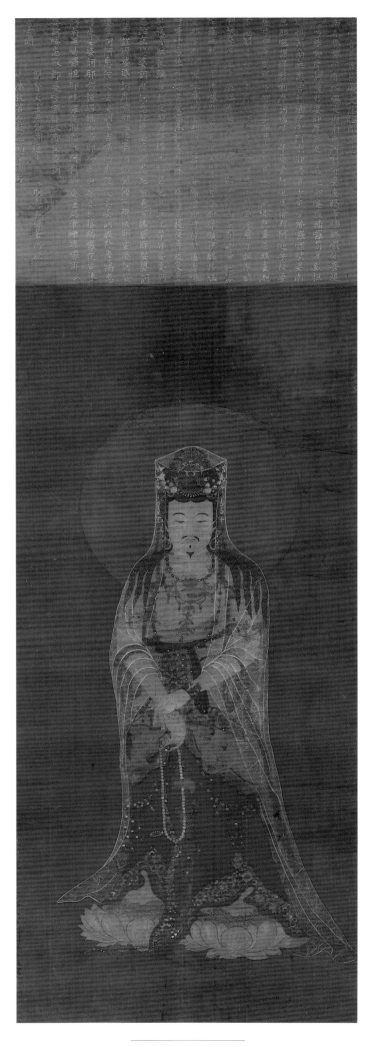

Amit'a Triad

KOREA, CHOSON PERIOD, 15TH CENTURY

CAST BRONZE WITH GILDING; 40.6 X 16.5 X 54.6 CM

WORCESTER R. WARNER COLLECTION 1918.501

At the close of the Koryo period, Buddhism in Korea began to languish. Once lavishly supported by the royal family and the upper social classes, its grand monastic institutions were viewed by the new Choson military leaders as feeble and corrupt. Official government support swung over to promote Confucianism, which developed its own patterns of affiliation with government officials throughout the country. In addition, Buddhist temples found themselves losing the landed estates upon whose revenue they had come to depend for sustenance.

Yet the absorption of the Buddhist faith into the daily life of the populace for a millennium helped maintain the institutions, even in their much reduced circumstances. Local and regional popular support emerged as monasteries assumed more active roles in the communities outside the confines of their compound walls. Solemn religious days were often expanded to include local festivals, markets, and other nonreligious but focal activities of nearby villages. Besides the large colorful banner paintings of Buddhist deities that were displayed prominently out of doors in the temple's courtyard on these holidays, parishioners could view mural painting and statuary inside temple buildings, too.

This rare fifteenth-century triad features a central image of Amit'a flanked by Ksitigarbha (Chijang Bosal in Korean) on his right and Avalokiteshvara (Kuanum Bosal in Korean) to his left. Worshiped in numerous forms, Kuanum serves Amit'a as his most compassionate agent, offering salvation in the Western Paradise presided over by Amit'a. Chijang had become a popular deity during the previous Koryo dynasty, one associated with vivid apocalyptic images of the kings of hell. In the Choson period his appeal to the faithful only expanded.

Each of the flanking figures sits on a lotus base emanating from the central stalk of Amit'a, who sits cross-legged, hands and fingers in a gesture of blessing. Originally this sculpture may have been placed in front of a large mural painting describing the visionary Western Paradise or depicting *apsaras* (heavenly attendants) and loyal disciples. Such arrangements with these three beneficent deities rendered in vivid mineral pigments and accompanied by assemblages of sculpture and painting within a hall dedicated to the worship of Amit'a are recorded, and fortunately a small number survive today in Korea. M.R.C.

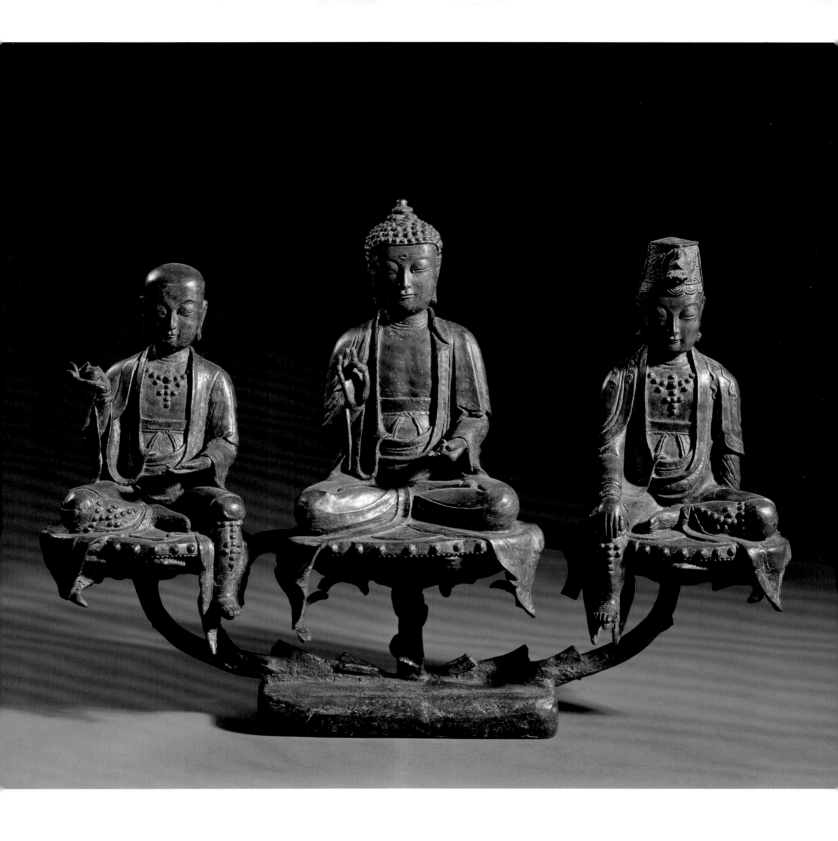

KIM CHE (KOREAN, ACTIVE LATE 16TH CENTURY), CHOSON PERIOD, DATED 1584

HANGING SCROLL: INK ON SILK; 52.3 X 67.2 CM

MR. AND MRS. WILLIAM H. MARLATT FUND 1987.187

Landscape painting in Korea first appears in the early Koryo dynasty in illustrations to religious sutras, although much older, seventh-century molded ceramic tiles with elaborate landscape designs foreshadow the painting tradition. Historical records of the Koryo period point out examples of colorful landscapes, portraiture, and Buddhist imagery that, by and large, have not survived today. Certainly by the twelfth century, professional as well as amateur scholar-painters actively depicted the landscape of Korea in addition to imaginary portrayals of China or the Buddhist realms.

These three basic pictorial modes are best identified among the work of official court painters in the royal academy (Tohwaso) in the early Choson period. They enjoyed official patronage and were also exposed to Chinese Yuan and early Ming dynasty paintings owned by members of the court, whose relations with China had greatly improved. Especially popular among fifteenth- and sixteenth-century Korean patrons were imaginary Chinese landscapes executed in bold dark brushwork, emphasizing stark mountain shapes and vast expanses of space.

Kim Che, an important writer and scholar whose father had preceded him at court, was one of the most celebrated court artists of the sixteenth century. His surviving works include figure paintings and landscape compositions in a distinctively Korean style that had emerged a century earlier in the imagery of the legendary artist An Kyon (1418–?). This painting is important in that it clearly documents Kim Che's painting style at the end of the sixteenth century and thereby provides a basis for understanding other, anonymous works having similar characteristics. This picture features brooding tonal contrasts and expansive distances composed amid an unfolding human narrative of the joys of rustic seclusion. It is winter, yet travelers come and go freely on foot, horse, and by boat. M.R.C.

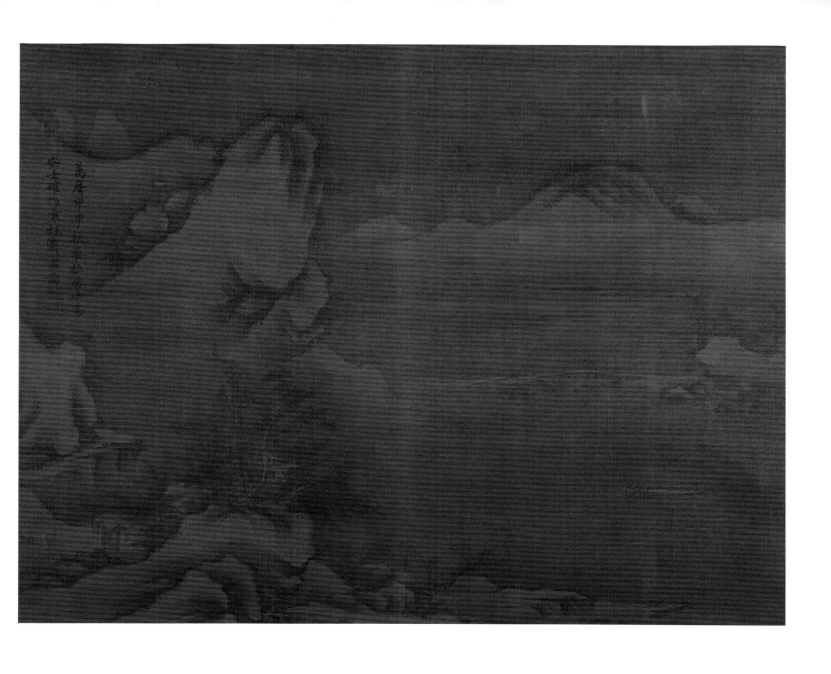

Jar, Punch'ong Ware

KOREAN, CHOSON PERIOD, 15TH CENTURY

STONEWARE WITH INCISED, STAMPED, AND SLIP-INLAID DECORATION UNDER A

CLEAR GLAZE; H. 37.5 CM

JOHN L. SEVERANCE FUND 1963.505

The body of this vessel is separated into three areas, each distinguished by a different surface design. Rising from the flat foot are schematic lotus petals, a motif closely associated with the bases for Buddhist images in East Asia. Next a composition of leaves, tendrils, and branches encompasses the vessel's midriff. These designs were first cut into the clay body and then filled with a clay slip that, when fired, turned white. The execution of the "drawing" in clay is casual, even naive, lending to the visual appeal of the jar.

Above is an impressed "rope-curtain" pattern, which rises to the neck of the jar beyond the four loop handles. These were used to secure a lid and suggest that this vessel, like others of this type, might have originally been used for the burial of a placenta. It would have been placed inside another covered wide-mouthed jar then deposited in the earth inside an outer stone box. This custom had been practiced by aristocratic families in Korea since the Three Kingdoms period in the belief that it would bring happiness to the child.

Punch'ong wares evolved from the Koryo celadon tradition, which perfected inlaid slip decor under a vivid blue-green glaze. By the fourteenth century such technical sophistication had given way to a ceramic tradition that emphasized generous forms made from a coarser clay fabric and expansive surface designs featuring naturalistic motifs executed in seemingly casual patterns. This transformation likely resulted from the effects of the early thirteenth-century Mongol invasion, and its continued influence upon Choson ceramics had a profound effect on the native aesthetic. M.R.C.

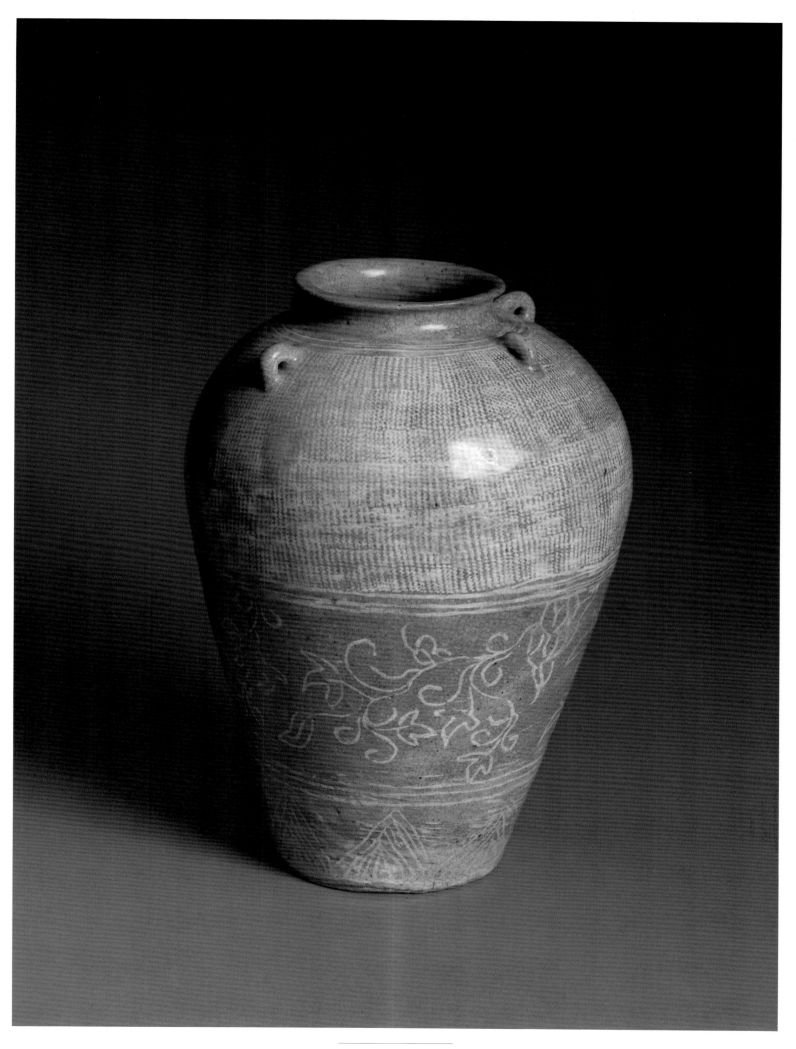

243

Portrait of a Monk

KOREAN, CHOSON PERIOD, 18TH CENTURY

HANGING SCROLL: INK AND COLOR ON SILK; 114.7 X 79.7 CM

MR. AND MRS. WILLIAM H. MARLATT FUND 1990.16

With the fall of the Koryo dynasty, Buddhism went into a serious decline in Korea. The newly established Choson dynasty favored the tenets of Confucianism and supported it vigorously into the eighteenth century, while at the same time suppressing Buddhist institutions and religious practices. But this state effort was not entirely successful, for shamanistic and Buddhist values had by then become deeply instilled in the populace, especially among the lower social classes.

Out of necessity Buddhist temples found other, private means of support for preserving their institutions and rituals that included ancestor worship as well as prayer offerings to all the deceased with the hope that they might be reborn into the Western Paradise. Buddhist activists in the late sixteenth and seventeenth centuries helped form armies to repel the invading Japanese forces. These efforts were rewarded by the court and thereby helped bring about a revival of Buddhism in the mid-Choson period, led by eminent monks.

This portrait issues from that period and from the older, enduring Korean tradition of ancestral and shamanistic portraiture. These paintings were especially commissioned for annual family rites, and they were frequently displayed in special buildings for that purpose. Buddhist monasteries, too, customarily had a building within their grounds set aside specifically for worship in which portraits of illustrious priests or temple founders were continuously on display. These were intended to inspire young monks and as a way to transmit temple history.

Although he remains unidentified, this impressive monk was likely a high priest of the Son (Zen) sect, which became popular in Korea in the sixteenth century. He is seated on a mat in front of a low desk. A set of religious books is depicted, one volume of which is open to reveal the text written in gold script. A wooden writing box with brush, water dropper, ink stone, and ink stick are visible. The monk holds a staff with an elaborate dragon's head finial from which a long whisk of white hair issues. Elegantly painted, it is transparent, revealing the monk's multicolored, gold-brocaded robes. His face, in contrast, is plainly detailed and penetrating in its distant expression. The painting no doubt provided suitable inspiration to those who meditated before it, seeking guidance in the conduct of their religious career through the lessons of past enlightened masters. M.R.C.

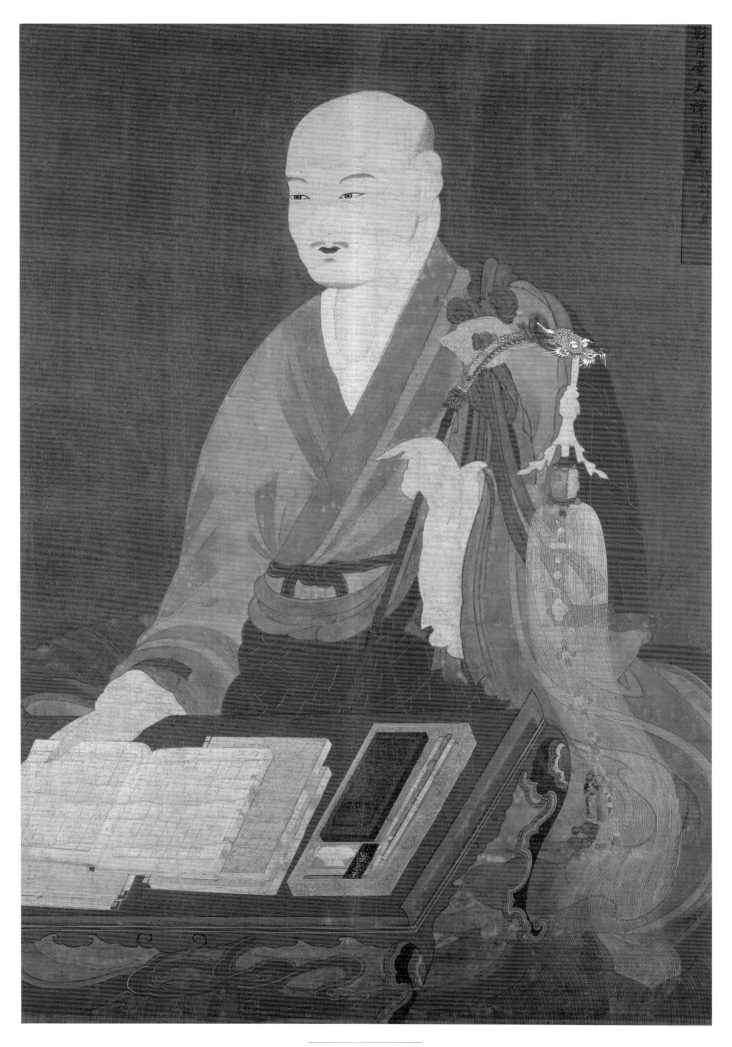

影月堂大禅師真

Storage Jar with Dragon and Clouds Design

KOREA, CHOSON PERIOD, 18TH CENTURY
PORCELAIN WITH UNDERGLAZE IRON DECORATION; H. 35.5, W. 38.7 CM
LEONARD C. HANNA JR. FUND 1986.69

The seam visible halfway up the surface of this swelling form reveals that the jar was constructed from two pieces. The foot is low and appears small for a jar of this volume, but actually its size serves to emphasize the vigor of the overall shape. The low mouth with sharp undercutting enhances this visual effect. This feature also suggests the vessel may have been produced at the official kilns in Kwangjin, southwest of Seoul. There similar underglaze iron painted jars were produced for official government functions using refined porcelaneous clays and high-quality glazes. Rural kilns also produced similar storage vessels, although with a stronger grayish tint because of the higher iron content in the clay body and glaze. And whereas the painted designs on these countryside pieces often appear awkward or hesitant, this jar demonstrates the dynamic skills of a talented metropolitan painter.

Indeed it is precisely at this time, the eighteenth century, that the Korean ceramic industry was at its most dynamic stage. The development from celadon to punch'ong wares had provided a background for the appearance of white porcelain in the mid-Choson period. Made of finer quality clays, it provided a clear surface with color tones ranging from "snow white" to blue-gray hues. Both at government sponsored studios and in rural kilns a new ceramic aesthetic emerged of which this storage vessel is a prime example.

A single undulating animal form—traditionally meant to represent a dragon—encircles the vessel. All brushstrokes are assured, concise, and brimming with energy as the creature swirls around the robust form. Even the traditional fungus-shaped clouds are rendered sketchily, as if their forms were dissolving in the wake of the dragon's speedy passage. M.R.C.

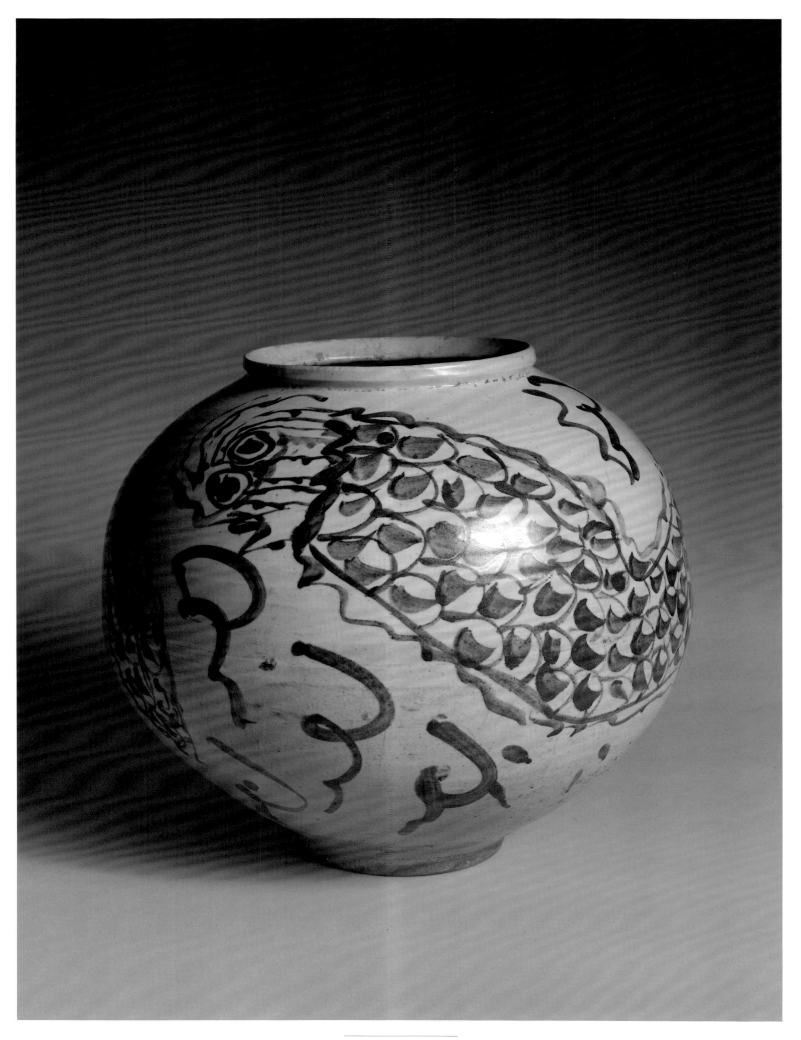

Scroll Box with Dragon and Phoenix Design

KOREA, CHOSON PERIOD, LATE 18TH CENTURY
LACQUERED WOOD WITH MOTHER-OF-PEARL AND TWISTED BRASS
AND WIRE INLAYS; 11.5 X 11.7 X 87 CM
THE SEVERANCE AND GRETA MILLIKIN PURCHASE FUND 1990.15

While large numbers of Korean ceramics and metalwork have survived from earlier times, relatively few lacquers have enjoyed a similar fate. Koryo period mother-of-pearl lacquers, among the most splendid decorative arts produced in medieval East Asia, amount to some twenty pieces, now largely dispersed outside Korea. These pieces were primarily used to store or present Buddhist texts or ritual objects.

With the advent of the Choson dynasty and its support of Confucianism, the production of lacquerwares shifted toward secular objects. Boxes for storing writing implements, jewelry, or documents, as well as furniture for the scholar's room, were made in great numbers. Gradually designs became bolder and more cursory while technique languished under the pressures of mass production. High quality mother-of-pearl became difficult to obtain.

This brilliant box is a rare example of the continued existence in the late Choson period of the highest standards of lacquer production, probably at a workshop supported by the government. The lid design features a dragon and phoenix amid stylized flowers, rocks, and clouds. The two mythical creatures are separated by a flaming jewel, outlined in twisted bronze and brass wires, a technique long favored in Korean lacquer art. The clouds on either side of the jewel, the back of the dragon, and the edge of the "cloud collar" panel that frames the scene were also created using this technique. Surrounding the two imperial animals is a mother-of-pearl landscape with rocks and flowering plants.

The extraordinary quality of workmanship, unique shape among all known Choson lacquers, and imperial symbolism distinguish this box. They indicate a very special commission for the protection of an important scroll, probably a Buddhist painting or ancestor portrait. M.R.C.

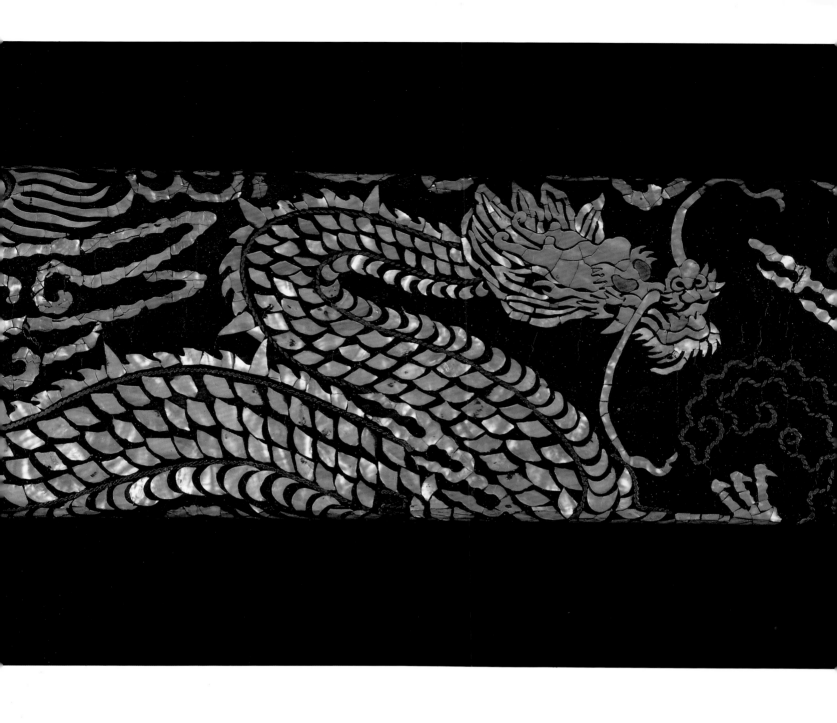

Select Bibliography

China and Central Asia

Bagley, Robert W. *Shang Ritual Bronzes in the Arthur M. Sackler Collections.* Washington, D.C.: Arthur M. Sackler Foundation; Cambridge, Mass.: Arthur M. Sackler Museum, Harvard University, 1987.

Brinker, Helmut, and Albert Lutz. Translated by Susanna Swoboda. *Chinese Cloisonné: The Pierre Uldry Collection.* New York: Asia Society Galleries, 1989.

Cahill, James. *Hills Beyond a River: Chinese Painting of the Yuan Dynasty, 1279–1368.* New York: Weatherhill, 1976.

————. *The Distant Mountains: Chinese Paintings of the Early and Middle Ming Dynasty, 1368–1580.* New York: Weatherhill, 1978.

————. *The Compelling Image: Nature and Style in Seventeenth-Century Chinese Painting.* Cambridge, Mass.: Harvard University Press, 1982.

Falkenhausen, Lothar von. *Suspended Music: Chime Bells in the Culture of Bronze Age China.* Berkeley: University of California Press, 1993.

Fong, Wen C. *Beyond Representation: Chinese Painting and Calligraphy, 8th–14th Century.* Exh. cat. New York: Metropolitan Museum of Art; Princeton: Princeton University Press, 1992.

———— et al. *Images of the Mind: Selections from the Edward L. Elliott Family and John B. Elliott Collections of Chinese Calligraphy and Painting at the Art Museum, Princeton University.* Exh. cat. Princeton: Art Museum, 1984.

Ho, Wai-kam, ed. *The Century of Tung Ch'i-ch'ang, 1555–1636.* Exh. cat. Kansas City: Nelson-Atkins Museum of Art, 1992.

Ho, Wai-kam, Sherman Lee, et al. *Eight Dynasties of Chinese Painting: The Collections of the Nelson Gallery-Atkins Museum, Kansas City, and the Cleveland Museum of Art.* Exh. cat. Cleveland: Cleveland Museum of Art, 1980.

Lam, P. Y. K., ed. *Jades from the Tomb of the King of Nanyue.* Exh. cat. Hong Kong: Chinese University of Hong Kong Art Gallery, 1991.

Loewe, Michael. *Chinese Ideas of Life and Death: Faith, Myth, and Reason in the Han Period (202 BC–AD 220).* London and Boston: Allen and Unwin, 1982.

Medley, Margaret. *The Chinese Potter: A Practical History of Chinese Ceramics.* 3rd ed. Oxford, Eng.: Phaidon, 1989.

Mino, Yutaka, and Katherine Tsaing. *Ice and Green Clouds: Traditions of Chinese Celadon.* Exh. cat. Indianapolis: Indianapolis Museum of Art, 1986.

Rawson, Jessica. *Western Zhou Ritual Bronzes from the Arthur M. Sackler Collections.* Washington, D.C.: Arthur M. Sackler Foundation; Cambridge, Mass.: Arthur M. Sackler Museum, Harvard University, 1990.

————, ed. *Mysteries of Ancient China: New Discoveries from the Early Dynasties.* Exh. cat. London: British Museum Press, 1996.

————, ed. *The British Museum Book of Chinese Art*. London: British Museum Press, 1992.

Spoer, Alexander C. *Literary Evidence for Early Buddhist Art in China*. Ascona, Switzerland: Artibus Asiae, 1959.

Watt, James C. Y., Wen C. Fong, et al. *Possessing the Past: Treasures from the National Palace Museum, Taipei*. Exh. cat. New York: Metropolitan Museum of Art; Taipei: National Palace Museum, 1996.

Wilson, J. Keith, and Anne E. Wardwell. "New Objects/New Insights: Cleveland's Recent Chinese Acquisitions," *Bulletin of the Cleveland Museum of Art* 81 (1994), 269–348.

India and Southeast Asia

The Art of India and Pakistan: A Commemorative Catalogue of the Exhibition Held at the Royal Academy of Arts, 1947–48. Edited by Leigh Ashton. Exh. cat. London: Faber and Faber, 1950.

Bachofer, Ludwig. *Early Indian Sculpture*. New York: Harcourt, Brace and Co., 1929.

Basham, Arthur L. *The Wonder That Was India: A Survey of the Culture of the Indian Sub-continent before the Coming of the Muslims*. London: Sidgwick and Jackson, 1954.

Coomaraswamy, Ananda K. *Hinduism and Buddhism*. New York: Philosophical Library, 1943.

————. "The Origin of the Buddha Image," (reprint from *Art Bulletin* 9, no. 4 [1927]). New York: New York University Press, 1927.

Czuma, Stanislaw J. *Kushan Sculpture: Images from Early India*. Exh. cat. Cleveland: Cleveland Museum of Art, 1985.

Giteau, Madeleine. *Khmer Sculpture and the Angkor Civilization*. New York: Harry N. Abrams, 1966.

Hallade, Madeleine. *The Gandharan Style and the Evolution of Buddhist Art*. London: Thames and Hudson, 1968.

Harle, James. *The Art and Architecture of Indian Subcontinent*. London: Penguin Books, 1986.

Huntington, Susan L. *The Art of Ancient India: Buddhist, Hindu, Jain*. New York: Weatherhill, 1985.

Lee, Sherman E. *A History of Far Eastern Art*. 5th ed. New York: Harry N. Abrams, 1994.

Le May, Reginale. *The Culture of Southeast Asia*. London: Allen and Unwin, 1954.

Lippe, Aschwin. *Indian Medieval Sculpture*. Amsterdam, New York, Oxford: North Holland Publishing, 1978.

Rhie, Marylin M., and Robert F. Thurman. *Wisdom and Compassion: The Sacred Art of Tibet*. Exh. cat. New York: Asian Art Museum of San Francisco and Tibet House, in association with Harry N. Abrams, 1981.

Rowland, Benjamin. *The Art and Architecture of India: Buddhist, Hindu, Jain*. London: Penguin Books, 1986.

Zimmer, Heinrich. *The Art of Indian Asia*. 2 vols. New York: Pantheon Books, 1955.

Japan and Korea

Akiyama, Terukazu. *Treasures of Asia*. Vol. 3, *Japanese Painting*. Basel: Skira, 1961.

Ch'oi, Sun-u. *Arts of Korea*. 6 vols. Translated by Paik Syeung-Gil. Seoul: Dong Hwa, 1979.

―――. *5000 Years of Korean Art, an Exhibition Organized by the National Museum of Korea*. Exh. cat. San Francisco: Asian Art Museum, 1979.

Griffing Jr., Robert P. *The Art of the Korean Potter: Silla, Koryo, Yi*. New York: Asia Society, 1968.

The Heibonsha Survey of Japanese Art. 31 vols. Tokyo: Heibonsha; New York: Weatherhill, 1972–80.

Kennedy, Alan. *Japanese Costume: History and Tradition*. Paris and New York: Adam Brio, 1990.

Korean Arts of the Eighteenth Century: Splendor and Simplicity. Edited by Hongnam Kim. New York: Asia Society Galleries, 1993.

Mason, Penelope. *History of Japanese Art*. New York: Harry N. Abrams, 1993.

McCune, Evelyn. *The Arts of Korea: An Illustrated History*. Rutland, Vermont: C. E. Tuttle, 1962.

Noma, Seiroku. *The Arts of Japan*. 2 vols. Translated by John M. Rosenfield. Tokyo: Kodansha International, 1966–67.

Pearson, Richard J. *Ancient Japan*. Exh. cat. Washington, D.C.: Arthur M. Sackler Gallery, Smithsonian Institution; Tokyo: Agency for Cultural Affairs, 1992.

Sansom, George B. *Japan: A Short Cultural History*. Rev. ed. New York: Appleton-Century-Crofts, 1962.

Shimizu, Yoshiaki, ed. *Japan: The Shaping of Daimyo Culture, 1185–1868*. Exh. cat. Washington, D.C.: National Gallery of Art, 1988.

Warner, Langdon. *The Enduring Art of Japan*. Cambridge, Mass.: Harvard University Press, 1952.

Textiles

Berger, Patricia Ann. "Preserving the Nation: The Political Uses of Tantric Art in China." In *Latter Days of the Law: Images of Chinese Buddhism, 850–1850*, edited by M. Weidner, 89–122. Exh. cat. Lawrence: University of Kansas; Honolulu: University of Hawaii Press, 1994.

Kennedy, Alan. "Kesa: Its Sacred and Secular Aspects." *Textile Museum Journal* 22 (1983), 67–80.

Reynolds, Valrae. "Silk in Tibet: Luxury Textiles in Secular Life and Sacred Art." *Asian Art: The Second Hali Annual* (1995), 87–97.

———. "The Silk Road: From China to Tibet—and Back." *Orientations* 26, no. 5 (1995), 50–57.

———. " 'Thousand Buddhas' Capes and Their Mysterious Role in Sino-Tibetan Trade and Liturgy." In *Heavens' Embroidered Cloths, One Thousand Years of Chinese Textiles*, 32–37 (English and Chinese). Exh. cat. Hong Kong: Urban Council, 1995.

Simcox, Jacqueline. "Tracing the Dragon: The Stylistic Development of Designs in Early Chinese Textiles." *The 1994 Hali Annual* (1994), 34–47.

Watt, James C. Y., and Anne E. Wardwell. *When Silk Was Gold*. Exh. cat. New York: Metropolitan Museum of Art, 1997.